Voices from the land

Jurgen Schadeberg

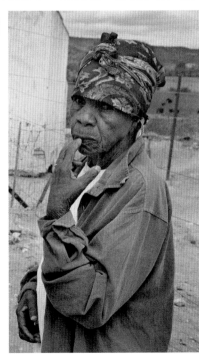

Voices from the land

Jurgen Schadeberg

PROTEA BOOK HOUSE PRETORIA 2007

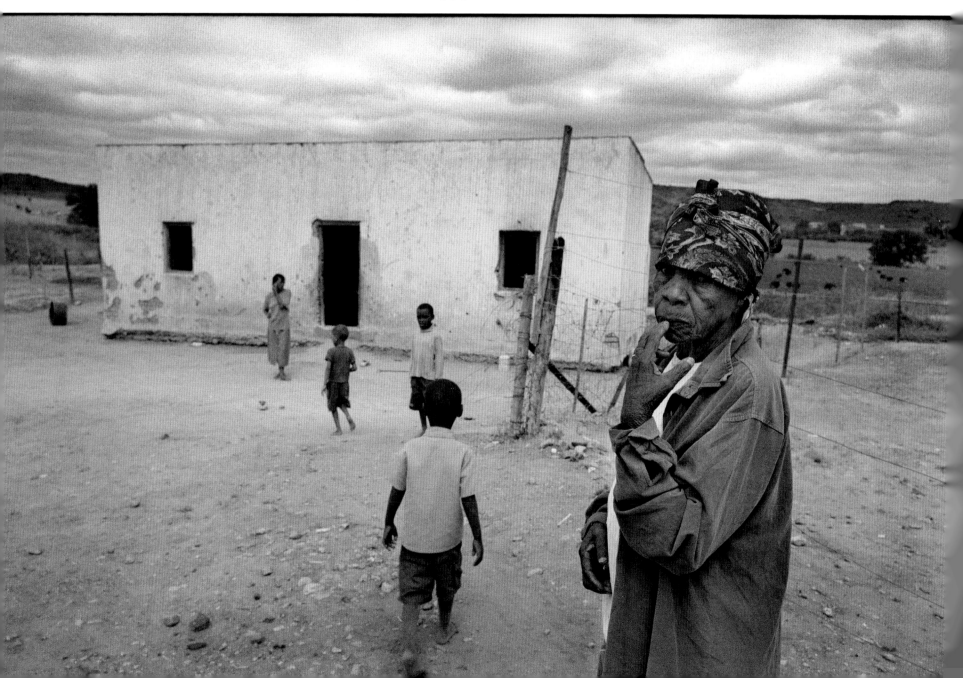

Voices from the land
Jurgen Schadeberg

PROTEA BOOK HOUSE
PO Box 35110
Menlo Park 0102
protea@intekom.co.za
www.proteaboekhuis.co.za

Photographer:	Jurgen Schadeberg
Producer and researcher:	Claudia Schadeberg
The writers:	Kenneth Chikanga
	Hazel Friedman
	Stephan Hofstätter
	Caroline Hooper-Box
	Julia Kupka
	Lucas Ledwaba
	Khathu Mathava
Designer:	Gabriela Muj-Lindroos
Sub editor:	Alf Hayter
Production assistant:	Vathiswa Ruselo
Reproduction:	PrePress Images
Printing and binding:	Tien Wah Press, Singapore

www.jurgenschadeberg.com

First edition, first impression 2005
First edition, second impression 2007
ISBN 978-1-86919-105-4

I would like to thank the following people and organizations for their support and for making this book a reality:

Gerald Kraak – Atlantic Philanthropies
Marc Wegerif – Nkuzi Development Association
Siphiwe Ngomane, Ntokoza Mazimande, David Kalauba,
Nandu Malombete, Sutane Lethole, Shandu Khumela
Stuart Wilson – Centre for Applied Legal Studies, Wits Law School
Bev Russell, Irma Grundling, Khathu Mathavha – Social Surveys
Ramesh Singh, Caroline Sande-Mukulira – ActionAid International
Charmaine Estment and Nathalie Vereen – CAGE
Gordon Naidoo and Farhanda Chand – OLSET
Hilary Julius, Human Rights Officer – Upington
Elna Lindoor, Sharon Bailey, Deena Bosch – Women on Farms Project
Florence Syzaar, Farm Activist – Oudtshoorn
William Syzaar, Community Activist – George

Our special thanks to the farmers and farm workers of South Africa who agreed to share their stories with us.

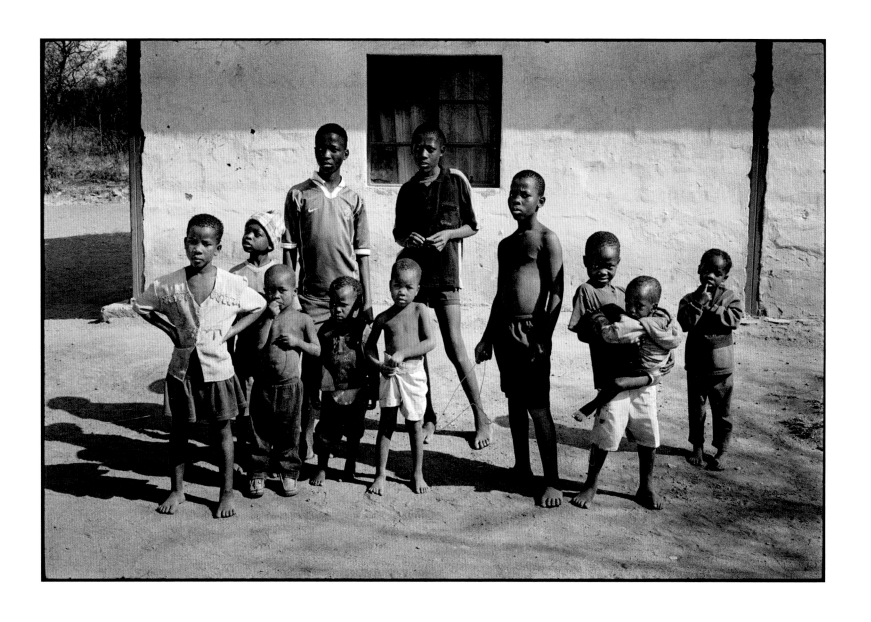

This book **"Voices from the land"** and the accompanying touring photographic exhibition, which is about the lives of farm workers, their plight, their problems, their hopes and fears, has been on my mind for many years. Having approached the public and private sector for support, with no success, it was only after meeting with Gerald Kraak from Atlantic Philanthropies that I found the support I was looking for. In collaboration with my project partner and wife Claudia, Marc Wegerif from Nkuzi, Stuart Wilson from the Wits Law Clinic, and a number of writers, I travelled throughout South Africa documenting farm life and farm labour conditions.

I travelled to the far corners of South Africa with writers such as Hazel Friedman, Stephan Hofstätter and others, where we found some promising and positive situations where farmers are providing for their workers by giving them a dignified and comfortable lifestyle. However, many farm workers are still living in unacceptable conditions and many are being evicted from their birth place. We allowed these men and women to talk about their lives and their problems, their grief and their anger. Many of the evictees we met were elderly and in bad health, a vulnerable and powerless group for which a farmer has little use, even though they might have sacrificed most of their lives in service. They were happy to voice the problems and fears which permanently played on their minds. In many cases we found the poor conditions endured by farm workers unacceptable in the New South Africa.

This book does not paint a black and white picture of the situation on farms with victims and perpetrators but rather a picture with various shades of grey. It is not an investigative report where we make judgements, but rather an attempt to open the eyes of society, particularly of those people in the urban areas who never come into contact with rural life and people. City dwellers buy their food in supermarkets and are presented with a tourist version of rural life while our politicians often visit the country on pre-arranged garden routes and are welcomed by cheering crowds, but they rarely stop to make surprise visits to hear the real stories of people's lives, the harrowing tales of destitution, poverty and despair.

This project is aimed at creating a greater awareness of rural problems to deflect possible conflict and to promote harmony, peace and prosperity. The United Nations Commission on Human Rights has noted that "forced evictions are a gross violation of human rights". The World Conference on Human Rights held in Vienna in 1993 declared that "to be persistently threatened or actually victimized by the act of forced eviction from one's home or land is surely one of the most supreme injustices any individual, family, household or community can face." "Children living on commercial farms are more likely to be stunted and underweight than any other children", and "farm workers have the lowest rates of literacy in the country".

There is, however, hope on the horizon with committed farmers and organizations such as Nkuzi working hard towards a better quality of life and a better future for all rural people. We should think in terms of nurturing rather than destroying the hands that feed us; and we should not forget that our progressive new Consitution, where the preservation of dignity, human rights, water, education and shelter is paramount, extends also to farm workers.

Jurgen Schadeberg
Johannesburg, May 2005

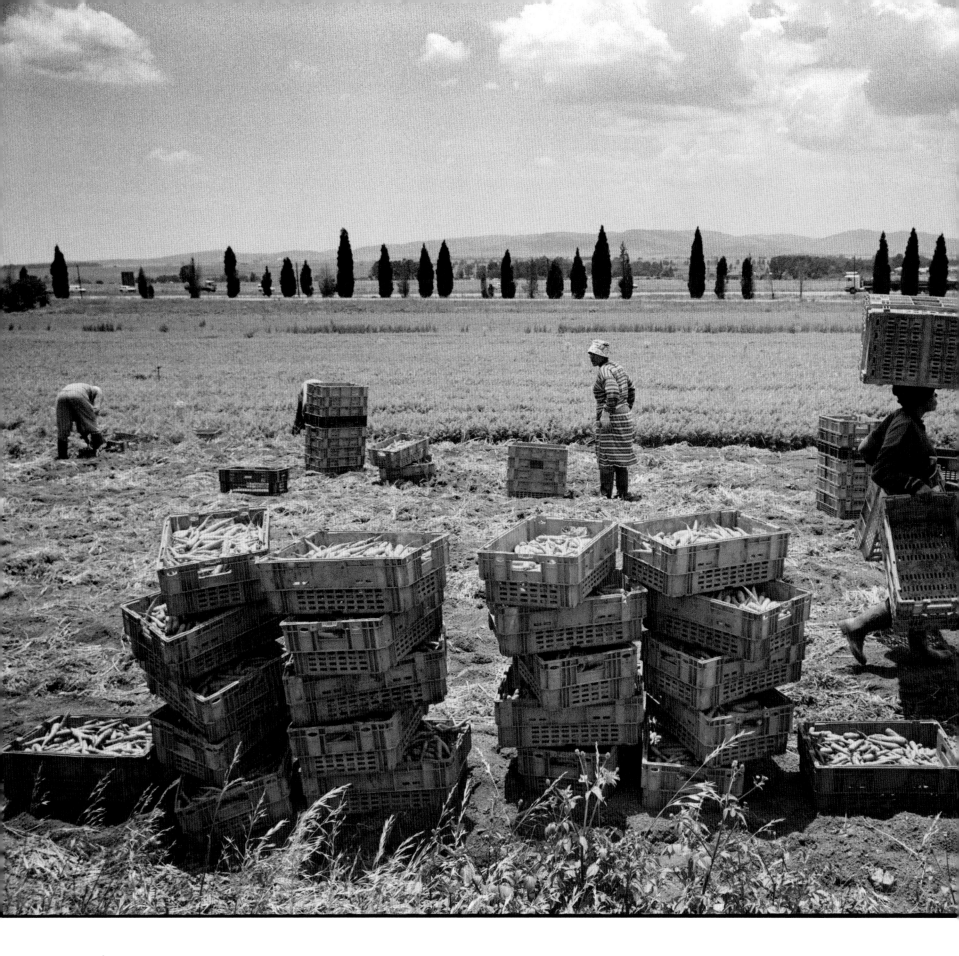

The power of positive action.
A success story – Green's Greens vegetable farm.

When farmers discuss the future, they speak darkly of land reform, minimum wages and black economic empowerment, but a very real threat to their operations is already felt.

At the National African Farmers' Union 2005 conference, Dutch agricultural attaché Gretha Kostwinder predicted that 25 per cent of South African farmworkers would die of Aids within five years. The National Chamber of Milling has also predicted that by 2010, Aids deaths will peak at 800 000 a year, which will slow population growth by 0,3 per cent a year and lead to a 7 per cent drop in wheat flour sales and a 12 per cent drop in maize sales by 2010.

Although very few farms have introduced programmes to tackle Aids, one – Green's Greens – started a programme in 2001 after its manager, Antoinette Erasmus, was horrified by the rate at which her staff were dying, or constantly sick, because of Aids.

Green's Greens, one of South Africa's top vegetable farms, is near Meyerton, about an hour's drive south of Johannesburg. It grows carrots, coriander, spinach, leeks and radishes, which are packed on the farm and supplied to top retailers such as Woolworths.

Jill Green and her late husband bought the farm in 1974. "At that time we had no clear idea of what to do with the land, so we put in

maize, lucerne and ran some cattle. We were living in a caravan at the time and started growing vegetables on the side, but soon the vegetables started encroaching on the lucerne," Jill says.

When her husband died unexpectedly in the late 1990s, Jill was left to run the farm on her own. She realised quickly that her staff would be the key to her success. She started an employee share-incentive scheme in 1999, years before the phrase black economic empowerment was even coined. More than 500 people are employed on the farm, of which they own a 25,6 per cent share through a trust, and two of the board's four directors are employees.

Former shop steward Charlotte Kwatshube is one of the directors. She joined Green's Greens after matriculating in 1993 and worked as a packer until she went on maternity leave in 1998. When she returned, she found that the farm's trade union had been disbanded because it had become ineffective and Jill had started negotiations on introducing the share-incentive scheme. This coincided with a major training initiative, necessitated by the fresh-produce industry having introduced strict quality-control regulations of the entire food chain, from the farm to the shop shelf.

Charlotte, because she had shown strong leadership skills, was selected by Antoinette to

train other workers in the packhouse. In 2003 Charlotte was promoted to training manager and elected onto the farm's board of directors.

"I help to ensure we take decisions that will keep the farm running," Charlotte says about her role on the board. "I want to see the farm survive for another 30 years."

One of the things that will ensure the farm's survival is its innovative Aids programme, which includes counselling, an Aids-awareness campaign and material and emotional support for HIV-positive staff. Antoinette started the programme in 2001.

"So many people on our staff were dying and I felt I needed to do something. So I started by inviting local Aids volunteers to talk to us about Aids," Antoinette says. Charlotte recalls that the talks were controversial at first. Most people did not want to discuss sex, and Aids was a taboo subject. Nevertheless, in December 2001, a group of about 10 workers, Charlotte included, formed the first group to go to the local clinic for testing.

Charlotte learnt she was HIV positive on a day when a colleague blamed Charlotte for the theft of her wedding ring. "I felt like crying, but I had to hold my tears back because I needed to manage this problem and ensure that production in the packhouse was not disrupted."

But she says what helped her pull through was the support that Antoinette and the other workers who had tested positive offered her. "Antoinette told me that if I did not want to die, then I would not die. She asked how old my children were. At that stage they were seven and 11. She said that if I held out and worked for 10 years, then at least my eldest son would be 21, and would be able to look after me and his brother. "Antoinette has guts; she has a way of saying things that makes you believe in them."

Green's Greens' Aids programme is funded largely from the farm's profits. Part is used for nutritional supplements – vegetables, Epap (a vitamin-enriched porridge), olive oil (for thrush), lemon juice (to boost the immune system) and mineral supplements like selenium – for HIV-positive staff.

"In the beginning, there was a lot of gossip around the bags of vegetables; as soon as people saw you with the bag, they knew you were positive. People were embarrassed to collect their bags, so Antoinette devised a system where she would call us to her office on the pretext that we had a telephone call. She would then quietly give us our bags, which we would then hide in our lockers.

"It was silly because, if there was a group of 12 people, at least six would be positive, and most of the people who had mocked the vegetable bags were those who had not been tested," Charlotte says.

But by the end of 2003, the stigma was lessening. "More people had been tested and, because of the Aids counselling, people began to see Aids as a problem that affected us all. Some are still scared to come out about Aids, but most of us are now quite open," Charlotte says.

Green's Greens' nutritional packs have made a profound difference. Before they were introduced, three or four people would die of Aids each year and there was a high level of absenteeism. Since 2003, only one person – a supervisor – lost her baby because of Aids.

Although there is openness about Aids on the farm, the workers, especially those who are women, cannot talk openly about Aids in their communities and homes.

"Many women won't tell their husbands they are positive because they are afraid they will lose them. It is also difficult to get our men to use condoms, because they would want to know why. Many women here are risking their lives for love," says Charlotte.

In 2005, Kostwinder put Jill into contact with Dr Hugo Tempelman of the Ndlovu Medical Clinic in Groblersdal, Limpopo. With funding from inter alia USAID, the clinic has set up a number of satellite Aids clinics in rural

areas. Now a weekly satellite clinic, which provides medical attention and pays for antiretroviral (ARV) drugs, has been set up on Green's Greens, where about 10 staff members are receiving treatment.

"The Aids programme has prolonged the working lives of many of our staff and kept their families with a breadwinner," Jill says. "I want to get the message across to all farmers that it is in their interests to start tackling Aids. They need to start with an awareness campaign to destigmatise Aids."

Aids takes a massive toll on farm productivity. "We invest a lot of training in our staff. For every skilled worker we lose, I need at least two unskilled workers to do the work."

Charlotte makes the point: "Many farmers say they feed the nation, but they don't take the time to take care of their staff – if you are sick you lose your job. Without workers, farmers wouldn't be able to feed the nation.

"But this farm is different. In 10 years time, I want my children to see this farm because it has done so much for me."

JULIA KUPKA
Meyerton
November 2004

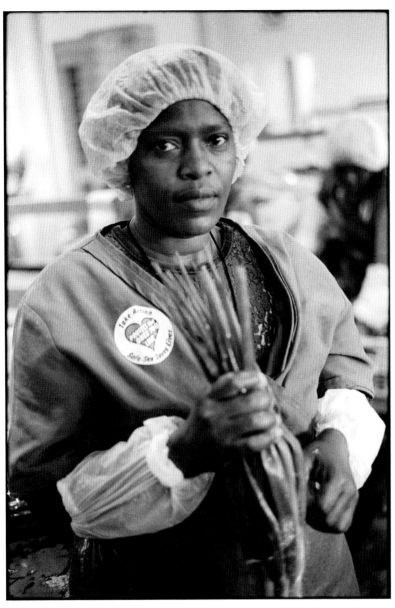

Siphwe Mtshali, aged 42, is the line supervisor. She lives in Orange Farm, earns R1 600 a month and looks after 10 children.

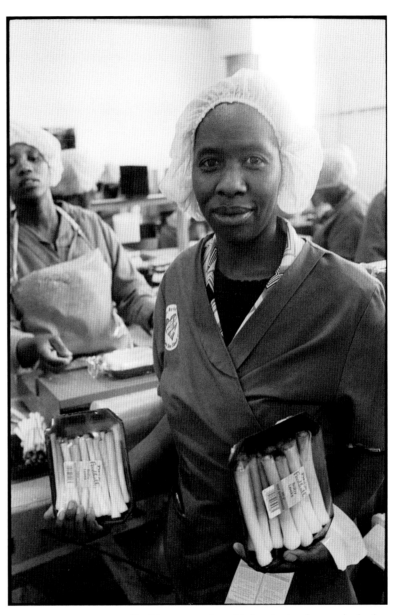

Packing supervisor Nobuntu Jende, packs leeks. She has been working on the farm for 17 years, earns R1 100 per month, lives in Thokoza, and looks after three children.

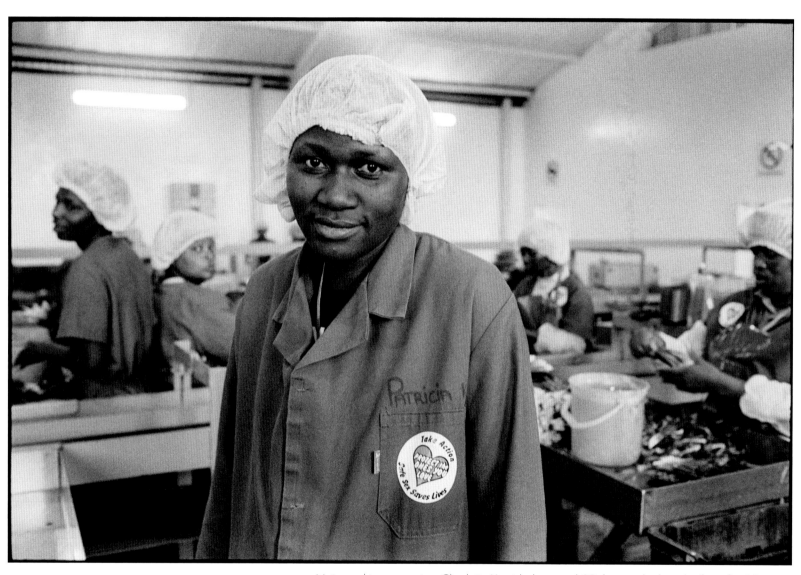

Main packing supervisor Charlotte Kwatshube, aged 32, has worked on the farm for 11 years.
She earns R2 500 a month and lives in Rondebult with her 3 children.

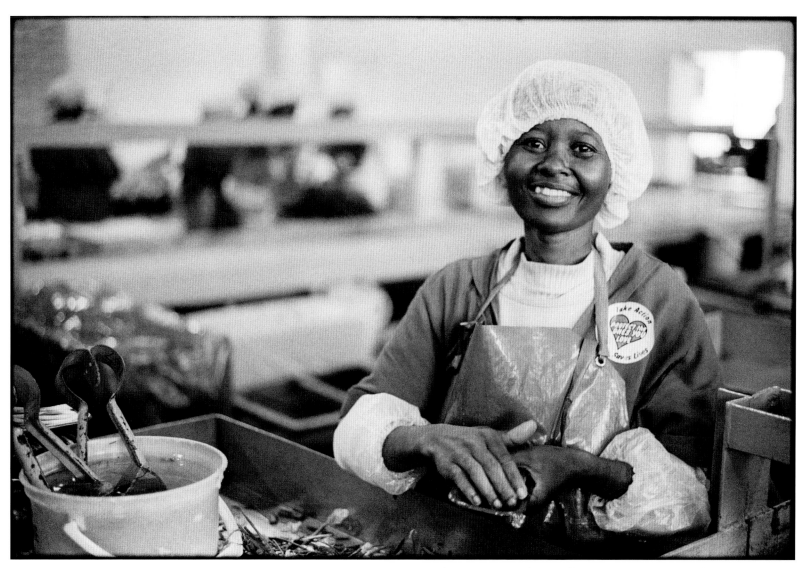

Packer Eunice Ngada, aged 32, has worked on the farm for six years.
She earns R871 a month and lives in Thokoza with her two children.

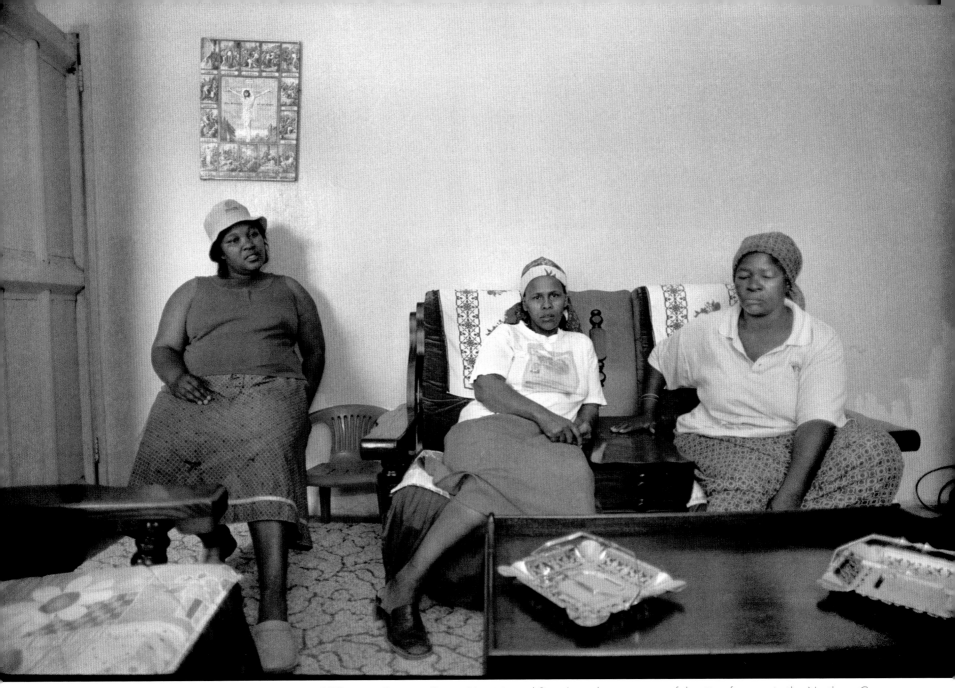

Wilhemina Bingwa, Grace Moraitje and Sara Legoshe are successful cotton farmers in the Northern Cape.

Watching the three women trudging through a cotton field in the sweltering heat, I thought of Leonard Cohen's words, "Everybody knows the deal is rotten. Old Black Joe's still pickin' cotton for your ribbons and your bows."[1]

For most of their lives as seasonal workers on farms in the Northern Cape, the deal was indeed rotten. They would earn a pittance for toiling in the sun from dawn till dusk, and would probably be evicted from their homes when too frail to work.

But times have changed. Three years ago Wilhemina Bingwa, Grace Moraitje and Sara Legoshe became beneficiaries of a government land-reform project. They were leased 200 ha of irrigated state land near Jacobsdal with an option to buy it. In their first season, the government contributed to contract-ploughing costs and donated seed and fertilizer. After that they were expected to make it on their own.

The results so far are encouraging. The three women, who between them support 13 children, now employ six full-time workers and hire seasonal staff for planting and harvesting. Last year they earned R300 000 from 45 ha of mealies and another R290 000 from 45 ha of wheat. A vegetable garden helps to feed their families.

Nevertheless, their smiles fade quickly when asked how much profit their farm is making.

Three committed women.

"Nothing," said Bingwa flatly. "We don't have money for a tractor or implements, so we hire contractors to prepare the soil, to plough and plant. Fertilizer and seed is expensive, and we have to hire a lot of workers for the harvest." Annual costs run up to R700 000.

The Land Bank will lend them only R20 000 each, but Bingwa estimates they need R1 million to turn their farm into a viable business. The dearth of capital for equipment and the production costs mean that much of the land they lease is fallow. "We will make a success of this just give us tractors and implements."

Moraitje believes it's unfair to expect them to succeed without support. "When white farmers started out, they did it with help. Fathers passed land on to their sons and the government subsidised them. We know we must struggle, but the government doesn't help us and white farmers don't help us."

All three have pinned their hopes on this year's successful cotton crop, which should fetch more than R1 million. "*Ons byt klippe* [we are biting stones], but we'll keep on struggling," said Legoshe. "Nothing will ever stop us from succeeding."

1. Leonard Cohen, *Everybody Knows*, on the album *I'm Your Man*.

STEPHAN HOFSTÄTTER
Jacobsdal
February 2005

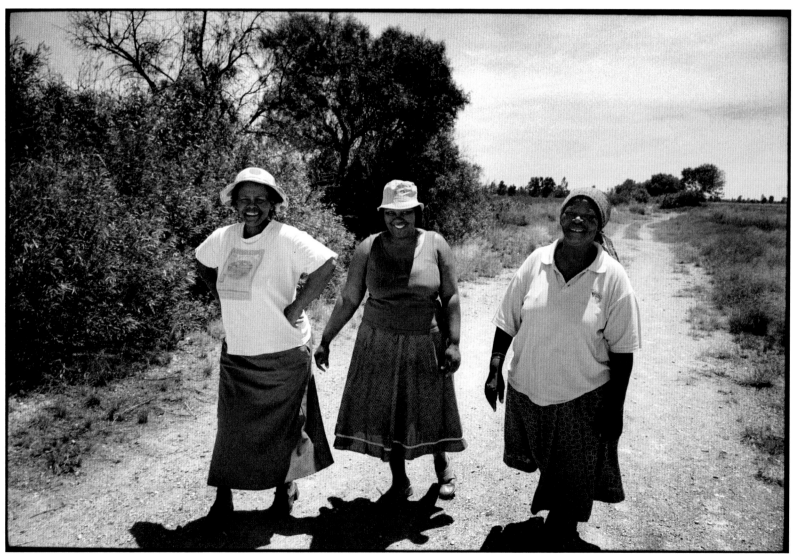

"Nothing will ever stop us from succeeding," say the three feisty cotton farmers.

We are simple backwater Boers...
Take us as we come...
Farming isn't what it used to be.

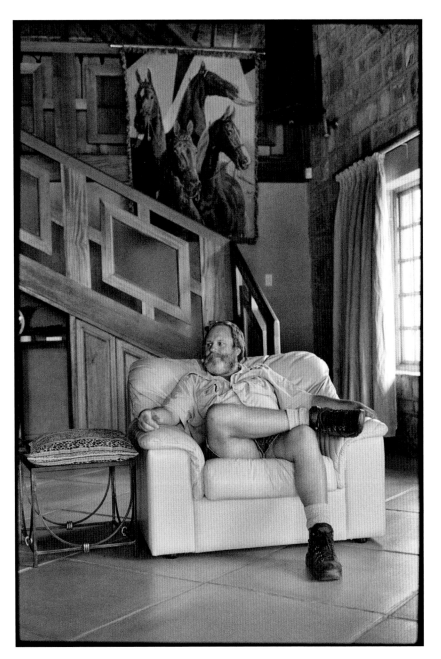

When I phoned Tina de Jager from Johannesburg to ask if we could meet at her farm on the edge of the Kalahari, she sounded wary. She wanted to know if I spoke Afrikaans. "Around here we only use English in self-defence," she explained. We are simple, backwater Boers, she was saying. Take us as we come.

A week later we were chatting amiably in what looked like the reception area of a luxury lodge about the pressures facing modern farmers. To our right, stairs led up to a mezzanine floor furnished with the latest office equipment – the nerve centre of the De Jagers' prize-winning cattle and saddle-horse operation, Doornhaag.

The farm lies just west of Vryburg, the heart of what has been dubbed the Texas of South Africa because of the number of top-quality cattle bred on the ranches in the area. Their breed, Santa Gertrudes, won the national championships in 1995, 1998, 2001 and 2004 and can be traced back to one foundation sire in Texas in the 1920s. The animals are auctioned on the farm. One fetched a record price of R45 000.

"Dad used to run his business from a notebook in his top pocket," lamented Tina, 38. "Farming isn't what it used to be." Tina's husband Willie, 49, also runs a sheep stud in the Western Cape and a citrus farm in the Eastern Cape. Despite a generally liberal outlook, he has strict ethnic classifications when it comes to the calibre of his staff. Every year when his oranges need

Willie de Jager, cattle and saddle-horse farmer in Vryburg, the Texas of South Africa.

picking, he hires a bus, loads up 150 workers from Vryburg and takes them to the Eastern Cape, a journey of 800 km. His farm lies in Xhosa territory, and he doesn't trust the Xhosa. "The Tswana is a peace-loving person, but the Xhosa likes to fight," he expounded. "Zulus are aggressive too, but the Zulu will confront you directly, the Xhosa comes round the corner."

Nevertheless, he was at pains not to come across as reactionary. He recalled another farm that he had managed south of Vryburg where the workers didn't know what a R50 note looked like. "Some people treat their workers terribly," he said with genuine concern.

A central gripe of the De Jagers is the barrage of new laws and regulations farmers must comply with, especially those governing staff. They have nine permanent employees on their farm who earn between R1 000 and R1 500 a month, depending on their level of skill.

Employment rules are too rigid, Willie insists.

"We farmers have a very special – how should I say, intimate relationship with our workers," he explained. "We live very close to each other and have known each other's families for years. The laws are good, but you must be able to implement them as they work in certain areas."

By this I expect he means farmers should be allowed to retain some elements of the old paternalistic style of management.

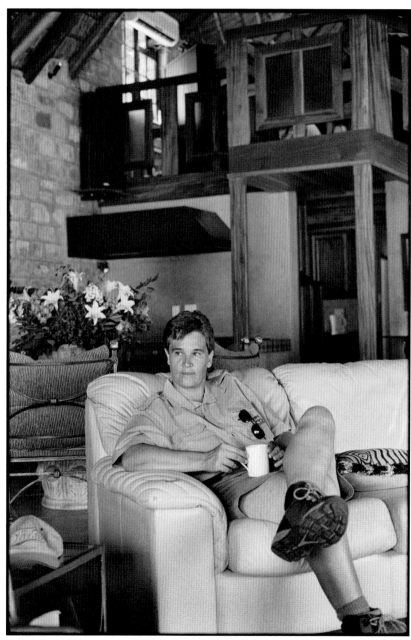

Tina de Jager: "Here we only use English in self-defence."

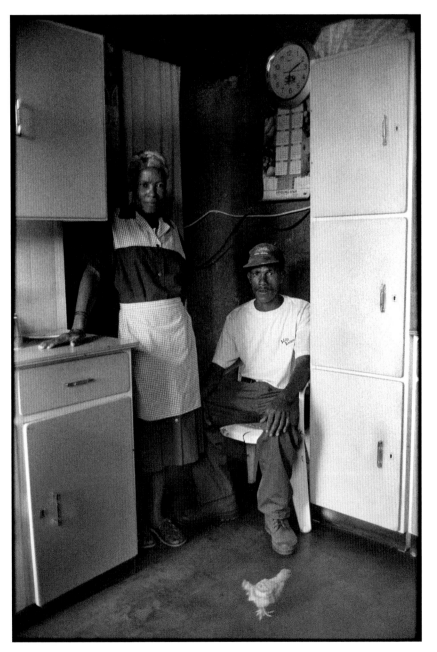

Doornhaag's workers get free meat once a month, Christmas presents every year – usually household goods – and a 13th cheque. They are taken to town in the bakkie for shopping and brought back home. A round trip with groceries would cost them R30 by minibus taxi. De Jager gives them compassionate leave and they work shorter days in winter. In return, he expects them to work late in summer and to take 14 days off a year instead of the mandatory 15.

Identifying what his workers have an aptitude for and giving them the scope to develop skills in specific areas is the key to his labour philosophy. "Otherwise they wouldn't feel responsible for anything," he explained. "Two guys love horses, another, Fin Steenkamp, is unbelievable with cattle. I have 300 head and he knows exactly where they are at any time of day or night."

Fin is one of Willie's most trusted workers. He came to these parts with Willie from his home district near Kimberley 17 years ago when he was 18. Willie often leaves Fin the keys to the main house when the De Jagers are away. He and his wife, Linkie, share a two-roomed, cement-and-brick house with a stone stoep. Outside is a chicken coop and a tin lean-to for his bakkie. They do not have electricity, they fetch water from a communal tank on a mound behind their home and they use an outside toilet. Though sparing in conversation, they say they are satisfied with their lot. Fin's only complaint is the weather. "It gets hot in here," he commented.

Fin Steenkamp and his wife, Linkie.
Fin has worked on Doornhaag for 17 years.

Fin has known Linkie most of his life but they got married only last August. She was married to a man who, a few years ago, tried to break into the De Jagers' safe while they were out. Tina arrived while he was inside the house and he held her at gunpoint with a rifle he had found. It was Linkie's brother who decided to risk his life, enter the house and disarm the man.

Tina prefers not to talk about these things. Her favourite subjects are her two passions – horses and sable antelope. "Once you've got horse sickness, you don't get cured. It's with you for life," she said. The small stallion we saw in a paddock on the way in was not the real McCoy, she continued. "We just use him to tease the mares to see if they're ready to mate." Her prize stallions are worth up to R300 000, and she'd rather not risk injuring them during an amorous dress rehearsal.

She insisted we drive out to see her sable herd. She bought the animals in Zimbabwe and breeds them for sale to hunting farms. When prices were at their peak, a single antelope could fetch up to R200 000, although these days they go for as little as R70 000.

"This is my hobby," Tina said proudly, her hair blown back as we raced around her sable paddock on the back of her bakkie, with Willie at the wheel. "Aren't they beautiful?"

STEPHAN HOFSTÄTTER
Vryburg
February 2005

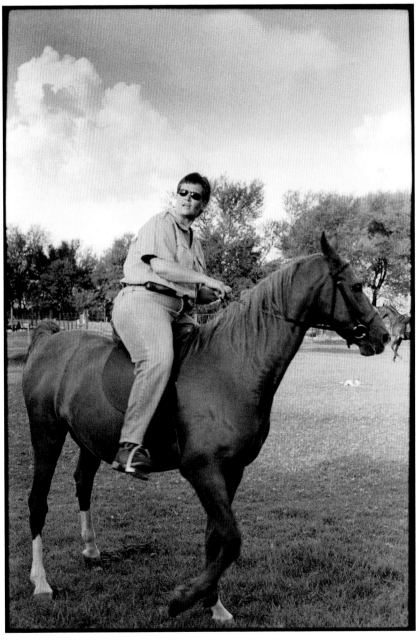

Tina de Jager, a prize-winning horse breeder.

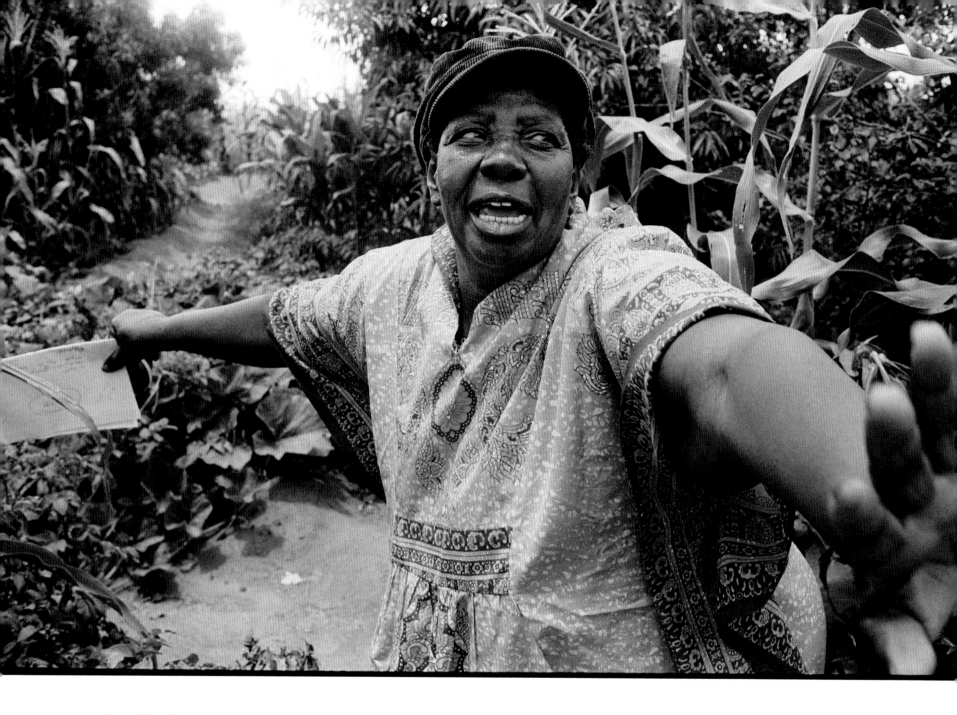

Tshepo Khumbane's little farm in Cullinan, 45 km north of Pretoria, doesn't look like much.

Naartjies, beans, grapes, mealies, pumpkins, green peppers, lemons, herbs, butternut squashes and lemongrass are planted around her house, in a seemingly haphazard way. But while commercial farms produce an average yield of 80 tons a hectare, Khumbane produces 90 without fertilizer or pesticides, and using only rainwater.

Like her farm, Khumbane's appearance can be misleading. On the face of it, she is a simple, rural woman, 68 years old, who walks barefoot and lives

simply, scrimping a living on the vegetables and chickens she sells in the area. Known to all as MaTshepo, she is a proverbial force of nature. She is a visionary who has made a real difference to the lives of thousands – often the difference has been between life and starvation.

She delights in the farm she has created, and evangelises relentlessly and loudly for her cause and her life's work – to bring the power of small-scale farming to the rural poor, to free themselves of state handouts, and to take control of their own destinies with dignity.

Khumbane grew up in Soekmekaar, a small rural area in Limpopo. The community lived off the land. Life changed in the 1950s when the apartheid government passed a chain of bills to replan agricultural settlements, she says. What was called the "betterment" policy saw rural black families being allowed only six head of cattle.

"Then they said no donkeys are allowed – 'we will take them by force or those who voluntarily give it up will get 25 cents'. No donkeys remained at all, except those on white farms." So the pots and baskets that the women in Khumbane's village

68-year-old MaTshepo is a veritable force of nature... "I'm not planting cabbages in your backyard, I'm planting cabbages in your heart."

made for the market could no longer be transported.

"Goats were the poor man's cows; everyone had goats. We got milk from goats and, when there was a celebration, one would be slaughtered. But then they said the goats destroy the environment, so they also went."

That was the beginning of the destruction of the community, she says. She decided to become a social worker, "because it had meaning". She was posted to a rural mission hospital in Sekhukhune. The malnutrition she saw there shocked her. "It was a nightmare. I was literally organising and managing people's funerals. So I reflected on how much the social environment helps contain the stress of poverty. I went to neighbouring farms with seeds instead of tablets and I said, 'Here, try a garden.'

"It is important for that little woman with nothing to produce her own food. It means a lot, because there's nothing more painful than not being able to feed your child. If that child dies, that self-blame can never be repaired. I know what it means." That was the start of something that grew much larger.

The turning point for Khumbane, which saw her return to the farming life she had grown up with, was witnessing a 75-year-old woman come to the hospital with pink-eye, pretending to be blind. She was getting an old-age pension of R70, looking after her daughter's children and wanted a disability pension too. She refused to take the medicine she was prescribed. When Khumbane saw her two weeks later, she was blind.

"I had to send this woman into an institution and get foster parents for the children. I broke into tears that day and I sat down and asked, why am I here? To earn, or to have a commitment to help?

Kill my conscience? No. That was the beginning of my activism. Every day, everywhere, I went into churches, spoke to people at bus stops, challenged chiefs and gave an account of what I saw."

The result was the birth in 1975 of a 5500-strong women's movement, going from village to village, teaching people to plant, to be self-sufficient, to look for their own solutions to their problems.

The government of the time didn't know what to make of her. "They thought I was politically motivated. I was being taken as a communist, there were threats of murder. Now and again they would send in the security police."

Today those trees still bare fruit, and Khumbane still works with rural communities, running farming workshops and teaching people how to harness rainwater. She has founded the Water for Food Movement, an organisation of mostly rural women who work with food-insecure households, and she is a member of the water affairs minister's advisory council – "the only way they could shut me up", she whoops and falls dramatically onto her couch, shaking with laughter.

"It's better if government is weak, it's fine. If government is weak, it gives people room to take responsibility for their own destination," she shouts, her eyes blazing. "The mind has turned into welfareism. Little girls make as many babies as they can because the state will take care of them. People are very negligent with their lives. Respect is gone. They have lost themselves. I used to tell them, 'I'm not planting cabbages in your backyards, I'm planting cabbages in your heart. MaTshepo is planting a seed in your heart'."

"I've had this vision for 40 years. It's not achieved yet, and these are my last years. I'm going to fight to the bitter end, I promise you." Khumbane is Cullinan's only black farmer. "Here, it's a white area. I've been brave my whole life! I mobilise!" she shouts, cracking up with laughter again.

When she dies, she says, her body will fertilise the soil. She throws her hands heavenwards. "The plant that grows from that is going to be crazy, just like me!"

CAROLINE HOOPER-BOX
Cullinan
November 2004

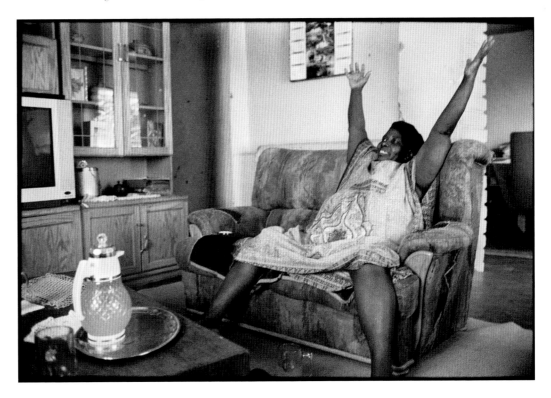

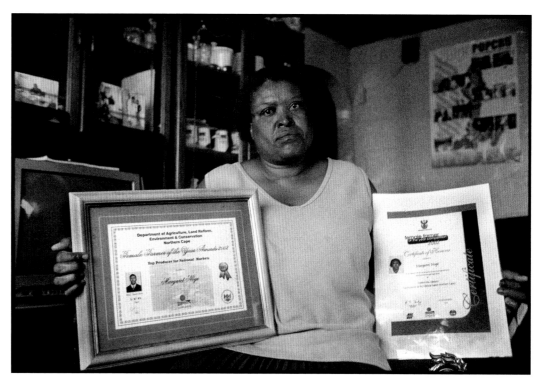

Margaret Noge proudly diplays certificates recognising her farming achievements.

Margaret Noge, prize-winning backyard chicken farmer, who strives to empower rural women.

In South Africa, there's nothing unusual about a township woman breeding chickens in her garage, slaughtering them in the driveway and selling them to her neighbours.

What is curious about Margaret Noge's case, though, is that she received official recognition for her efforts, partly because she was so successful. When she started out in 1998, the 45-year-old unemployed housewife and

mother had 50 chicks. Four years later, when she won the Northern Cape's Top Producer for National Markets award and became a finalist in the national Female Farmer of the Year competition, she was ordering 700 chicks at a time every six weeks from Bloemfontein and Johannesburg.

Of course, at the time land and agriculture minister Thoko Didiza was doing her best to promote the idea of using agriculture to empower rural black women, traditionally the poorest of the poor. Noge was supposed to become a poster image for what women could achieve with a little help from the government if they made a headstart on their own.

With R7 000 in prize money, the mother of four was given a R100 000 land grant – R75 000 to buy five hectares of Northern Cape scrubland near her home in Ritchie, and R25 000 to get her business going.

But three years later when I met her, she complained bitterly that the official attention had done more harm than good. To illustrate this, she showed me a letter she had received a week before from the department of health after a recent visit by a health inspector. It instructed her to stop slaughtering her chickens on the premises with immediate effect or face prosecution and the confiscation of her stock.

"I used to slaughter them right here," she said, pointing to the bricked driveway where her husband sat on a plastic chair with a lopsided grin. "What am I going to do now?" Her chicken run is the same low-slung, foul-smelling tin shed she built eight years ago, except that now there are only 200 chicks cooped in the far corner.

In another enclosure down the road she keeps sheep, goats, pigs and a few cows. "I had to slaughter most of them because there was

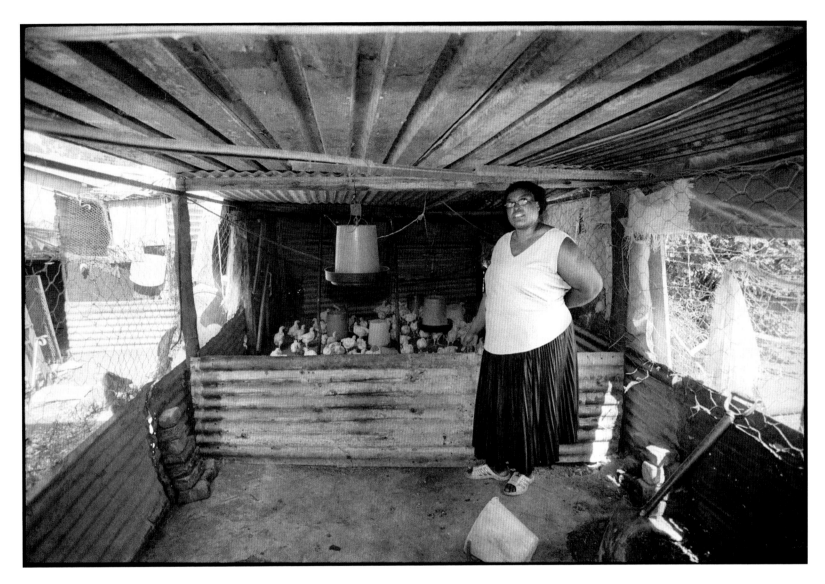

no space. Now they say I have five hectares, but that's barely enough grazing for one cow." Although she has the title deeds to her plot of land and framed certificates of her prizes on the mantlepiece in her spartan living room, she would need to raise R500 000 to build a commercial hatchery complete with abattoir and refrigeration rooms.

Noge received verbal assurances from agriculture officials that more help would be forthcoming, but nothing has materialised.

"I've been waiting for three years for the government to fulfil promises and every year I just fall down deeper," she thundered. "My business was better before, but I can't do anything with this uncertainty. It gets worse every day."

Her small-town celebrity status has also become a source of jealousy. When the government bought a 2000 ha commonage nearby, the people of Ritchie made it clear that Noge was not welcome to graze her cattle there because she had her own land, and council officials who dole out part-time jobs on public-works projects put her children at the bottom of the list.

"The premier doesn't know where I live. The MEC doesn't know where I live. Not even the mayor knows where I live, but they use me to promote the province," she said. "They just sit in Kimberley on big chairs eating all our money. I want to farm but I have no land."

STEPHAN HOFSTÄTTER
Ritchie
February 2005

Michael Africa, a suburban entrepreneurial farmer.

Michael Africa heeded Nelson Mandela's advice when he told the people of Kimberley in 1996 to take over unused land and work the soil. When he retired from the railways three years ago, he decided to turn his back yard into a farm.

Beyond his township house, where he raised six children and his wife, lies a 10 ha stretch of council land bounded by a gravel road used by trucks carrying diamond-laced gravel from the nearby De Beers mine. The council refuses to sell it to him because a row of electricity pylons march through the veld past his house, but after much badgering, he was given permission to extend his garden.

Armed with a pick and shovel, he dug a large pit, fitted it with a feeble pump to draw water and began to prepare the soil. But far from realising his dream of creating a flourishing garden in the desert, Africa's farm consists of a few patches of spinach, a coriander tunnel and rows of unused furrows overrun with weeds.

Makeshift livestock camps are populated by scrawny goats, chickens and a few raucous turkeys. The enclosures, divided by offcuts of wire mesh and bits of scrap metal, are littered with pipes and rusting tins covered in animal droppings. Two adolescent ostriches amble aimlessly around a shallow koi pond. "I want to use the ostriches for tourism activities when I've fenced the rest of the land," he explained.

Africa blames the government for his failure. Under apartheid he had always wanted his own piece of land to farm. Granted, he was grateful to the council for letting him use this vacant lot. But since then he had been left to his own devices. Countless requests to the department of agriculture for a soil-analysis test to see which crops would flourish here have fallen on deaf ears. He has asked for the use of a tractor and a R50 000 grant to build a tomato tunnel, but to no avail.

The fact is, Africa does not really tally with the department of agriculture's vision of an emerging class of black commercial farmers.

Increasingly, the government is using terms such as generating growth and employment, economic viability and global competitiveness when talking about black empowerment in agriculture.

Apartheid robbed Michael Africa of the right to buy and farm his own land, but it could be that democracy and its promise of transforming control and ownership of land has come too late for him. For the bureaucrats processing grant applications and deciding where to allocate resources, he is no doubt just a retired railwayman who wants his hobby to supplement his pension.

Perhaps Africa senses this. Unsurprisingly, like many in these parts, his thoughts have of late begun to turn to diamonds. I picture him walking out into his fields under the fierce Northern Cape sun and contemplating the sweat he has poured into furrows now nurturing weeds. I picture him leaning on his shovel to catch his breath and watching the De Beers trucks thunder past. He must be thinking there are easier ways to make a living.

Africa is in fact convinced that the pile of gravel next to his water pit must be rich in diamonds. But he doesn't dare sift it. That would invoke the wrath of De Beers, who have helped him clear some of the land and could be a source of funding for future farming proposals.

Still, it doesn't rule out the possibility of a chance discovery. "Who knows, maybe I'll find a diamond one day," he says with a crafty twinkle in his eye.

STEPHAN HOFSTÄTTER
Kimberley
February 2005

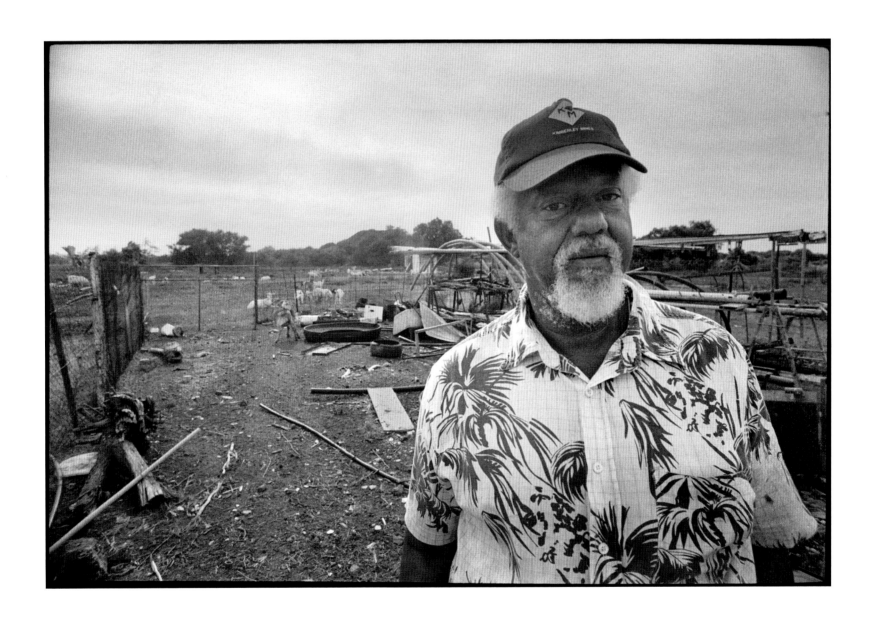

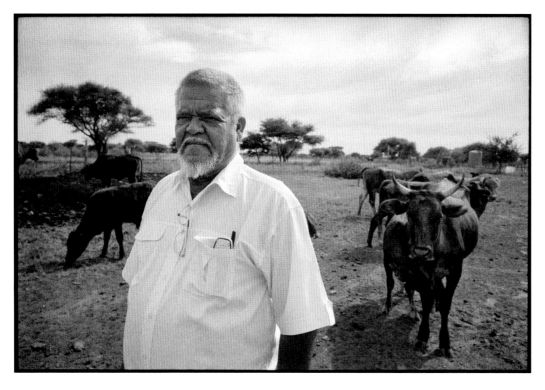

Russel Malander, cattle and sheep farmer.

Russel Malander, head of the National African Farmers' Union in Kimberley, wants more land.

The black farmers of Kimberley have a lot to complain about. Around the city lie open plains stretching as far as the eye can see, yet land can't be had for love or money. Vast stretches are owned by a handful of white cattle ranchers, who have no desire to sell, and almost all the rest belongs either to diamond miner De Beers or retired farmers who have clubbed together to buy in game, which has pushed up land prices beyond the reach of new farmers.

When the government does buy land for emerging farmers, they are expected to farm it communally. This means they cannot use it as collateral to get loans and can't fence it to protect their stock from thieves.

Russel Malander heads the Northern Cape branch of the National African Farmers' Union. For the past decade he has kept his livestock at Roodepan, 500 ha of scrubland used by more than 50 farmers. It is a stone's throw from a formal township surrounded by squatter camps on the outskirts of Kimberley.

By day, sheep, goats and cattle graze in the unfenced pan, by night, they are herded into enclosures. Stock theft is a constant headache. Some thieves strike brazenly in broad daylight but most push their bakkies up to the camps at night, pass a few sheep over the fence and drive away with them. Malander started with 35 sheep. He has 20 left.

Malander showed us around his enclosure with proprietorial pride. This is the only patch of the commonage he can call his own, even if he doesn't actually own it. Allocations are done through the commonage committee. He is puzzled by the provincial government's reluctance to help black farmers acquire title to their land.

"You can't farm the way you want on a commonage," he said. "The bulls serve any cow and you end up with inferior genetic stock."

Like other black farmers around here, Malander wants a government grant to buy his own fenced farm far from the city's informal settlements.

Hernando de Soto, a Peruvian economist, argues in his book, *The Mystery of Capital: Why Capitalism Triumphs in the West and Fails Everywhere Else*, that the primary reason developing countries remain poor is because of their failure to convert billions of dollars worth of real estate into capital.

In Europe, the United States and Japan, property rights evolved over centuries into tradeable commodities.

In much of Africa and Latin America, they still exist only as a function of quasi-feudal relationships with local elites, traditional leaders, warlords or gangsters – and are subject to arbitrary termination or alteration. They, therefore, have no value outside their immediate context.

Malander has never read De Soto but his views support the book's central thesis. "We all want title deeds," says Malander, "otherwise our farming will never become profitable."

As we left, his neighbour was tying thorn bushes to the fence around his enclosure. It might deter the stock thieves.

Boetjan Maphile and his wife, Micky, live in a tin shed on a tiny enclosure that belongs to Russel Malander, the president of the Northern Cape branch of the National African Farmers' Union. Every day Boetjan, 48, takes Malander's cattle and sheep out to graze in a pasture shared by 50 other stock farmers and every night he brings them in again.

His 36-year-old wife does domestic chores and looks after the chickens and pigs.

Both have spent the past two decades as itinerant farm workers on white-owned farms, but three years ago a drought drove them to seek work in Kimberley. That is how they landed up on Malander's plot.

There is no electricity, sewerage system or running water. Micky must fetch water in a plastic container from a municipal tank about 100 m away, and they share ablution facilities with other people living on the surrounding encampments.

Boetjan leans over the fence around their shack. "It's good to be here, except there are too many *skelms* [crooks]," he says. He does not mind being paid R450 a month, even though the minimum wage is R714.

His wife is shy and retiring. She does not lift her eyes from her washing. A few months before, in broad daylight, a shepherd was murdered on the commonage for five sheep. A stock farmer who lives on his own enclosure a short distance from the Maphiles was arrested and charged with murder.

Suspicions were aroused when the man started offering local abbatoirs sheep without ID tattoos. Or he would sell 50 of his flock of 200 one day and still have 200 sheep left the next. He is out on R2 000 bail.

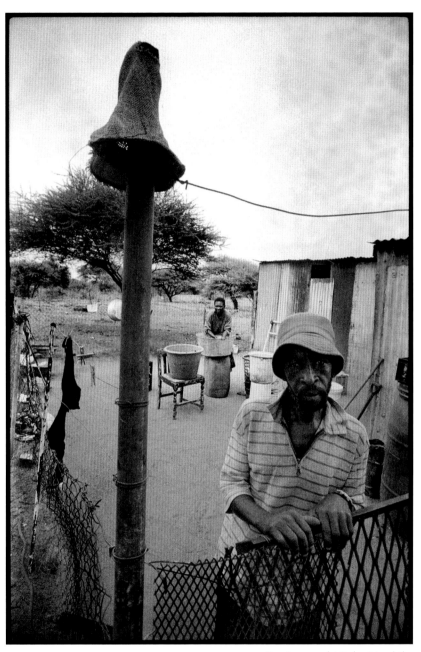

Boetjan and Micky Maphile.

Boetjan has never seen the thieves. When barking dogs wake him up at night he goes out to investigate. But by then the thieves have already gone.

"We feel very unsafe here," he says.

STEPHAN HOFSTÄTTER
Kimberley
February 2005

Farmer Tello Samiel Setloboko, 74,
in Cedarville, Eastern Cape.

He is up every day at five working on his farm from which he sells
wool, cotton and cattle. When Tello Samiel Setloboko is asked what
he does for pleasure, he looks momentarily confused before offering "I
read the Bible." Due to his hard work his family has prospered and so
too has his community. In 1986 Tello built a dam so that 20 other
households would have regular access to water. The project took
three months and not only did he buy all the materials himself but
he also paid salaries to the six men who agreed to help, despite the
fact that they benefited from the free water. "I did it so that they
would have the energy to work."

Cedarville
July 2004

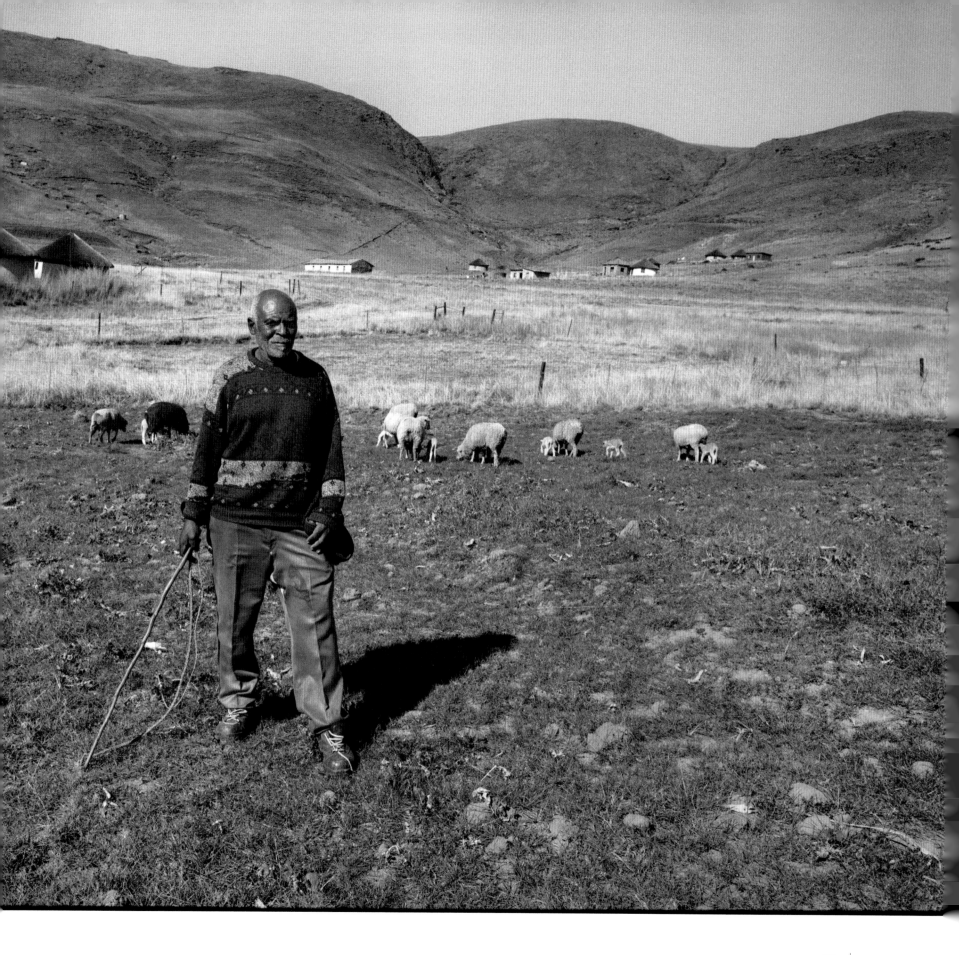

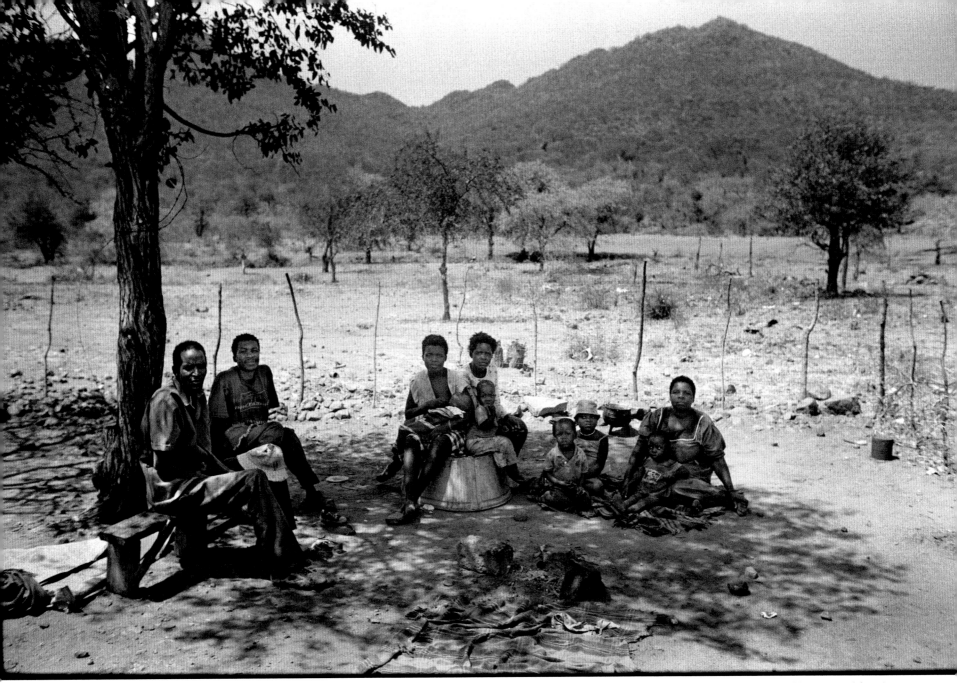

Joe Siema and his evicted family.

The Universal Declaration of Human Rights adopted by the general assembly of the United Nations in 1948 states that "no one shall be subjected to arbitrary interference with his ... home".

The South African constitution asserts that "everyone has the right to have access to adequate housing", and goes on to say that "no one may be evicted from their home ... without an order of court" and "no legislation may permit arbitrary evictions".

Evicted farm dwellers in South Africa not only loose their homes, but often face the simultaneous loss of a job and access to land for production, the destruction of their social networks and the disruption of their children's education.

Black South Africans have been systematically dispossessed of their land for centuries. No black person was allowed to own land; they

Evictions from farms.

could only reside on a farm at the discretion of the white owner, rent accommodation in black townships, or live in "native reserves" – later bantustans – with permission from a traditional leader.

While black agriculture was destroyed, the white farming sector was built with the help of government gifts of land, subsidies and protection, free black labour and "drought-relief" hand-outs, which continued until the last days of apartheid.

Many black farmers were either removed completely or forced to provide the land owner with free labour or a share of their crops simply for the privilege of staying on what had been their land.

In the 1960s, the apartheid regime set about abolishing labour tenancy in order to get more black people off land in "white areas". Those who remained were reduced to wage labourers.

Labour tenancy survived in parts of Mpumalanga and KwaZulu-Natal due the resistance of land owners who benefited from the system.

By 1994, the residence of blacks on commercial farms, almost exclusively white owned, remained entirely at the discretion of the owners who could evict them at whim.

In this context the new constitution required the government to enact legislation to give "a person or community whose tenure of land is legally insecure as a result of past racially discriminatory laws or practices ... tenure which is legally secure, or ... comparable redress".

The government subsequently produced new laws, which many land owners complain are too restrictive, while non-governmental organisations (NGOs) and trade unions assisting farm dwellers argue that they are too weak and have not been effectively implemented.

The Extension of Security Act (62 of 1997), commonly known as ESTA, says no person may be evicted from land that he or she had permission to be living on without a court order.

The act applies outside areas proclaimed as townships and creates a procedure to be followed in order to evict people from farm land. Those who have lived on a farm for more than 10 years and are more than 60 years of age or disabled are allowed to stay on the land for the rest of their lives unless they breach conditions set out in the act.

In practice, many people continue to be evicted illegally by owners who resort to extra-judicial means, such as threats and intimidation. The South African Human Rights Commission (SAHRC) found in 2003 that court-ordered evictions were a small percentage of all evictions and concluded: "There is widespread non-compliance with ESTA."

The Land Reform (Labour Tenants) Act (3 of 1996) gives labour tenants the same procedural rights as other occupiers in terms of ESTA. The act also provides an opportunity for labour tenants to claim ownership of the land that they occupied and used. About 16 000 such claims have been lodged, the vast majority from Mpumalanga and KwaZulu-Natal, but only a few hundred have been settled.

The Prevention of Illegal Eviction and Occupation of Land Act (19 of 1998) provides procedures for owners to evict illegal occupiers and affords the occupiers some procedural rights as well. This act has been largely used in urban areas and on farms when occupiers have not had permission to occupy the land as required by ESTA.

Important constitutional court and supreme court of appeal judgments, such as in the Grootboom and Modderklip cases, have confirmed the duty of the state to respect people's right to have a home. In these cases, the government has been instructed not to evict people without providing alternative accommodation and to implement programmes aimed at ensuring access to housing for all. The extent to which these legal precedents have found their way into government practice remains debatable.

While political changes and the constitution demand the recognition of farm dwellers' rights, commercial farmers face serious economic challenges. South African agriculture has for some time seen the prices for farm inputs rising faster than prices paid for farm products, which has put a squeeze on profitability.

During the past 20 years, farm subsidies, tariff protection and other regulations in the farming sector have been removed creating a situation where South Africa now has one of the lowest levels of agricultural support in the world. Farmers now have to compete in global markets still affected by massive subsidies paid

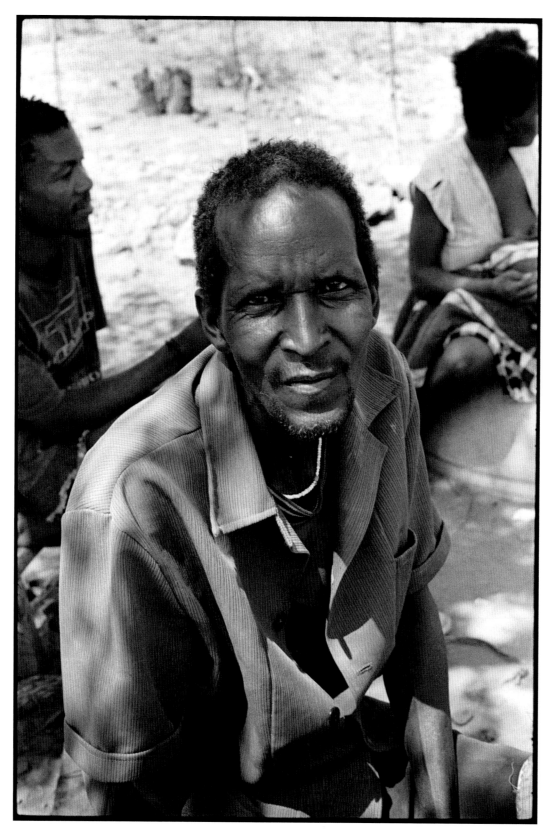

Joe Siema,
an evicted farm worker.

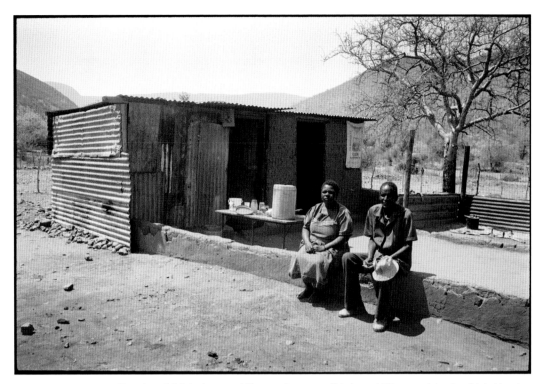

October 2004, Joe and Emma Siema – Tshikuwi Village – North of Makhado.
His family has been evicted from a farm and are now squatting in this village
which is made up mainly of farm evictees.

to European and North American producers.

At home, farmers have had to adapt to and carry the cost of new labour and tenure legislation aimed at improving the conditions for workers. Many farmers have risen to the challenge and done well in the less-regulated environment by becoming responsive to market conditions and cutting costs. One of the impacts of these adjustments has been the reduction in the total number of farm employees from more than 1,3 million in the mid 1980s to less than 1 million in 2001 and an increased number of temporary employees. These changes have inevitably impacted on the eviction of residents from farms.

The 2001 census found that there are 2,8 million black people living on farms, most of them workers and their families. Some commentators have estimated the number to be as high as 5,3 million and noted the difficulty of carrying out a census on often inaccessible farms. It is well known that, despite their important economic contribution, most farm dwellers live in extreme poverty. Reports from NGO groups and the SAHRC have also confirmed that evictions and other human-rights abuses remain widespread on farms, although until recently there was no information available on the scale of these problems.

The National Eviction Survey carried out by the Nkuzi Development Association and Social Surveys from 2004 to 2005 established that there have been around 950 000 people evicted from farms since 1994. Of these, less than 10 000 were evicted through the legal court process, the rest having been forced off the land through various forms of threats and coercion.

The farm dwellers' lack of knowledge of their rights and a lack of assistance in helping them to exercise their rights has made farm dwellers easy targets for such abuses.

These statistics and the stories in this book confirm that evictions remain a serious matter, a continuing human tragedy and a sad continuation of land dispossession in modern-day South Africa.

MARC WEGERIF
Programme Manager: Policy and Research
Nkuzi Development Association
May 2005

Potential conflict between a farmer and a long-term tenant
has been resolved with the help of the Nkuzi Development Association.

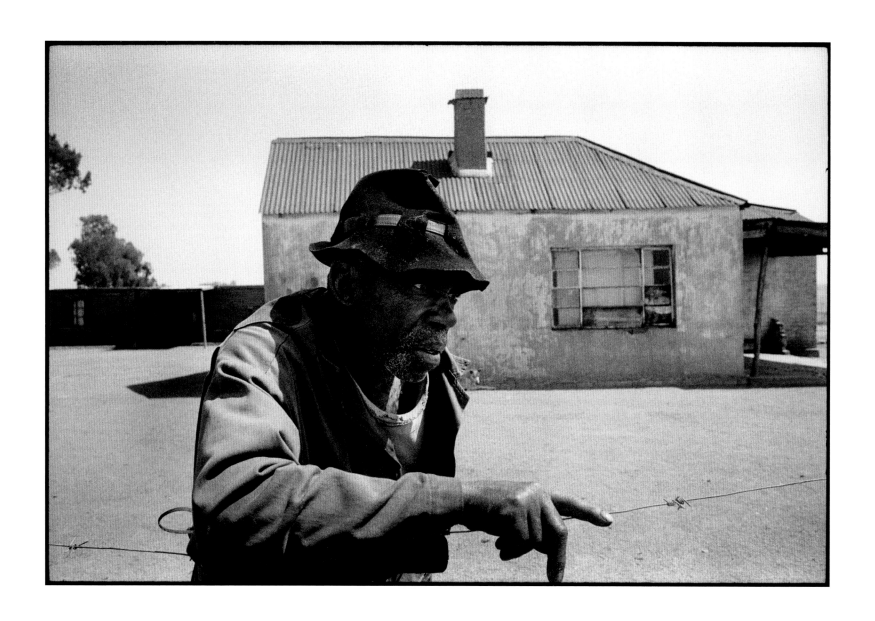

Devon, Springs, September 2004

Twala and his wife have lived on the farm Devon for a long time. However the farm was sold and tension arose between Twala and the new owner, Mr van Heerden. Van Heerden agreed to Twala keeping four cattle if he would pay half of the cost for the fencing to keep them in. Van Heerden also objected to Twala wanting to get a bull, because it would interfere with Van Heerden's prize cows.

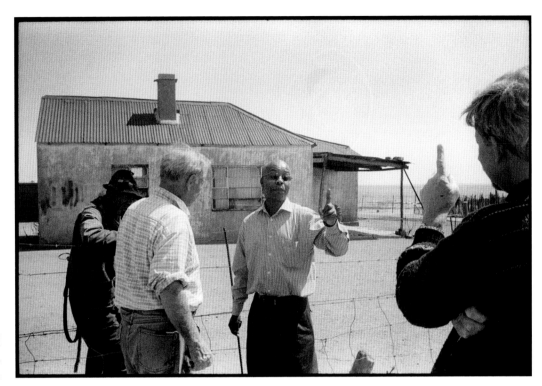

Siphive Ngomane, centre, brokers a deal between long-time tenant, Twala, left, and Van Heerden and his son.

After heated exchanges and extensive negotiations assisted by Nkuzi's Siphive Ngomane, the farmer and his son agreed that a section of land around Twala's house would be fenced off to allow Twalas' cattle to graze there.

The fence is now up and the water supply, which had been cut off, has been restored. Current relations between farmer and tenant are fine.

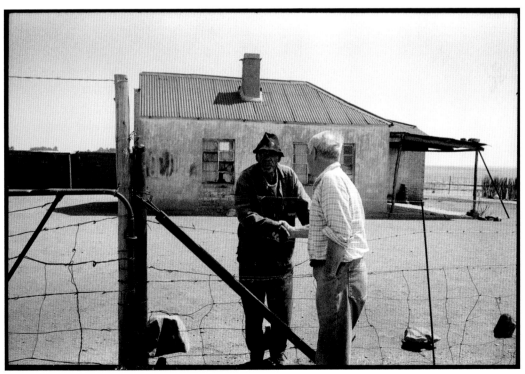

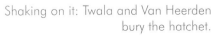

Shaking on it: Twala and Van Heerden bury the hatchet.

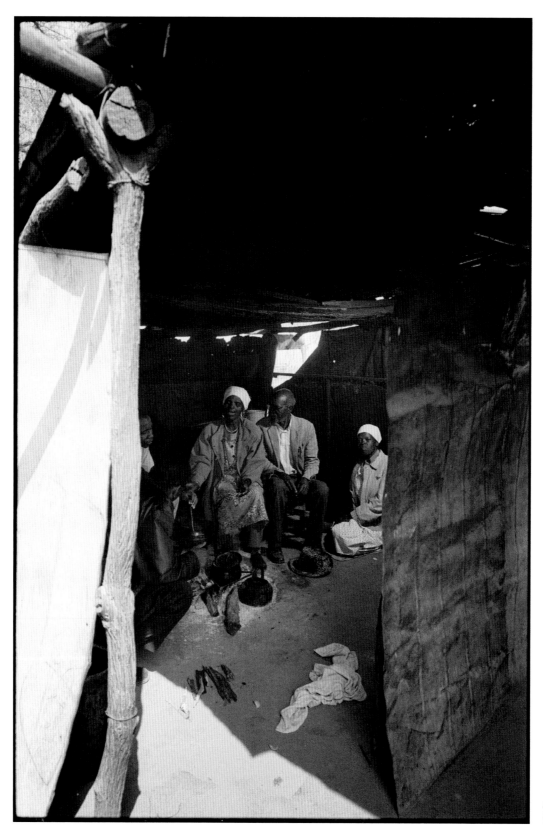

A temporary shelter for evicted farmworkers and their families.

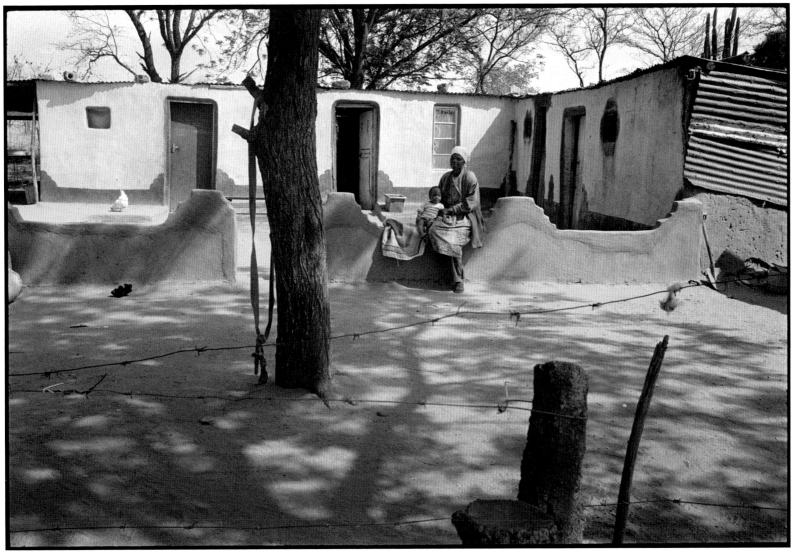

Vaalwater – September 2004.
Sebolaeshi Letta Lekoto, 60, is among the members of a group of families who have been evicted from the surrounding farms, and now live in temporary settlements on the roadside.

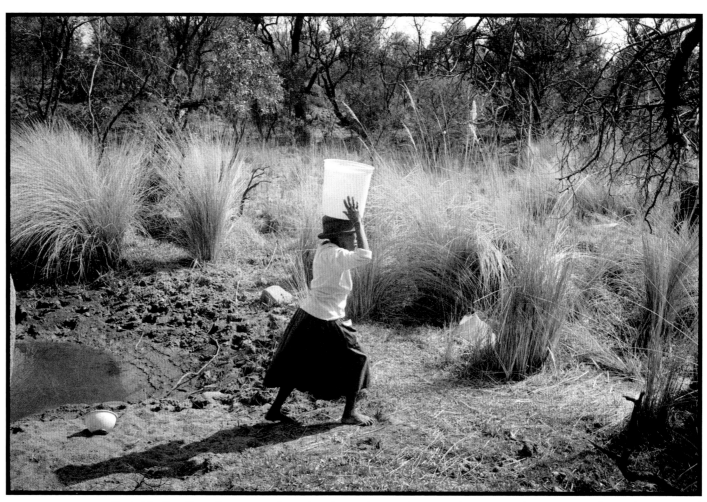

Linah Modimolla collects water from the almost dry river because the water to her compound was disconnected.

Diedreft farm, Leeupoort, September 2004.

The farmer, in an attempt to evict a number of families from the farm, cut off their water supply. The families were forced to fetch water from an almost dry river. After several months, on the advice of Nkuzi and the department of land affairs, the farmer agreed to sell the farm to the families. The deal has yet to be finalised.

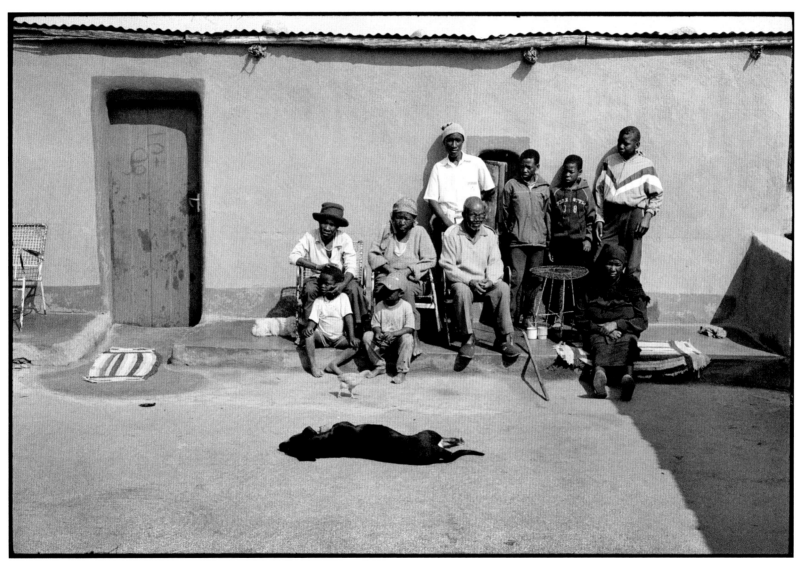

A family who live on the Diedreft farm.
Standing, from left to right, Meckson Modimoko, Jonas Khosa, Petrus Lefoka and John Khoza.
On the chairs, from left: Linah Modimolla, Tabia and William Majapolo.
Sitting, in front, from left: Tumelo Mahtetsa, Steve Majaplopo and Johanna Kekae.

A positive ending for the Boya family.

Tweefontein changed hands, and the new farmer tried illegally to evict September Boya and his wife, Johannah, because he wanted to turn it into a game farm.

Nkuzi intervened and the Boya family settled in Hammanskraal after the farmer agreed to move the family there and pay them R20 000 to set up a new home.

Johannah Boya on
Tweefontein.

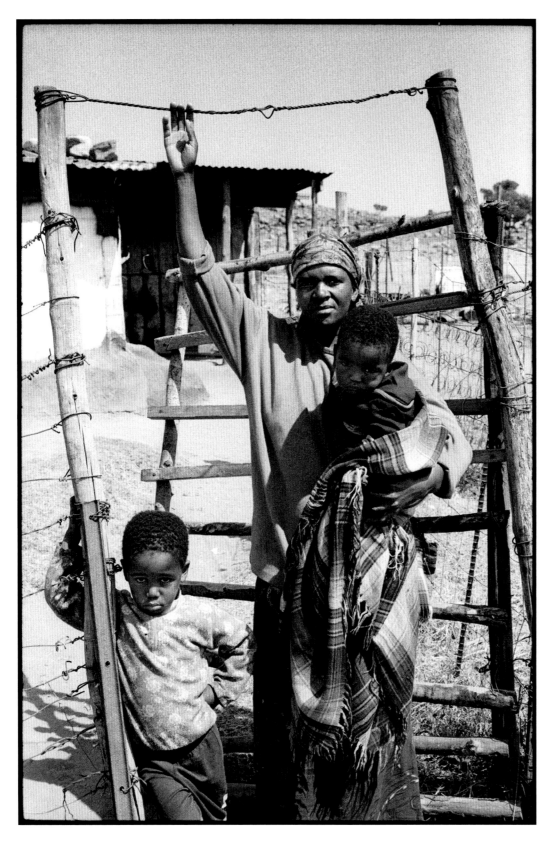

In September 2004, these families were threatened with eviction from Eendrag farm near Heidelberg.

The Pheko Family: Christmas, Ruth, 32, and baby Tshepo in front of their home. They are part of a family of six. The husband, Joseph, works on the farm, looking after livestock. Nkuzi has helped Ruth to get child support grants for two of her children.

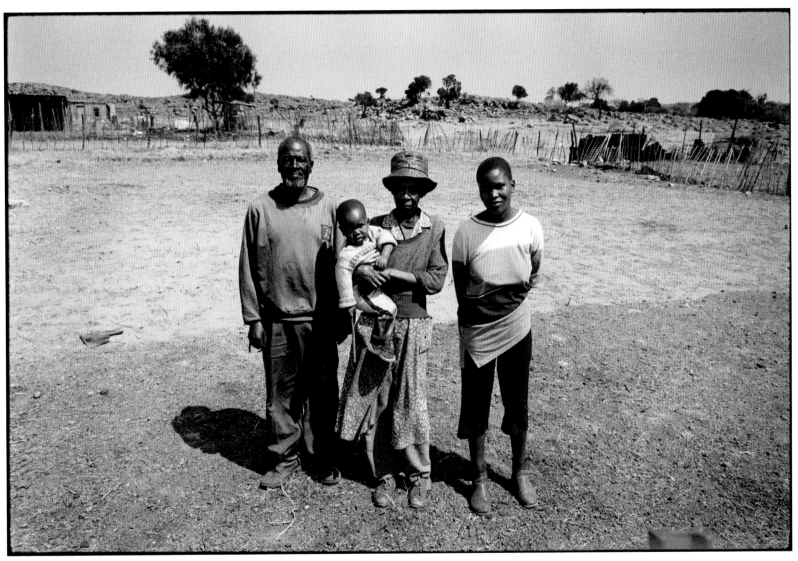

The Mokoena family: Ben Mokoena, 76, has been on the farm for 30 years.
From left are Ben, his grandchild, Minky Mofokeng, his wife Puseletso, and his daughter Thepelo.
The family was given this small field after operations stopped, but they have no money to buy seeds.

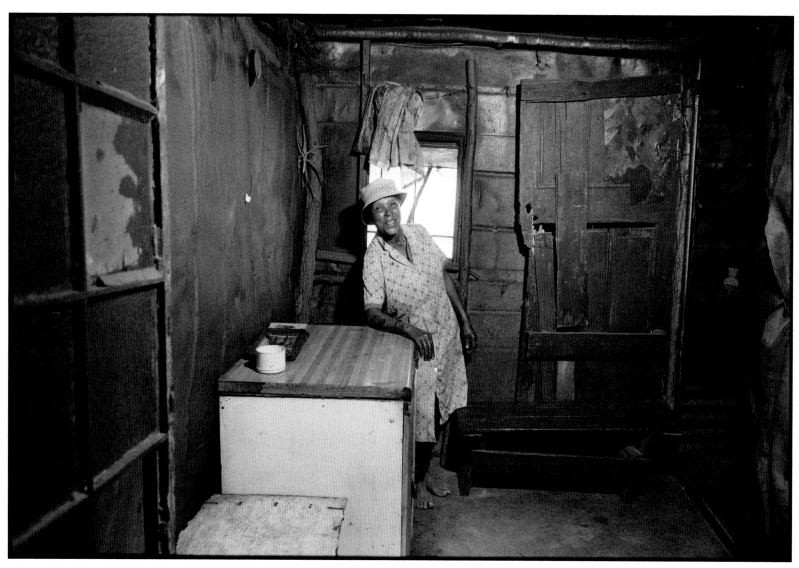

Grace Williams in her home on Eendrag.

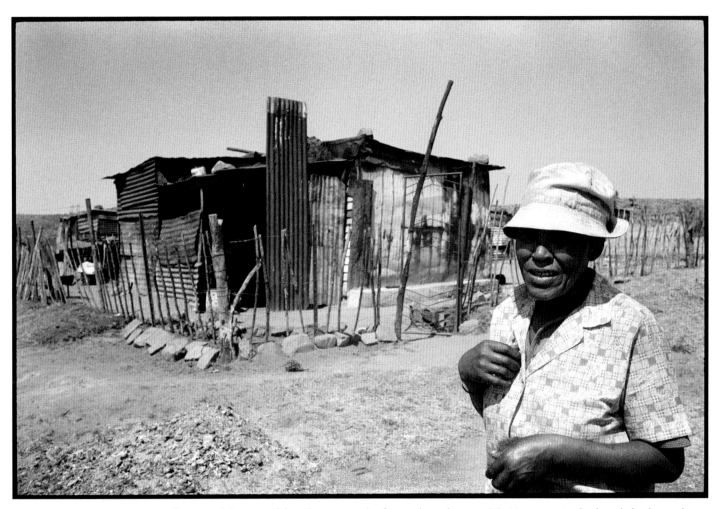

Grace is 50 years old and came to the farm when she was 12. Her parents died and she lives alone.
She was given a stand by the farm owner on which to build her home.

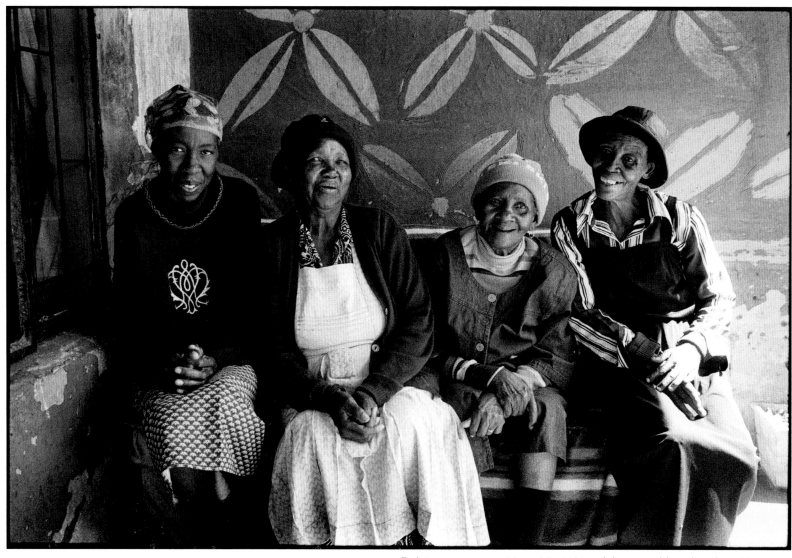

Fighting to stay on: Mary, Mimi, Magdeleine and her daughter, Veronica.

Boys Town, Magaliesburg, September 2004

A church took over a farm on which tenants had been living for more than 50 years and created Boys Town which employed some of the tenants. Now the church wants to sell the land and has issued eviction notices. However, these have been suspended because of pressure by the Rural Legal Trust, The Wits Clinic and Nkuzi, and the water supplies have been restored.

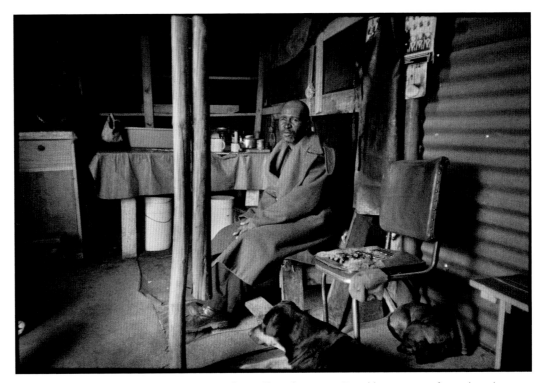

Jackson Shezi lives in a Bronkhortspruit informal settlement, where he sells meat to make a living.

We visited Jackson Shezi, 67, who was evicted from the farm Rusfontein in the Bronkhorstspruit area more than 10 years ago.

The old farmer they worked for grew mealies, peanuts, lucerne and some other crops, but he died in 1993 and his son took over. Jackson says the son was a very different character to his father and abused the workers. He would often manhandle them, swear at them and call them names. Hardly a day went by that he did not assault one of them.

Jackson worked as a farm hand doing any- thing that needed to be done on the farm. He would drive trucks and tractors and was also the farm mechanic. For all that he was paid R120 a month. The new boss had told him that what he had been paid previously was too much. Other workers, he says, would earn as little as R90 per month.

In 1994, Jackson, aged 56, was finally forced to leave the farm because of the way he was treated. He first settled in the Nkangala region and later he moved to the newly estab- lished Dunusa township in Bronkhorstspruit.

To make a living, he buys meat at an abat- toir and sells it in his neighbourhood.

He and some of the people who were evict- ed from the farm did seek help from social workers, but nothing came of it. They needed legal assistance but they did not know where to go for help. They had nowhere to go after living on the farm all their lives.

KHATHU MATHAVA
Bronkhorstspruit
May 2005

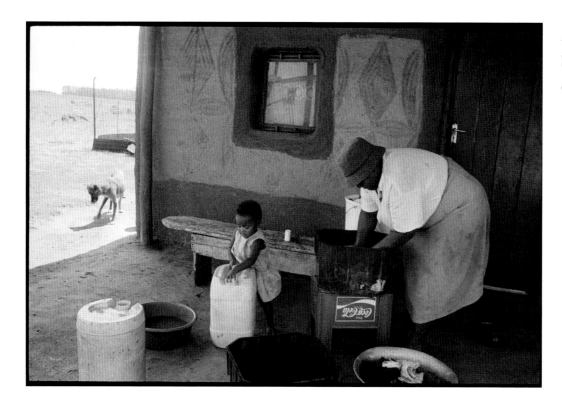

After 20 years on a farm, the Sithole family live under the constant threat of eviction.

Despite a reduction in grazing lands the Sithole livestock and family are managing to survive.

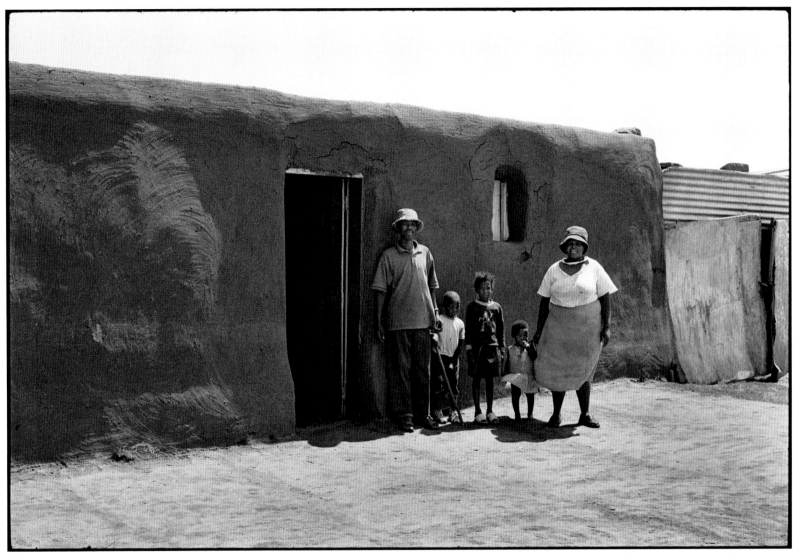

Ndundu Sithole, his wife, Maria, and children, Alinah, Enoch and Lindi.

The Sithole family have lived and worked on Enselspoort Farm, near Vanderbijlpark, for more than 20 years.

The previous farmer, who died, allowed the family to keep and graze their livestock – 16 cattle, three sheep, one donkey and a horse – on the farm. The new owner reduced the land they could use and started threatening them with eviction. Nzuki intervened, a legal wrangle has ensued and for the moment the Sithole family remain.

KGALEMA WA GA KALAUBA
Fochville
November 2004

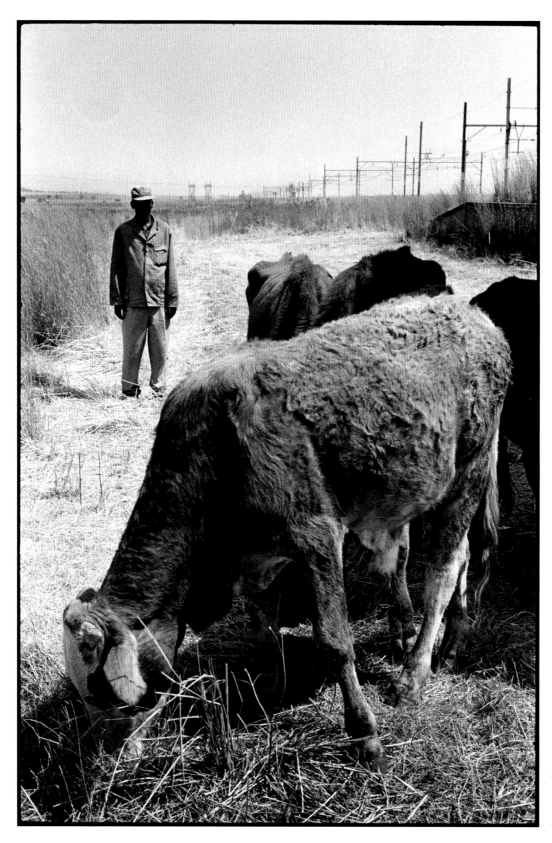

A precarious grazing ground between a busy road and a railwayline is a last resort for Jacob Molefe.

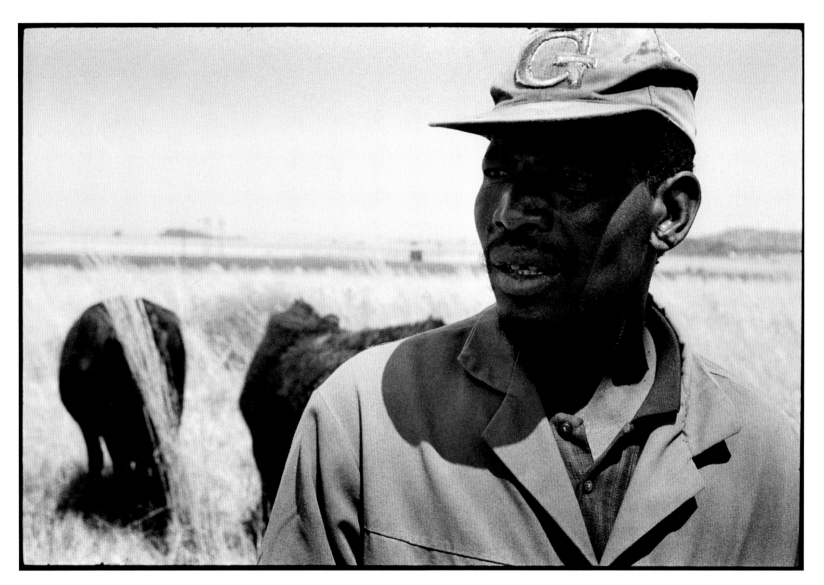

Jacob Molefe worked on a farm for 25 years but was fired after refusing to sell his livestock which had been allowed to graze on the farm.

In desperation, he has taken to grazing his cattle on the verges of a busy road. The farmer is still trying to evict Molefe but Nkuzi and the Wits Law Clinic are opposing this and are applying for the restoration of Molefe's grazing rights on the farm.

KGALEMA WA GA KALAUBA
Fochville
November 2004

Farm worker Booi van Wyk lost a foot at age 84 and was told not to return to the farm where he lived and worked all his life.

One morning Booi van Wyk woke up and found it painful to walk on his left foot. His big toe had gone septic.

At first he didn't take much notice of it. He'd been a farm worker for more than half a century and knew better than to let minor aches and pains bother him.

Eventually the pain became unbearable and he hobbled to the farmhouse to ask if he could use the phone. He wanted to ask his son to pick him up and take him to a doctor. But by the time his son arrived it was too late – half his foot had to be amputated.

For a while the operation appeared to have been successful. Soon the pain returned and Booi was regularly asking the farmer to get his son to take him to see the doctor in Kimberley. One day he was told not to come back.

"So we just went," said Lena, 67.

A few months later Booi had his entire foot amputated. He was 84.

The Van Wyks had shared a four-roomed brick cottage on a maize farm near Douglas for 20 years. They had raised their children in that house and expected it to be their last home.

"I'm not happy about this, but we just had to go," said Lena.

"I brought my mother and father to the farm so I could look after them. They are buried there. It was peaceful and we wanted to die there."

The couple found out only afterwards that they were legally entitled to stay on the farm because they'd lived there for more than 10 years.

Booi, now 91, almost stone deaf and barely able to talk, sits on a rickety chair in the shade of a tin shack in a Kimberley township, his life slowly ebbing. He was never paid out for his injury because the farmer hadn't registered him for workman's compensation.

"The *baas* never knew about his foot [being amputated]," said Lena. "We never wanted to bother the *baas*. We kept to ourselves."

When the Van Wyks arrived in Kimberley seven years ago, "the comrades" allocated them a dusty plot on which to build a shack. Booi's son dropped them off there with all their possessions – except their two sheep, which they had to sell.

"When he brought us here there was nothing, just open veld," said Lena.

They built a temporary shelter, which was blown down several times. "Every time we had to start from scratch. Then I saved enough money to buy corrugated iron and we built this shack."

Although sturdy enough to weather Northern Cape thunderstorms, the two-roomed structure is icy in winter and turns into a furnace in summer. They have been on a waiting list for a council house for six years.

STEPHAN HOFSTÄTTER
Kimberley
February 2005

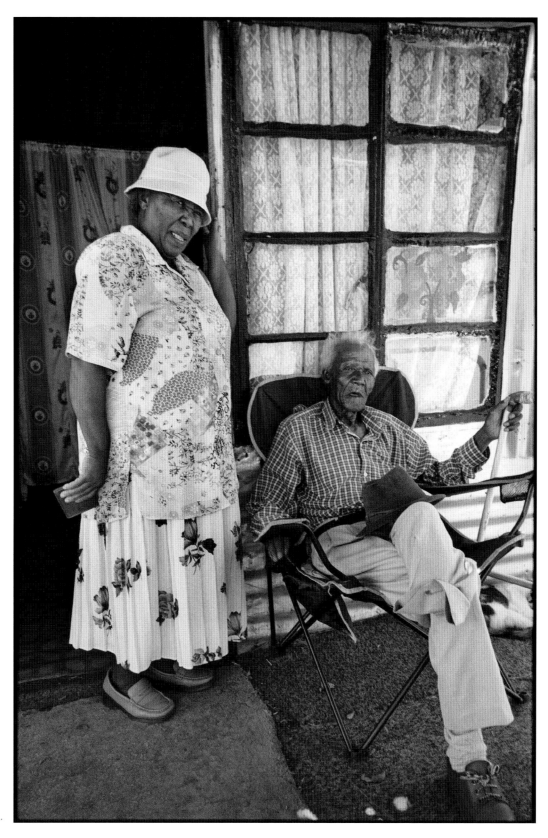

Lena and Booi van Wyk.

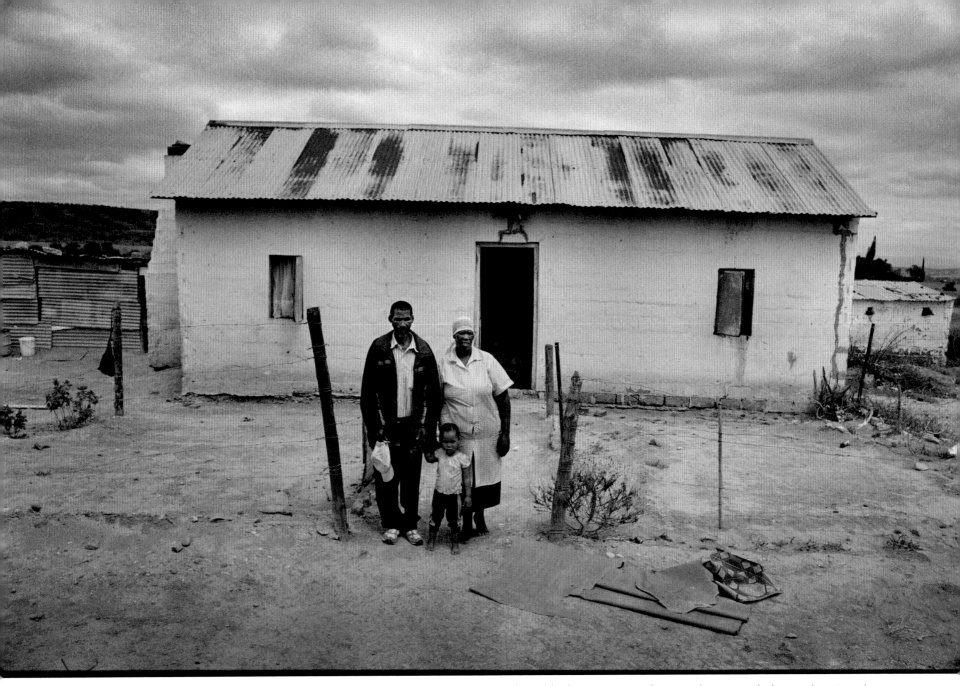

Jane Oosthuizen and her husband, Salman van Hansen, who is blind in one eye and can no longer work due to chronic asthma.

It has been said that if the major wars of the past century were fought over land, the battles of this one will be over water.

It is a battle that the farm workers on Buffelsdrift farm in Oudtshoorn fight daily. They say the farm owner has cut off their water supply and they are forbidden to use water from the dam on the farm. The dam is only for the livestock and crops. The workers must fetch water from the school, which is half a kilometre away – and two buckets a day is all they are allowed.

"The farmer is clearly trying to get rid of us," says Jane Oosthuizen, who was born on Buffelsdrift 40 years ago. "But no matter what methods he uses to try to force us off, we will not move, because we have nowhere else to go."

Although they live on the farm, Jane and her husband, Salman van Hansen, can no longer work. He suffers from chronic asthma, the consequence of decades of exposure to the pesticides used on ostrich farms. He doesn't receive medical compensation. Their son is also indigent – a car accident left him permanently disabled.

"The farmer is clearly trying to get rid of us," says Jane Oosthuizen, who was born on Buffelsdrift farm 40 years ago. **"But no matter what method he uses to try to force us off, we will not move because we have nowhere else to go."**

Their neighbour, Leah Bruintjies, also has nowhere to go. The 89-year-old illiterate pensioner supports her five grandchildren on her paltry pension of R820 a month. One of her daughters is dead, the other unemployed.

Although they live on Buffelsdrift, her grandchildren are forbidden to go near the water. Neither they nor the adult workers are allowed to walk freely on the farm road. "If the owner is around, we must step to the side until he passes," says Willem van Staden, 72, who with his wife, Johanna, 64, and their daughter, Maria, 15, have lived on Buffelsdrift for the past nine years.

Willem suffers from epilepsy and hypertension and cannot work. Their other children assist them, but their children are forbidden more than a cursory visit to their home.

Proof of the farmer's paranoia is the padlocked gate leading to the Van Staden's immaculately maintained cottage. Visitors must climb over the fence. Attempts by the Van Staden children to enter through the front gate have been met with verbal and physical abuse, which are commonplace on Buffelsdrift.

Workers complain that if they are tired or they don't run when the foreman calls them, he gives them a *klap* (smack).

Buffelsdrift, a popular tourist destination for those in search of an authentic ostrich-farm experience, is notorious in farming circles for the serf-like treatment of its workers. They work from 5am to 6pm and most earn about R200 a week. Overtime pay usually consists of polony and eggs. There are no toilets and workers must defecate in the fields.

It wasn't always like this, says Jane. The previous owner provided the workers with a bucket toilet system. He also promised they would never be evicted. But two years ago, he sold the farm.

"We are constantly told that our homes will be bulldozed. But we are not scared anymore. We will live and die here."

But even death brings no respite for the workers. They say the farm owner will only let them bury their dead on Buffelsdrift if the families pay with their homes.

HAZEL FRIEDMAN
Oudtshoorn
March 2005

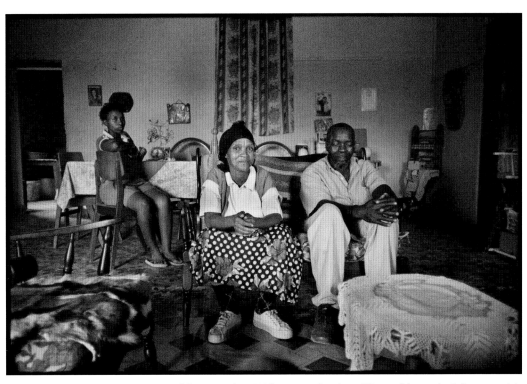

Retired farm worker Willem van Staden, 72, and his wife Johanna, 64, with their granddaughter Maria,15, in the background.

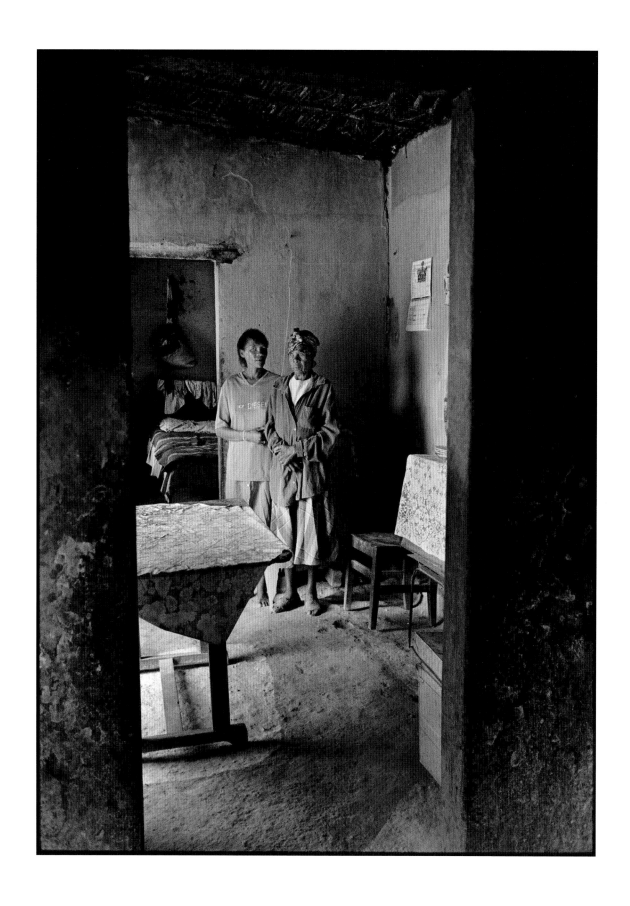

89-year-old pensioner, Leah Bruintjies, with her unemployed daughter, Griet Fortuin, 34, in their home. They and Leah's five grandchildren are threatened with eviction.

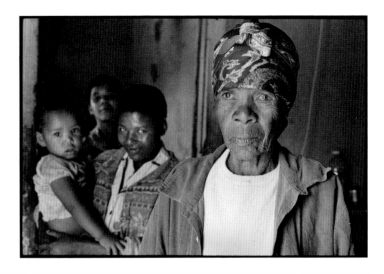

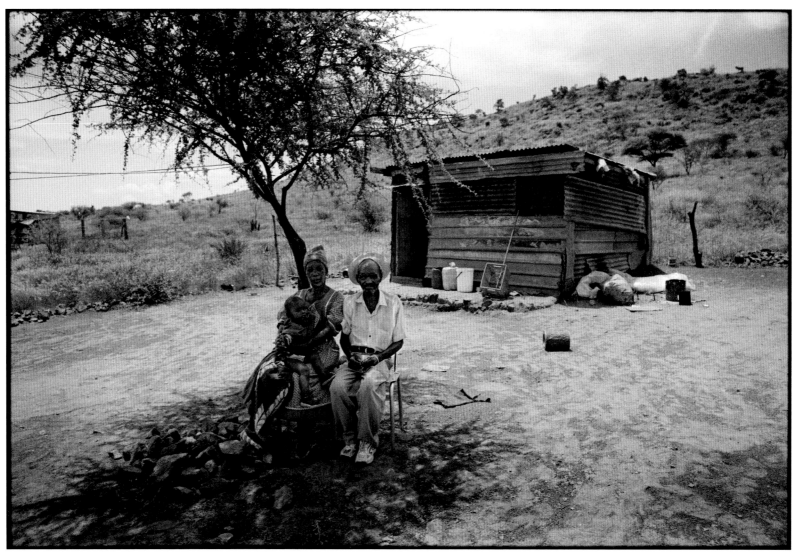

Piet and Grace Buffel.

Piet and Grace Buffel, evicted farmworkers, are left with a shack and a thornbush.

When Piet and Grace Buffel were evicted from a citrus and olive farm in Hartswater, they went on a spending spree that lasted for four months with the money they were paid as compensation. They bought a new radio, smart clothes for themselves and their extended family and food they had never been able to afford before.

Grace, 56, worked as an olive picker earning R30 a week and Piet, 67, brought home R150 a month for maintaining the farm's irrigation system – almost five times less than the minimum wage. They were given mealie meal, meat, washing powder, tea, sugar and bread. Their reward for leaving the farm when Piet couldn't work after developing a chronic cough (later diagnosed as asthma and bronchitis – a common complaint among irrigation workers) was R2 010. They remain grateful.

The Buffels lived in a four-roomed brick house which had electricity, an outside tap and toilet. Now they spend their days under a thorn tree in a squatter camp next to a township in Hartswater. At night they retire to their one-roomed shack, which cannot accommodate half the furniture they owned. Their bed is on bricks and paint tins, their clothes are packed in battered metal trunks on the floor and a rickety kitchen cupboard holds their rudimentary utensils. Unlike many shack dwellers, they do not have a separate cooking hut. Meals are prepared over an open fire made in a battered tin, punched with holes, which is lying next to their shack. They do not have their own water supply or toilet.

Grace works as a cleaner at the township school and Piet, who said he was registered for disability and had received a once-off payment of R940, gets a pension of R740 a month.

Both insist the farmer treated them fairly. "I am satisfied," said Piet. "I had nowhere else to go. He paid us that money and he put us with our furniture on his truck and brought us here. He was good to me and never treated us badly."

STEPHAN HOFSTÄTTER
Hartswater
February 2005

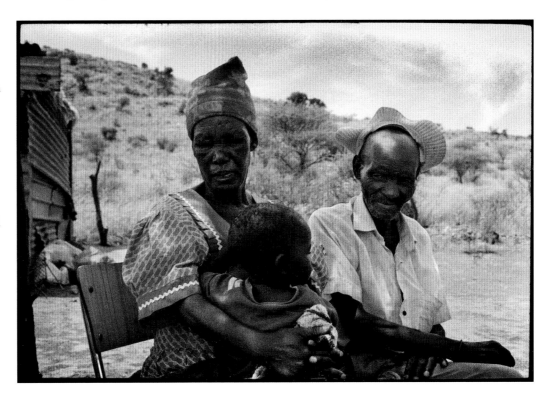

**Gert and Sina Slinger,
threatened with eviction and victimised
after 50 years of hard labour...
"He will never chase us from our home."**

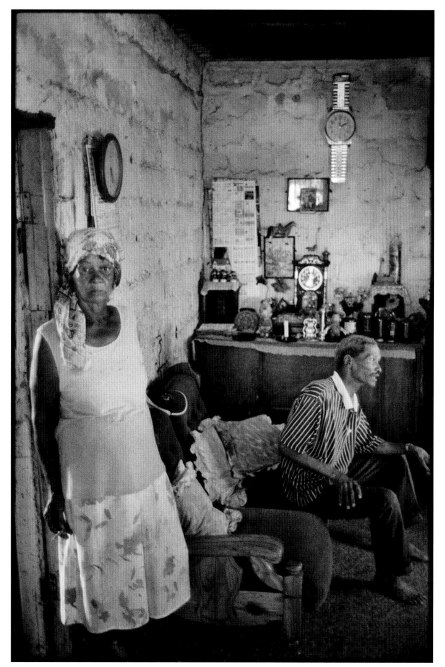

Gert Slinger's world keeps shrinking. For 50 years, he lived and worked on a cotton farm next to the Orange River. First he was in charge of a team of oxen that ploughed the fields and, later, with the arrival of tractors, a driver. He was appointed farm supervisor, given a three-roomed brick house to live in and a small field in which to grow maize and vegetables. His wife, Sina, whom he married in 1965, worked in the farmer's kitchen and could roam the farm to collect firewood.

Two years ago the family who had employed them for decades decided to sell. In terms of the Extension of Security of Tenure Act, the Slingers are classified as long-term occupiers and have the right to remain on the farm permanently. But the new owners saw things differently and served them with a lawyer's letter, giving them a week to leave.

"I went to the police to ask what we should do," said Slinger, 66, a permanent expression of outrage on his wizened face. "They said it wasn't an eviction notice and we had a right to stay, so we stayed."

Since then matters have steadily deteriorated. Slinger was told he could no longer grow maize in the farmer's field and had to reduce the size of his pumpkin patch. When he refused, the fence protecting his garden was vandalised and the pipe supplying water to his vegetables was ripped out.

One morning the farmer arrived with a bulldozer, ripped the gate leading to Slingers' house off its hinges and closed the access road. On another occasion a fight erupted when the farmer's wife started burning grass five metres from the Slinger home, which has an extension built from reeds.

Sina says: "I told her the car parked here had petrol in it. It was dangerous, man. I was trying to stop the flames from

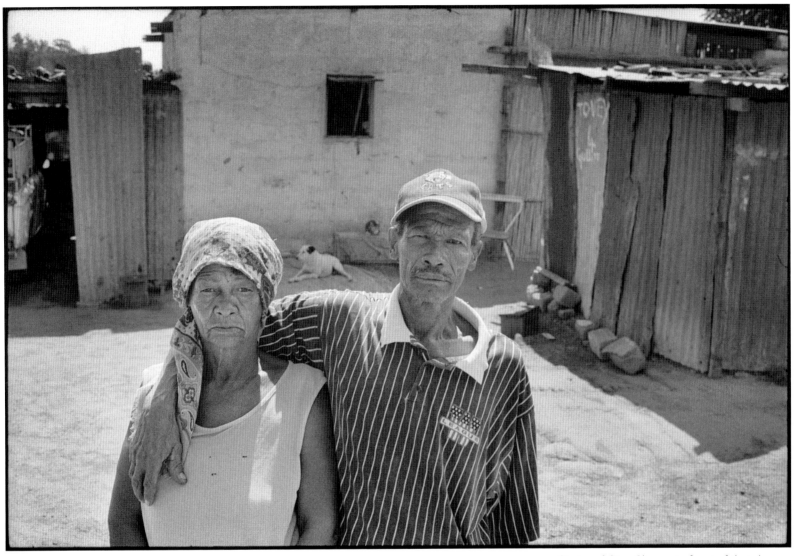

Gert and Sina Slinger in front of their home.

spreading when she grabbed me…"

Sina, 63, was charged with assault for her efforts. She remains outraged: "I am a Bushman maid and she's young and strong," she rasped. "How could I attack her?"

The constant harassment means the Slingers are loath to invest in home improvements. Their house is in need of repair and has no toilet or electricity. "We're too scared to fix the house or build new rooms for my children when they visit from Stellenbosch," said Sina.

Late last year the farmer switched to legal tactics, accusing the Slingers of selling liquor on the property. In terms of the tenure law, any unlawful practice can be considered a fundamental breach of the occupancy agreement, and in November the Slingers were served another lawyer's letter, this time giving them three weeks to leave or face legal action.

They have refused to go.

"He will never chase us from our home," said Gert, vowing to fight the matter in court.

Meanwhile, the farmer has banned them from moving more than a metre from their front door, threatening to have them arrested for trespassing if they fail to comply.

"Why is this man doing this?" asks Sina with wide, uncomprehending eyes. "All I want is to live here in peace."

STEPHAN HOFSTÄTTER
Near Kanoneiland
March 2005

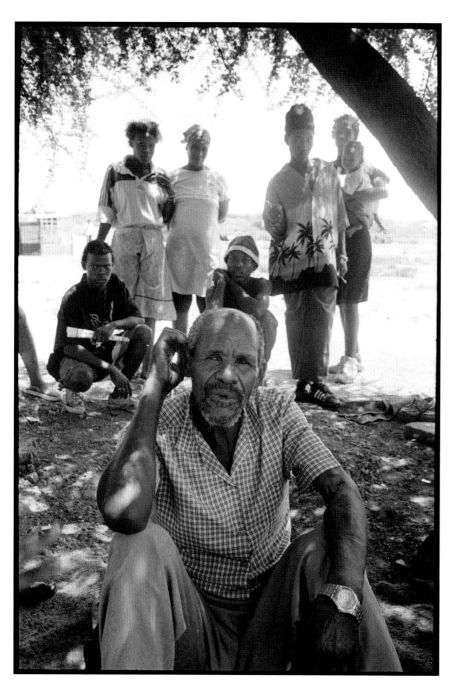

Moses Gaditshose.

Hartswater, February 2005

Moses Gaditshose, 68, lives with his wife and two of his children in a squatter camp perched at the edge of a municipal rubbish dump in Hartswater in North West province. The wind has strewn refuse among the tiny shacks. On calm days, a sickly sweet stench hangs over the settlement.

Gaditshose started work at the age of 18 as a tractor driver at the local co-operative, delivering bails of lucerne to farms in the district. He lived in a shack on the co-operative's farm for 44 years, first alone and then with his wife and four children. When the land was sold in 1999, they were told to move.

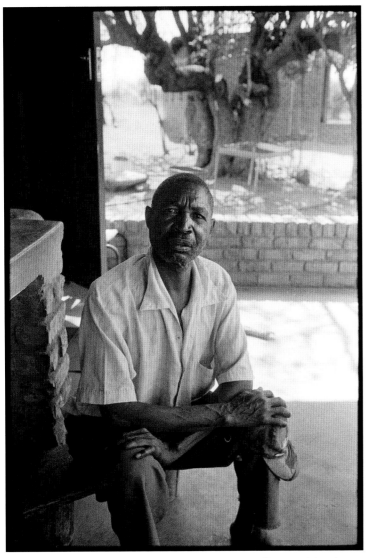

George Musekwa.

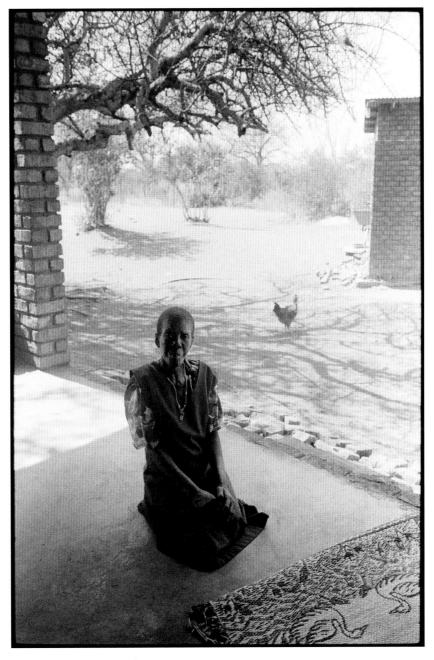

Emily Musekwa.

Dorp farm, Waterpoort September 2004

George Musekwa and wife, Emily, have been threatened with eviction by a new farmer who is turning the farm into a game ranch. The Musekwas were born on the farm.

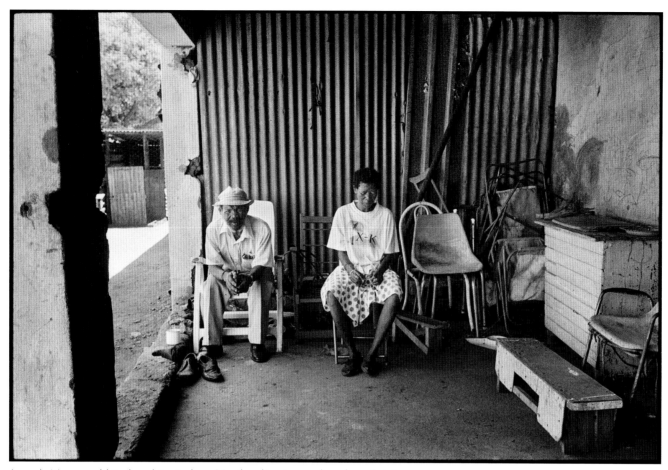

Joseph More and his daughter-in-law, Martha, live in an abandoned dairy.

A stately lane of poplars lines the road running through the fertile valley between the Vaal and Harts rivers in the north-eastern tip of the Northern Cape. They were planted in the 1930s when the government initiated South Africa's largest irrigation scheme to stimulate growth and create employment after the drought and great depression in the 1920s. Behind it lie endless fields of sunflowers and maize, watered by overhead pivots fed by a network of canals. The fields are made up of thousands of small parcels of land – *plotte* – once allocated to poor white farmers and largely still owned by their descendants.

Joseph More has spent the best part of a century as an itinerant farm worker in these parts, working for a succession of white farmers on the *plotte*. When I met him he was sitting in a plastic chair outside a derelict dairy. The main shed had been partitioned with string and blankets to create three "rooms": one for More, another for his son, Adam, and his wife, Martha, and the third for her aunt. It was built from mud and plastered. Now it has giant cracks running along the graffiti-decorated walls and could collapse in a storm. It has no electricity, no water and no ablution facilities, except for a long-drop toilet in the veld. At 85, this is the place More calls home.

He was born on the *plotte* in 1919. Before reaching high school, his father told him he couldn't afford his fees, books or uniform. So More started working as a shepherd, the lowest-paid job on the farm where they lived. He earned 25 pence a month. Memories of growing up were dominated by disputes between his father and a succession of farm owners, one of whom was fond of riding his horse among his workers and lashing them with his sjambok "for no reason". "When you were on good terms with the farmer, you would stay and raise your children on his farm," said More. "When there was a dispute, you moved."

He finally settled for three decades on a farm at Jan Kempdorp, where he met and married his wife. They raised 11 children there.

Once his offspring left home, More decided he'd had enough of farm life and moved to a township in Warrenton with his wife and found work in a butchery. His wife died in 1990 and he returned to the life he knew best, this time on a farm near Kuruman. Four years later the farm was sold and More was evicted. He was 75. For the next decade he lived with relatives

Joseph More, aged 85, has resigned himself to spending his final years without a home.

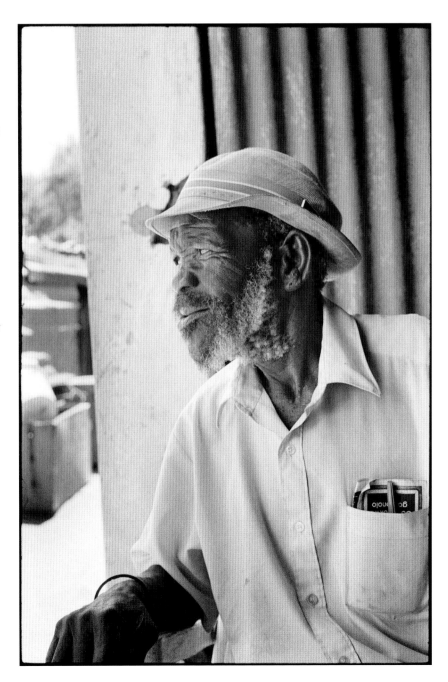

on different farms. Then in 2003 his son and daughter-in-law invited him to move in with them.

Adam and Martha More had spent 25 years on a maize farm in the Vaal-Harts valley. They had lived in an old shop converted into workers' quarters and raised five children there. A year after they invited the old man to join them, the whole family was thrown out.

Martha remembers the day her husband came in from the fields, walked into the kitchen and told her to start packing. He'd just learned the farmer planned to sell his land to a man notorious for being cruel to his workers. When Adam said he refused to work for him, he was told the farm was being sold with its workers. "The farmer told him we couldn't stay there unless we worked for the new *baas*," said Martha.

The family started moving their possessions to friends and relatives in the district and went to the Jan Kempdorp municipality for help. They were told they should put their names on the council housing list, but it could be years before anything became available. In the meantime, there was an abandoned dairy on land bought by the municipality...

When More looks out across the Kalahari veld to where a bathtub lies abandoned under a thorn tree, there is no anger left in his gaze. He has resigned himself to the fact that he will probably die a squatter. But he worries about his grandson, Simon, who was in grade eight when the family was evicted. Simon spends his days looking for work on the *plotte*, returning to sleep in a shack erected next to the dairy. He never went back to school.

STEPHAN HOFSTÄTTER
Jan Kempdorp
February 2005

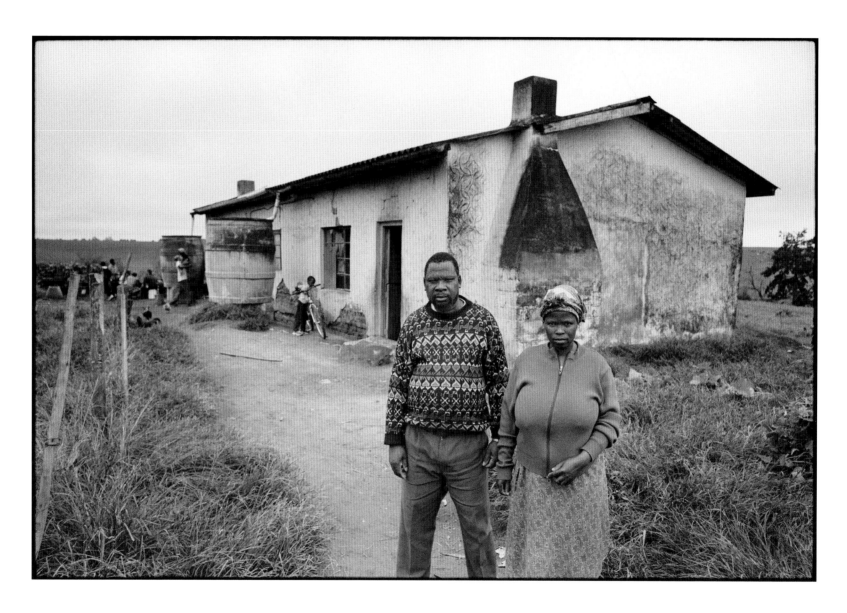

Solly Chota lives with terror of eviction. The 45-year-old labourer believes his future is precarious, despite the fact that he has been working on this farm in George for decades. His wife, Gloria, says that, should they be forced off the farm, they would have to return to the rural Eastern Cape, where unemployment and poverty are rife. The Xhosa-speaking couple are reluctant to say much more: "Someone might report our conversation to the *baas* who doesn't welcome nosy strangers on his land."

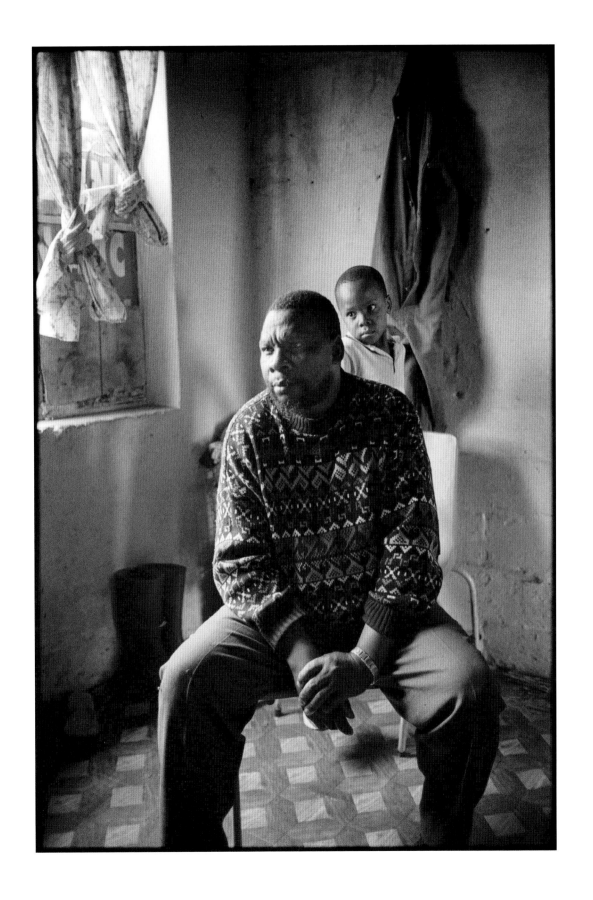

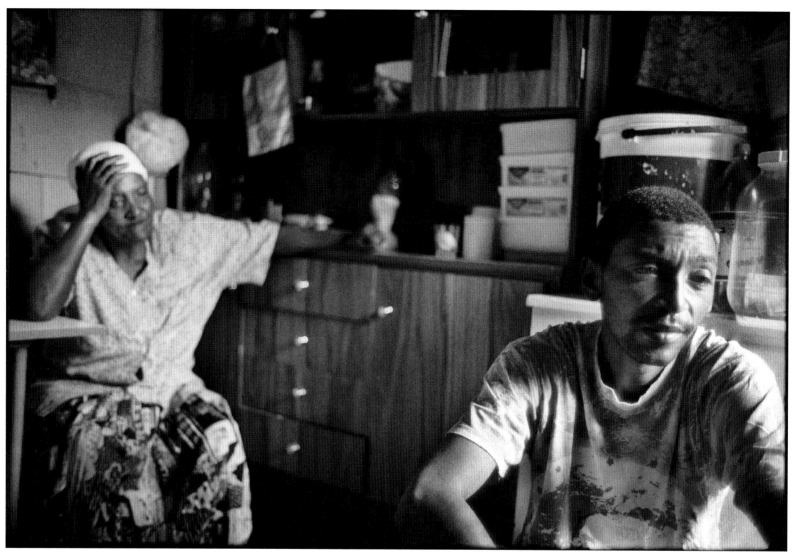

Mina Loos and her son Sulaman, 28, evictees from Mandalay farm, who now live in the Tousranten informal settlement near George.

This is a story about a farmer, a bicycle and a family. It begins on a farm. It ends in an informal settlement. And not everyone lives happily ever after.

Mina Loos, her husband, Koos, and two sons, Sulaman and Gregory, lived and worked on Mandalay farm in George for 14 years.

Koos, because of a severe back injury, was unable to work and receives a disability grant. Sulaman belonged to the farm's irrigation team. One day, the farmer bought a bicycle for Sulaman, who lent it to Gregory, who was remiss in returning it. The farmer ordered Sulaman to lay a charge of theft. He refused. His family was ordered off the farm.

Today, the Looses share a single-roomed shack in an informal settlement. Mina, the anchor of the family, has made it as homely as possible. Although the family subsists principally on Koos's disability grant, Sulaman

A bleak future because of a missing bicycle.

and his wife sometime get work as casual farm labourers.

Sulaman is currently working as handyman. A tall, stooped, malnourished young man, he is already revealing the ravages of a life lived too hard, too young. His eyes constantly brim over, he is often unsteady on his feet, and his moods alternate between unbridled despair and bitterness. He feels responsible for his parents' plight. His only refuge is a bottle of whatever happens to be available.

Legislation has been promulgated to transform rural South Africa and improve farm workers' security of tenure. The law states that farm workers over the age of 60, who have worked on a farm for several years, are entitled to remain there with their families.

But farmers are finding other means of evicting long-term worker-tenants and their families from their lands. They cite social problems and alcohol and drug abuse, as well as concerns that farm labourers will be in a position to make further land claims if they live on a single property for a prescribed amount of time.

The Looses have sought legal assistance and plan to take their case to the land claims court.

Right now, though, Koos cannot bring himself to talk about the eviction. Most days,

when he is not stricken by back pain, he sits silently on a makeshift stoep constructed from corrugated iron and other flotsam. At the time of his family's eviction because of the "theft" of the bicycle, he was 58 years old – just two years short of being guaranteed a permanent roof over his family's head.

HAZEL FRIEDMAN
George
April 2005

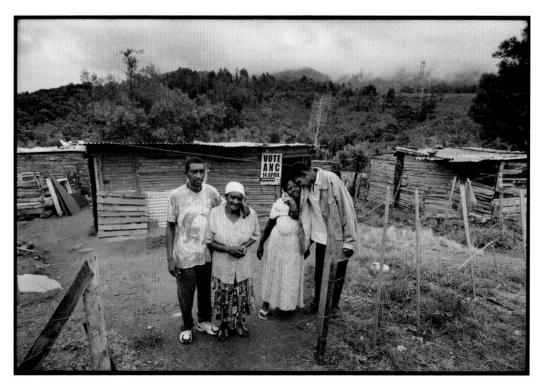

Evictees Sulaman Loos, his mother, Mina, Robert Qegu and his wife at the Tousranten informal settlement near George.

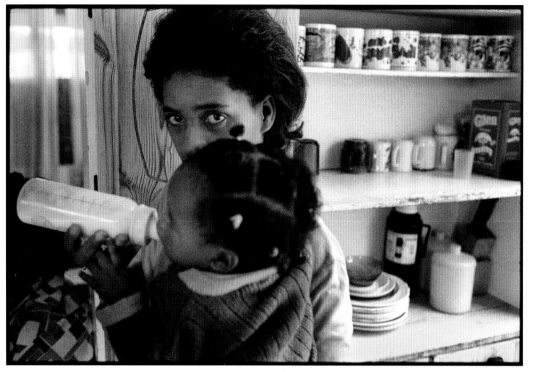

Martens's daughter, Carla, with granddaughter, Simone.

Lancewood is a model dairy farm in George, which treats its workers with dignity and respect.

There are a few taboos on Lancewood farm.

One of them is the use of the word "*baas*".

"Our employer doesn't like us to address him in that way," says Martens Layman, a mechanic on the farm. "We are treated as employees, not servants." He adds: "In fact, things work differently here than on most other farms in the area."

Located in George, Lancewood is owned by father and son Jack and Mark Rubin.

Although vegetables and flowers are also cultivated on the farm, it is principally renowned for its state-of-the-art dairy. But what distinguishes the farm most are the conditions under which its employees live and work.

One of the few non-white mechanics in the area, Martens earns R4 000 a month. On average farm mechanics earn about R2 000. He lives with his wife, Rachel, and their family in a spacious, immaculately maintained house.

The minimum wage on Lancewood is R900. The 163 workers have medical insurance, disability and pension provision, as well as funeral cover. The farm children are provided with free transport to and from school.

On the first week of each month, Mark consults the farm employees on issues ranging from farm productivity to the renovations of workers' homes.

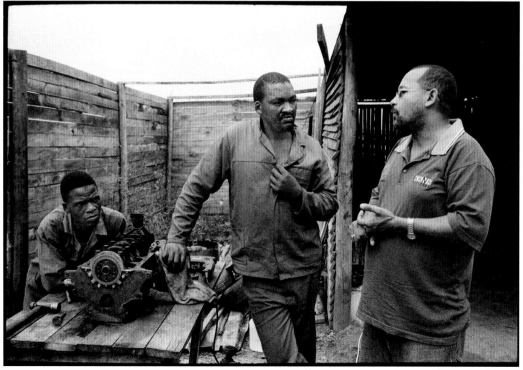

Martens Layman, centre, farm mechanic.

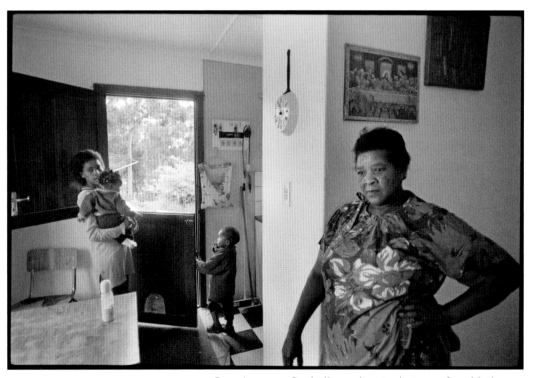

Martens's wife, Rachel, whose family's future is secure.

"Some of the other farmers in the area are hoping Lancewood fails," says Martens. "They still think that by bullying their workforce, ignoring their needs and paying them low wages they'll get more out of them."

For those who subscribe to the belief that farm-worker empowerment and increased productivity are contradictions in terms, Lancewood's success is self-evident.

It is renowned countrywide for its superior quality cheese and dairy products. Milk is outsourced from 20 producers in the George area, who are paid a premium for their milk, all of which is produced from natural pastures. Preferring to keep a low profile, Lancewood founder Jack Rubin, now retired, attributes the farm's success to a "committed workforce with an innovative entrepreneurial spirit, which includes integrity and respect."

In an era of farm deregulation and a prevailing attitude of *baasskap* among many farmers averse to change, the principles propounded by Lancewood are indeed worthy of respect.

HAZEL FRIEDMAN
George
April 2005

Betty Layman, Rachel's mother, in their comfortable home.

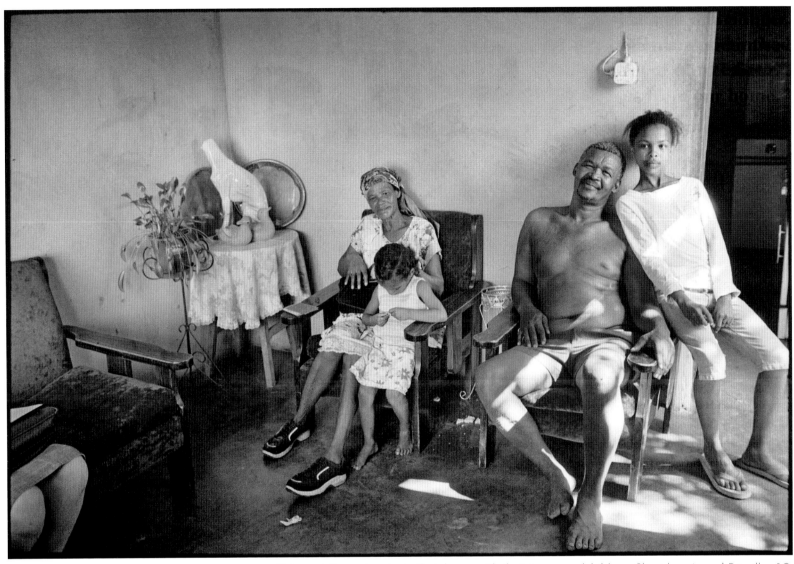

Elsie and Owen Jacobs in their home with their two grandchildren, Sherisha, 4, and Priscilla, 13.

If you turn off the highway between Upington and Keimoes at the long, white packing sheds where raisins are being processed for export, you will soon find yourself driving over a canal and then the Orange River itself as it bulges around a long, almond-shaped island. This is Kanoneiland.

Most of it is covered with irrigated vineyards but there is also an upmarket residential area with a quaint trading store and, here and there, rudimentary labourers' cottages.

It is in one of these, perched alongside three others on the bank of the Orange, that you will find the Jacobs family. Elsie and Owen Jacobs have both worked on a grape-export farm here for more than a quarter of a century. They have raised four children here and their three daughters in turn had their children here. Two of them, Sherisha, 4, and Priscilla, 13, live with their grandparents in their six-roomed house.

At first theirs looks like one of the better homes inhabited by farm workers. Originally it

A family denied clean water.

had three rooms, but the farmer they worked for added more as the Jacobs family grew. The spruce kitchen boasts a full-sized fridge, and a large TV aerial dominates the lounge. The house even has an oval-shaped bathroom, complete with a ceramic toilet, not the ubiquitous pit latrine that is the signature of so much of rural South Africa.

But a closer inspection reveals a different, far more sinister picture. Every room in the house is crawling with flies; cockroaches cover every inch of available space inside the kitchen cupboards; and permeating everything is a sickly sweet stench of decay.

It turns out that, not only is the Jacobs' home no longer electrified, they have also been denied that most fundamental of human rights – access to clean water. This has turned their house into a breeding ground for disease.

Their problems started after Owen, 55, and five other workers were told to pack their bags, leave their families behind and go to work on another farm, 80 km away, that belonged to the same owner. They refused and were fired for taking part in an illegal strike. The workers took their case to the Council for Conciliation, Mediation and Arbitration (CCMA) and won. The farmer was ordered to reinstate them with back pay.

That's when he turned nasty. There is a vineyard opposite the Jacobs' home, with a canal running alongside it. A pipe from the canal used to supply the row of houses and their gardens with relatively clean water. Soon after the CCMA ruling two years ago, the farmer filled up the canal with soil.

At about the same time he entered the Jacobs' home and removed their pre-paid electricity system while they were out in the fields. They have been without power ever since.

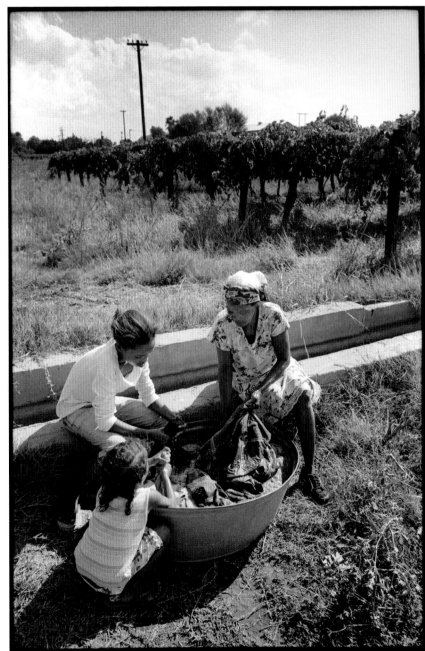

The Jacobses do their washing in water drawn from a muddy irrigation canal.

**The Jacobs' family water
dispute is linked to eviction.**

Elsie Jacobs draws drinking
water from the polluted river.

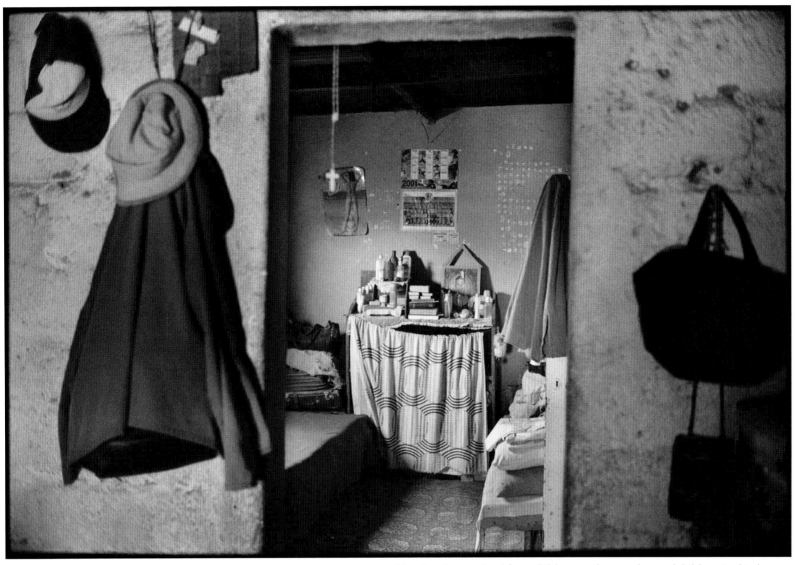

The Jacobses raised four children and several grandchildren in this house.

But even worse was being deprived of water. Now all three families must walk 100 m to draw water from another canal where workers bathe upstream.

"You see these little insects swimming in here," says Owen, cupping some canal water in his hands. "We must drink this stuff. Last month I was sick and bleeding inside for two weeks."

Elsie and the other mothers wash their children and do their laundry next to the canal in a large zinc tub filled with muddy water.

To make matters worse, the canal flows regularly only in summer during irrigation time. In winter it is turned off for up to three weeks at a time. That's when the Jacobses turn to the river itself, which is more like a sewer.

Because there is no running water to flush their toilet, the Jacobses make of use of the dense bush growing on the steep river bank behind their house. A small clearing metres from their tiny back garden is used as a rubbish dump. There is no municipal refuse-removal service.

A steep path strewn with refuse and excrement runs down to the river. Up this path Elsie, 53, carries a bucket of water drawn from a gap in the reeds where the children have fished out dead cats and dogs. It is the last resort for people who would otherwise go thirsty.

"I just pray to the Lord that my little ones don't get sick," says Elsie.

STEPHAN HOFSTÄTTER
Kanoneiland
March 2005

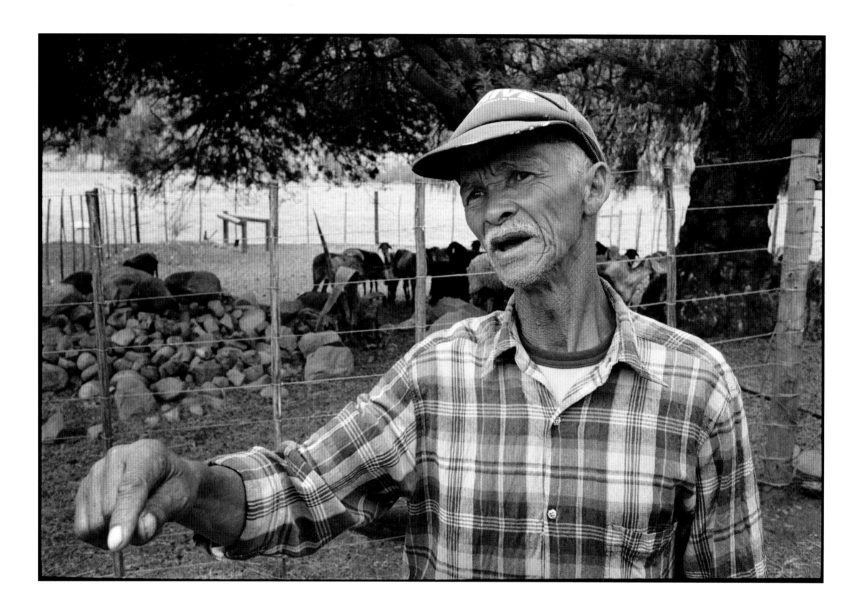

The name Blommetjies Vallei (Flower Valley) evokes images of floral carpets covering the craggy slopes of Oudtshoorn's farmlands. But the name has become a mockery of everything it purports to represent. The farm is arid, eroded; a small flock of scraggy sheep graze lethargically; and the riverbed that is supposed to run through the farm is desert-dry.

It shouldn't be like this. Blommetjies, one of the government-sponsored farm labourers' co-operative projects, was supposed to be the prize flower of worker-owned and -run farms. Today, it is a scar on the skin of worker empowerment and, daily, Adam Maart is reminded of what it could have been and why it failed.

His father was a farm labourer for 45 years until ill health and age prevented him from working. He was consequently evicted from the farm where he worked and died soon after.

It was always Maart's dream to pioneer an agricultural heritage that would do both his ancestry and progeny proud. "We had this dream of growing sorghum, breeding sheep and experimenting with tunnel farming," the 60-year-old Maart recalls.

Maart and 41 other farmworkers secured a R200 000 government subsidy to turn a piece of Oudtshoorn farmland into a worker-run co-operative. The farm owner agreed to sell the workers a portion of his land. It seemed like a win-win transaction. The farmer received a sizeable sum, the soil was fertile and a river

Adam Maart, a farmer whose access to water, and therefore his livelihood, has been denied.

ran through the land. "The agreement was that we would have access to this water 24 hours a day," says Maart.

That was three years ago. He says the farmer subsequently reneged on the agreement. He re-routed the water, depriving the workers of their most vital farming resource.

According to Maart, the department of land affairs is aware of this but has not intervened, despite the fact it is illegal to re-route a natural water source. Maart says the farmer, through harassment and intimidation, has blocked the workers from gaining access to the water.

"The closest water supply, apart from the river, is a kilometre away. We have to fetch the water by hand, yet when we bought this land the water was literally on our doorstep."

He points to the now-cracked earth that was once a river bed. "We lost more than 60 sheep because we didn't have enough water to keep them alive."

The remaining livestock are Damaras: sinewy sheep, resembling goats, that are able to survive extreme temperatures with little water. But even they seem to be taking strain at Blommetjies Vallei. They were bought from the farmer who sold the workers the land. He

apparently charged them R450 per head. In nearby Beaufort West, a plump Merino sheep can be bought for about R500 to R600 per head.

"Many of the workers don't know their rights because they are illiterate," says Maart. "They are intimated by the farmer and scared of the government. But, one day, despite the

farm owner's efforts to show that workers can't do it for themselves, Blommetjies Vallei will blossom."

HAZEL FRIEDMAN
Oudtshoorn
April 2005

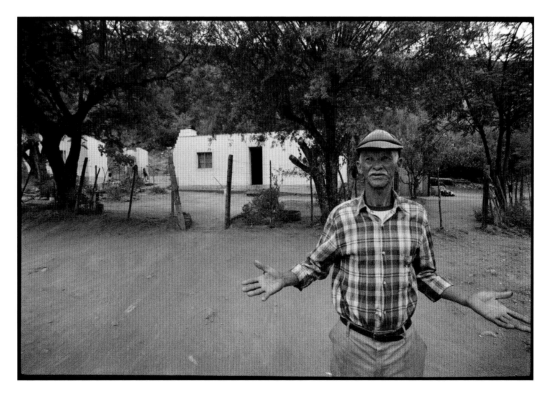

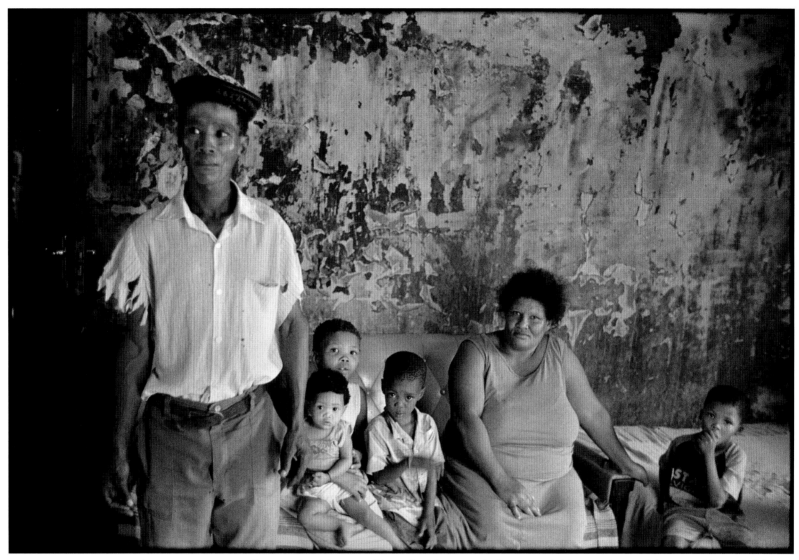

Evictees Jan Mattys and his wife, Mietjie, with their two children and two of their neighbours' children.

Fifteen evicted family members now live in a derelict farmhouse with no water, electricity or toilet facilities.

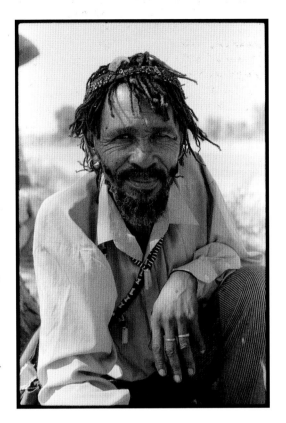

Jan van der Westhuizen, right, is a traditional healer at Andriesvale. "The main complaint we are fighting here is the big virus – the HIV," he says. He would like the whole community to be tested. "But for that we need counsellors. There are no qualified counsellors here."

Transport is another major headache. The nearest clinic is 15 km away and the only ambulance serving the area has to drive 200 km from Upington. "You call an ambulance at 10 a.m. and they arrive at 6 p.m. that night. It happened many times that I've visited sick patients who have died by the time the ambulance arrived," he says.

Van der Westhuizen freely admits to smoking dagga. "It comes from nature – how can it make you stupid, like the doctors say?"

To him alcohol is responsible for the many social ills that afflict this neglected community, including sexual abuse of young children at the local primary school. "It's turned our people into barbarians, animals," he says.

Jan Mattys had a small pumpkin patch that used to feed his wife, Mietjie, and two children. It was cleared from the arid Kalahari veld and watered by a windmill.

Last summer, when the wind died, so did his pumpkins. Now he and his family, who are members of the Khomani San community who won a R15 million land-claim settlement amid much fanfare in 1999, are starving.

Their staple diet is mealie meal stored in old paint tins. The last time they had any fresh fruit or vegetables was a few slices of sweet melon at Christmas. Once a month they get scraps of meat from his brother, a farm worker, who is given a sheep to slaughter every month.

Sometimes Jan's family goes three days without a morsel. Then he swallows his pride and goes begging.

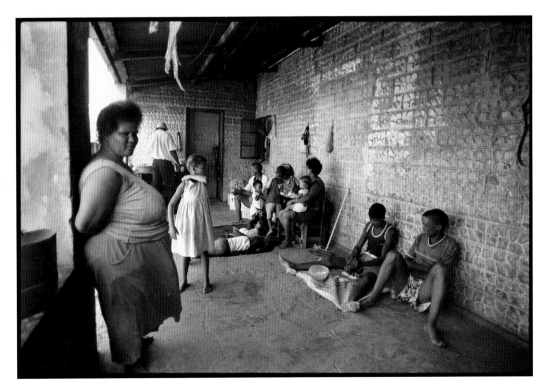

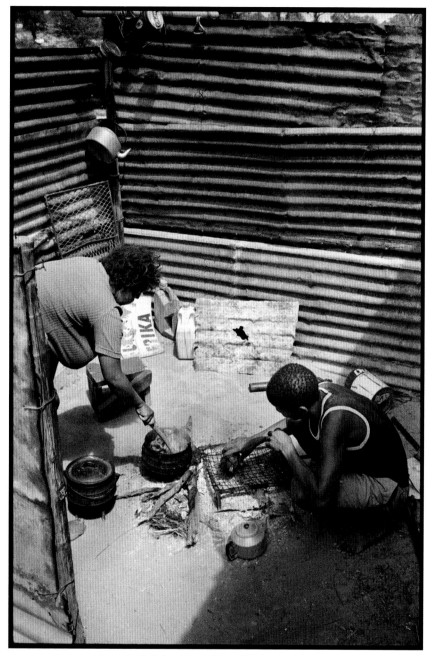

A makeshift kitchen where they are preparing porcupine stew.

"This isn't healthy," says Jan, his gaunt face and emaciated frame underlining his words. "We just don't get enough to eat."

Their only source of income is scrounging for firewood and selling it at the roadside to hunters and tourists travelling in air-conditioned four-wheel-drives to the Kgalagadi Transfrontier Park, an hour's drive north. This brings in about R800 a year.

"This must pay for school fees, clothes and food," says Mietjie. Jan, 35, lived and worked on a nearby cattle ranch with his family for 11 years. Three years ago the farmer – "a decent man" – died. His son was a sadistic tyrant who punished the slightest transgression with his fists. Jan decided the family had to move.

Now they share a derelict farmhouse with two other San families – a total of 15 people, all evicted farm workers – on one of six farms bought for the community. There is no electricity, no running water and no toilets. Scrawny dogs root for scraps among the rubbish and wrecks of cars. Two donkeys are harnessed to a cart, which is the only means of transport in this place of vast distances. The house's windows are broken and closed up with corrugated iron. There are holes in the roof, mattresses are lying on the floor and large cracks run across the walls. One wall has been converted into a school blackboard, with the words: "1. The president of the ANC is Mr Thabo Mbeki."

Small groups of Khomani San are sitting on a porch under animal skins pegged to a wire clothesline. Some are just staring into space. The children are playing with dolls and a stoned youth is drilling holes into ostrich-shell discs that will be used to decorate leather pouches sold to tourists.

Some women are tending three-legged cooking pots over two smouldering fires in corrugated-iron enclosures built against the porch. One contains bean soup, the other porcupine stew. Next to it lies the singed head of a porcupine, its exposed teeth forming a macabre grin. Since the diesel pump that watered their gardens broke down, the people have been reduced to beggars and scavengers.

The situation is no different at the other settlements dotted on the Khomani San farms and villages, a community of about 1000

living on the edge of the Kalahari desert. Broken pumps lie idle next to disused boreholes, and people wonder what became of their dream of turning this barren earth into a thriving farming, hunting and tourism enterprise.

One of the problems is that the farms were bought with ageing or derelict infrastructure, and the new owners had neither the financial nor technical skills to get them running profitably.

A lack of support from government departments and hostility from local police, who graze their sheep on one of the farms and use it as their personal hunting ground, clearly played a role. A recent report by the South African Human Rights Commission noted that police had allegedly removed a pump used to water a vegetable garden and provide drinking water for game, livestock and domestic consumption. The report also called for the prosecution of police officers accused of murdering Khomani San tracker Optel Rooi, and recommended a change in staff at the police station serving the area.

Mismanagement and corruption among the Khomani San are also major factors. Despite being in possession of assets worth millions – land, livestock and game – financial statements are incomplete or missing. Community leaders have accumulated substantial personal debts, using the farms as collateral. Vast sums have been squandered on buying vehicles rather than repairing pumps that could revive stock or game farming. One four-wheel-drive bakkie, bought for hundreds of thousands of rands, has been impounded by the police after it was allegedly used to transport stolen sheep.

Jan looks longingly at the veld. It is in excellent condition after recent rains and could easily support more livestock. "I want to be a sheep farmer," he says. "That would end our suffering."

STEPHAN HOFSTÄTTER
Scotty's Fort farm, Andriesvale
March 2005

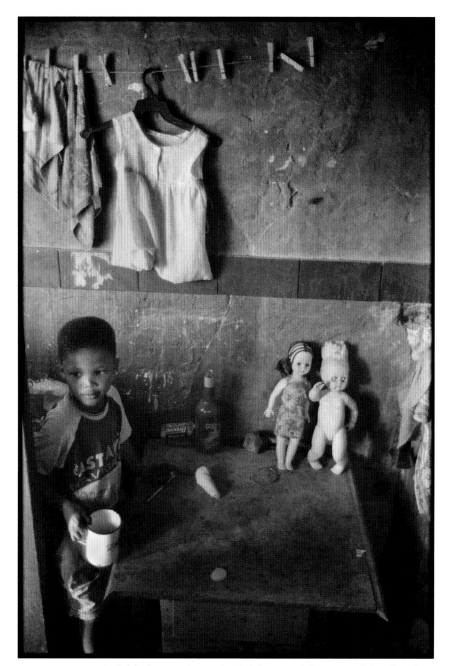

A child plays in the makeshift home of the evicted San families.

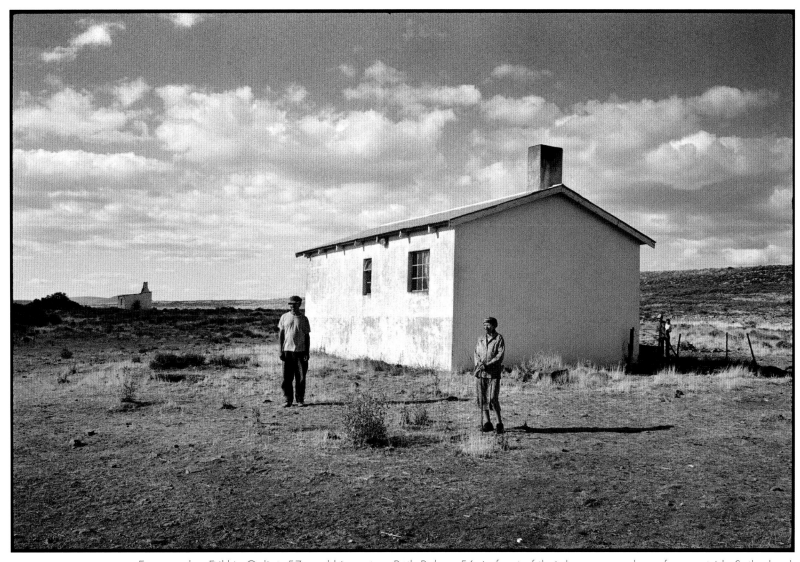

Farm worker Frikkie Goliat, 57, and his partner Beth Robyn, 56, in front of their home on a sheep farm outside Sutherland.

We met Frikkie Goliat on Human Rights Day. He had been working in the garden. "Don't you get public holidays off?" I asked. "No – the farmer doesn't worry about that stuff," he replied. "You must just work." Besides, Goliat had no idea it was a holiday.

Goliat, 57, has lived and worked on a sheep farm near Sutherland for more than 30 years. The farm also breeds Arabian horses sold to sheik millionaires in Dubai. The farmer, a local strongman whose home-made weights lie in

Frikkie Goliat's pay is between R500 and R700 a year.

the yard, is known to be one of the richest men in the district. He pays Goliat less than R2,50 a day.

Goliat lives with his partner Beth Robyn, 56, in a spartan three-roomed cottage. Cooking is done on a coal stove in the kitchen as there is no electricity. An outside tap supplies them with water, and they use a pit latrine some distance from the house.

In the lounge there is a picture of the farmer's son as a schoolboy. He played rugby for Western Province but is now a full-time farmer himself. "I raised that child," says Robyn, who used to work in the farmhouse kitchen until she was diagnosed with heart trouble and pensioned early.

Five workers have left this farm, citing poor pay and intolerable conditions. But Goliat and Robyn plan to stay. They say the farmer has never assaulted them, although he is an impatient man. "Some days he has a short temper, but we've been with him so many years it doesn't bother us," said Goliat. "We're better off here than in the location," Robyn agreed. "We get free water, free wood and free food."

Goliat's main gripe is what he earns. On weekdays he works from 7 a.m. to 5.30 p.m. with up to two hours lunch break; on Saturdays he works a half day; and Sundays he's given off. His only holidays are Christmas and Easter. At Easter the couple must ask for special permission to visit friends or relatives in the township next to Sutherland 20 km away. Every Christmas they are taken to do their shopping in Ceres 200 km away. It is their only regular contact with the outside world, and the only time Goliat gets paid.

"The *baas* pays between R500 and R700 a year depending on how many days we've worked," explained Goliat. "I don't know why he does this. We'd rather be paid at the end of every month. You need some cash sometimes to buy clothes or other necessities, but we have to wait until the end of the year."

They have never dared to ask for more.

STEPHAN HOFSTÄTTER
Sutherland
March 2005

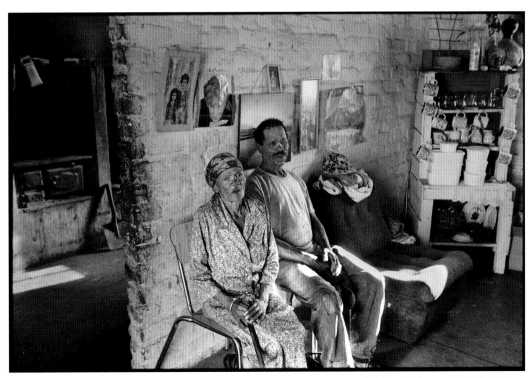

Frikkie Goliat and Beth Robyn.

In a green grassland dotted with sheep, in the hills and wetlands of the Mpumalanga/Kwa-Zulu-Natal border, is the pretty farming town of Wakkerstroom. It has become one of the world's favourite bird-watching spots and tourism is booming. Soon the town will get its first hairdressing salon.

But lift the chocolate-box lid and you will find tales of wrath and fear.

For many years, the Wakkerstroom farmlands have been the site of bitter dispute between landowners and labour tenants.

Farmers have been accused of vicious attacks on farm workers, and have been widely condemned for their reluctance to co-operate in settling land claims in the area.

The farmers in turn say they have been unjustly vilified. Threats of death and land invasion are a real and constant fear, says Pieter Bruwer, whose family, originally French Huguenots, have farmed crops and livestock here for five generations. He would prefer his children – a daughter and three sons – not to follow in his footsteps.

Picturesque Wakkerstroom, a magnet for tourists and bird watchers, has a history of land disputes and conflicts.

Dealing with the politics of Wakkerstroom's land reform process and constant negative media interest in the area consumes much of Bruwer's time. A de facto leader in this community, second-in-command of the local Commando and quietly intense, he insists: "That's not why I'm on the farm. I'm here to produce food and fibre for the people of the country."

Bruwer speaks of murder plots and hired assassins. He himself has received three death threats. "The first time they phoned me and said, if I went into town, they would kill me. Then they phoned five farmers in the area and said if we were present when they wanted to invade the land, they would kill us.

"It's very unfair. The whole world expects the farmer and landowner to be responsible for uplifting poor people, supplying everyone with land because we own it, and being the biggest job creator in the country. Why? We are just plain farmers."

Bruwer grew up knowing he would be a farmer like his forbears. "It used to be a lot different at that stage. It used to be nice. There were not a lot of troubles and problems at that time."

But these days he often thinks about packing it all in. It is not just the politics of farming that is making Bruwer question whether to continue in his family tradition. It is becoming harder to pay the bills, he says. "Prices used to be good. We had an agriculture-friendly government at that time."

Cheap Chinese agricultural imports are also taking their toll. And while new technology means farmers these days get much bigger and better harvests, "at the same time the people supposed to be eating our crops are dying of diseases like Aids".

There is real anger in much of what Bruwer says. But now and then a playful humour cracks the grim visage.

Meeting Ottard Klingenberg and Manfred Beneke for a night out in a bar in town, Bruwer watches bemused as the two fifth-generation farmers of German ancestry sing bawdy German drinking songs. Hennie Koch, a former policeman recently hired by Bruwer to look after his sheep farm, joins the party.

When Bruwer and Koch remove their caps, they bare newly shaven heads. The "Germans", as they are known, hoot with laughter. "If you need hair to enhance your personality, you've got a big problem," Bruwer wisecracks.

The men are in a playful mood, but their guns stay strapped to their hips. Almost all the farmers in this area have military training. Not long ago, Wakkerstroom's only bank was robbed by eight men wielding semi-automatics. Using the network of Commando members in the area, who are in constant radio and cellphone contact with each other, the outlaws were cut off at a bridge on their way out of town. Beneke and his son were waiting for them.

"I killed the two who shot at my son. The other six we got hold of later."

Judy Wheeler and her husband, Graeme, a former navy officer, have bought a plot in Wakkerstroom and say they don't feel as afraid as they used to when they lived in Durban. They are hoping to start a chicken farm and a bed and breakfast.

"In Durban, you look over your shoulder. You have to be aware when you step out of the driveway. Here we have more friends. Your arm gets tired from waving to everybody."

As for the land activists in the area, "I think they are trying to rush things", says Judy. "What the government wants to achieve is excellent, but there is no infrastructure for it, which is so typical of Africa. It's no different out here."

Bruwer says the government has not taken a firm enough hand with the agitators. "That makes us all jittery at ground level – we're scared, we're really scared. We don't know what's going to happen in the future."

But he'll allow himself some tentative optimism: "I'm hopeful that in my children's lives, things will be sorted out. The young black people that I get to meet every day, I'm very positive about them. On both sides people are really putting in a big effort at reconciliation."

CAROLINE HOOPER-BOX
Wakkerstroom
September 2004

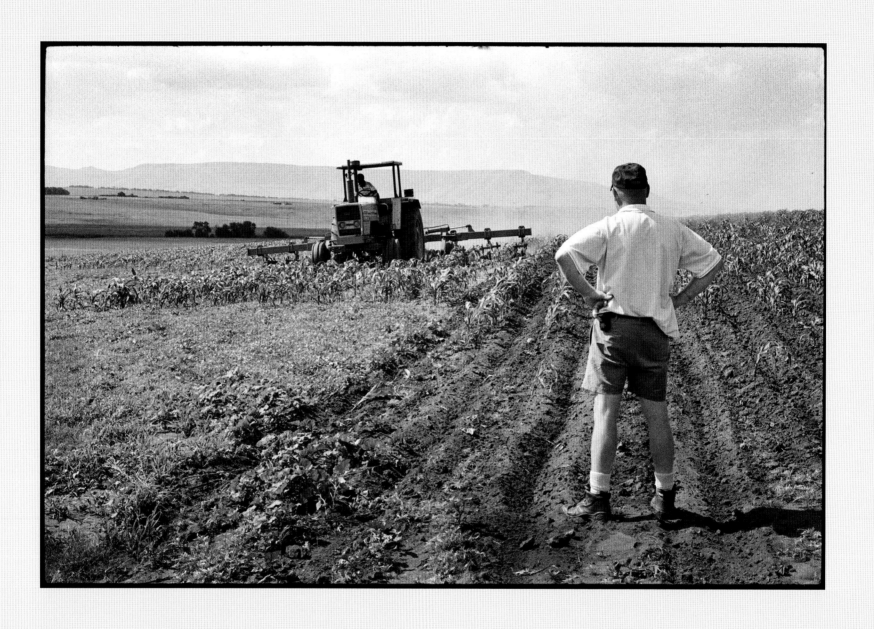

Wakkerstroom farmer Piet Bruwer.

Farmer Piet Bruwer, 42.

Wakkerstroom, a small rural town in southern Mpuma-langa, has for many years been the site of bitter conflict between land owners and activists. Farmers have been accused of vicious attacks on farm workers, and have been condemned for their reluctance to co-operate in getting land claims in the area settled. The farmers in turn say the accusations are false.

Intimidation and attacks on farmers are a real and constant threat, says Bruwer, a leader in the farming community. He himself has received three death threats. "We're scared, we're really scared. We don't know what's going to happen in the future."

Wakkerstroom farmers in the field
and in their local pub.

Piet Bruwer inspecting his maize crop for the stalk borer bug. "It's quite a problem this year."

In foreground, from left, farmers Otthard Klingenberg, Manfred Beneke and Piet Bruwer meet up for a drink at the Wakkerstroom Country Inn. They don't have the time to see one another very often, says Bruwer, so when they do, it's usually a raucous evening. Klingenberg and Beneke are fifth-generation farmers.

Judy Wheeler, Graeme Wheeler and Piet Bruwer. Judy says: "In Durban, you have to look over your shoulder... here your hand gets tired from waving." The Wheelers moved to Wakkerstroom from Durban and live on a 4,7 ha plot. They plan to sell chickens and open a B&B.

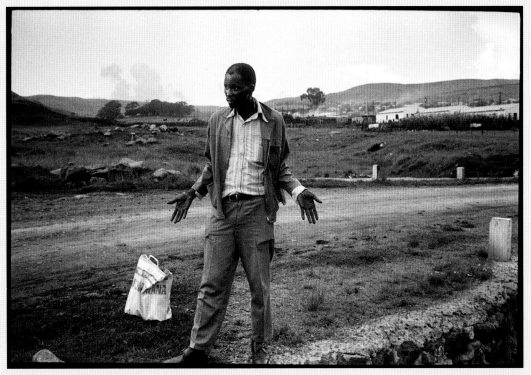

Joshua Twala.

The tranquil village of Wakkerstroom is perched on the windswept Drakensberg escarpment, a stone's throw from Blood River, where the greatest battle between the Boer and Zulu nations was fought. Today it is a well-known birders' paradise. Tourists with binoculars slung over their shoulders, wearing sturdy boots and parkas, are a common sight on gravel farmroads that criss-cross the surrounding hills.

These same hills are filled with tales of visits by balaclava-clad men, who kick down doors of farm workers and torture them with cattle prods, or fire random shots at their huts in the dead of night. For some, the war between the Voortrekker and Zulu over land and cattle is far from over.

Joshua Twala is one of several labour tenants I interviewed who allege that they are victims of a reign of terror conducted by farmers intent on driving them off their ancestral land. All said their troubles began after they had lodged land claims on the farms.

During apartheid, black tenants were obliged to provide free labour to farmers in exchange for the rights to live on and use white-owned land. A post-apartheid law allowed these labour tenants to claim the land they occupied and used.

When I met Twala for the first time almost a year ago he was defiant and spoiling for a fight. He took me around his homestead, pointing out places where the events he was describing had happened. Twala's detailed accounts never varied during subsequent retelling.

He told how security guards working for the farmer whose land he was living on, arrived at night and fired shots in the air; how his dogs were abducted on two occasions, never to be seen again; how more than once shots were fired and stones were thrown at the doors of his huts. But he vowed he would never leave. "It would be better to die where my ancestors are buried," he told me. His wife, Aslinah, confided she was often too scared to go to sleep at night. "Every time the dogs bark, we think it could be them coming to attack us. Then we wait for sunrise and consider it luck to still be alive."

Twala's neighbour, the late Ntabeni Nkosi, was 81 when his homestead came under siege. His daughter, Thembi Nkosi, described the events that unfolded soon after the family had lodged a land claim. "There was a knock on their door. One of the children opened. He was hit by a stone and hurt so badly he had to be hospitalised," she said. The

children fled to relatives in the township the next day, but Ntabeni Nkosi stayed.

The next night his visitors returned, padlocked his hut from the outside and fired shots at it. He broke out at dawn and fled on his horse, returning two days later. By then his huts had been burned down along with his possessions. "He opened a case, but it was never investigated," said Thembi. Three months later he was dead.

I decided to visit the farmers accused of being behind these nocturnal visits to hear their side of the story. They refused to be interviewed, preferring to issue threats of legal action.

The local police chief, Alfred Ueckermann, was more obliging. He admitted the area had a history of complaints of farm workers being assaulted, but that was all old hat. "It stopped years ago when farmers and farm workers were incorporated into the rural safety plan," he said. He flatly denied that police had taken part in any attacks or turned a blind eye to torture.

Black policemen I interviewed told a different story. They voiced dissatisfaction with the reluctance of senior white officers to act on complaints from farm workers. Charges of assault and intimidation laid against prominent, wealthy farmers were never investigated. One policeman said that a farmer whose name cropped up regularly in complaints had armed his workers to do his dirty work. Some were police reservists.

During my third and last visit to Wakkerstroom, I bumped into Twala buying groceries in the township. He was clearly rattled and reluctant to talk. It turned out he had been threatened with a defamation suit for telling his story to the press. We offered him a lift home.

To leave Esizameleni township's eastern exit, one must drive half a kilometre through an open field with dense, high grass growing on the verges of the road. The exit point had been blocked with a tree stump and large stones. We decided to err on the side of caution and take a different route out of the township.

Later I asked Twala who would have wanted to ambush us. "The people in the township thought you wanted to kill me," he explained. "Farmers come in here all the time and drive away with people, then they are blindfolded and beaten up and left to die in the forest."

The other side of Wakkerstroom: stories of conflict, terror and brutality.

Elizabeth Mazibuko's eyes are solemn and empty. She is like a person without a soul. That is how she describes herself.

Once she lived in a homestead of 10 mud huts with her husband, nine children and their offspring. She expected to die and be buried there, just like her forebears. But since her eviction she has not been allowed back.

"This is very painful for me," she says. "Most of my family is buried there and I cannot visit their graves."

Now Elizabeth, 68, and her husband Mlanda, 73, live in a two-roomed shack, which belongs to her brother-in-law, in Esizameleni township outside Wakkerstroom. Her brother-in-law does night shift in a nearby tavern and lets the couple sleep in his bedroom while he is away.

Mlanda was a shepherd all his life. Now he sits outside the shack in the sun, staring into space. Elizabeth supplements her pension by making reed mats, which she sells for R50 each. On the farm, two huts were set aside for her work, which brings in up to R1 000 a month. Now her loom rests on two tables pushed together in her brother-in-law's cramped kitchen.

"I want to go back to living on the farm again," she says. "If people took the land back by force, that would be good. Then I would have my children back there."

The Mazibukos were thrown out of their kraal in mid-winter last year after their son, who tended livestock for the farmer who owned the land, was accused of stealing a cow. Their son claimed that, despite his protests that the animal had strayed, he was assaulted by one of the farmer's security guards as punishment. When he refused to return to work, the family was told to go, because the money for their rent and grazing came from his pay. I first met Mlanda in Wakkerstroom a few weeks after it happened, when his possessions were still piled up in an open shed outside the shack.

His version of the events is different. He insists the real reason they were evicted was because labour tenants in the district had started lodging land claims. The family was banned from attending public meetings convened by NGOs or land-affairs officials to explain the claims process.

"The farmer would send spies to draw up a register and, if you were there, you had to account for yourself."

Mlanda lodged a claim and soon afterwards his son was targeted.

One night a sheep froze to death on the hills overlooking Wakkerstroom, where winter temperatures regularly plunge well below zero. Mlanda says the farmer's guards used a cattle prod on his son to extract a confession of stock theft, which would be used as grounds for firing him and evicting his family. The charge didn't stick.

When Mlanda's son refused to return to work after the second assault, the farmer no longer needed a theft charge to terminate his employment. He simply sent a notoriously vicious local headman on his payroll to visit the Mazibukos.

"He said, 'Your son no longer works on this farm. Why are you still here?'

"I asked him where was I supposed to go? He said, 'I will be back on Wednesday. You must be gone with your cattle.' This happened on the Monday."

Mlanda was too terrified of the headman not to obey. He had a reputation in the district as "the messenger who talks with his fists and sticks".

The next day the couple loaded their possessions onto a cart and, with 20 cattle in tow, made the trek down the valley to the village. Competition for grazing in the township is fierce, and most of his cattle have starved to death. Only four remain.

"I find it very strange," he says with a philosophical nod, "I was born here, my forefathers were born and buried here, and now this young boy is chasing us away."

STEPHAN HOFSTÄTTER
Wakkerstroom
February 2005

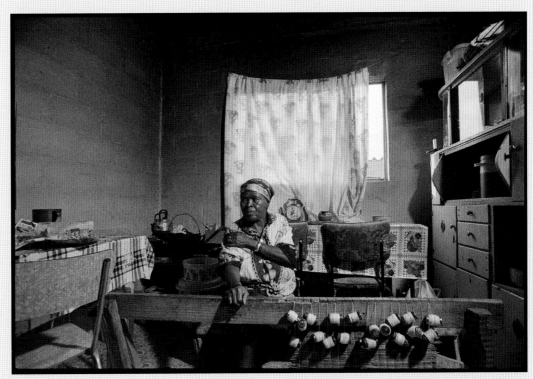

Elizabeth Mazibuko.

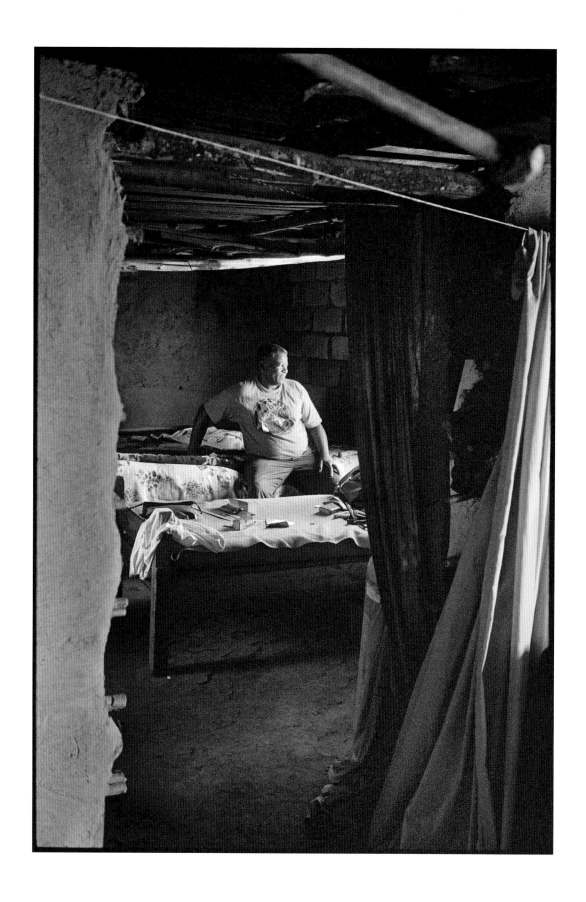

Mangaliso Kubheka, the national organiser of the Landless People's Movement, at his kraal.

As we neared Mangaliso Kubheka's kraal, he stopped his bakkie and scowled. "The bulls want to fight!" he yelled over his shoulder as he jumped out and bounded across the veld. "If they break the fence and my cattle stray into the white man's land, there's always trouble. He will start poisoning my cattle."

Moments before the two bulls had been grazing placidly in their own camps. Now they were lunging at each other across a three-strand fence, which was strained to breaking point.

Kubheka took off his shirt and launched himself at his bull, arms flailing like a man possessed. The creature looked baffled, and then seemed to toy with the idea of lowering his horns and storming this apparition. Then he backed off and the tension between the two animals evaporated. His adversary, a big, rust-coloured brute, ambled back to his herd in the white man's paddock. Two enemies had pulled back from the brink of war.

It was a strange episode. Kubheka is the national organiser of the Landless People's Movement (LPM), a small but vocal land-rights lobby, which has sent shockwaves through the white farming community with its outspoken views on land redistribution.

Here he was trying to keep fences intact.

We had met that morning at the Ingogo crossroads on the old Durban road. Nearby is a school, which his children attend. It used to take them 15 minutes to walk home from there until the farmer who owns the land closed the road they used. Now they must walk two hours along a railway service road. As we drove to his kraal in his rattletrap, Kubheka, once a fervent African National Congress (ANC) supporter, told me about his recent visit to the World Social Forum in was

Brazil. On his return, the police were waiting to interrogate him. "One of them asked me why I was always fighting, that Mbeki was doing a good job. 'You've got a job with the government', I told him, 'but as long as we don't have land and people are being evicted and killed on farms, we are not free. Mbeki is a boss boy serving white interests'."

Many farmers accuse the LPM of trying to incite violent land seizures. I put this to him.

"We don't want Zimbabwe," he said emphatically. "We want to occupy unused land peacefully. But people are running out of patience here and we won't stop them if they decide to invade land."

The Kubheka homestead is a row of derelict huts, one of which had lost its roof in a recent storm. A few gaunt dogs with protruding ribs rooted around for scraps of food and a goat licked the brick walls for salt.

He is under continuous threat of eviction from his ancestral land.

Kubheka's two-roomed brick house smelt of dampness and cow dung. A bucket next to his bed caught water dripping from the roof and clothes hung from a string running diagonally across the room. A portrait of his late wife, who died in a car crash, hangs above a threadbare couch in the lounge.

He suddenly seemed ashamed of the squalor. The constant threat of eviction discouraged his family from investing in improvements, he explained. We should continue our discussion under a thorn tree.

Kubheka was born here in 1950 and, at the age of 19, left for Johannesburg, where he worked in a chemicals factory and later ran his own taxi fleet. Violence between the ANC and Inkatha Freedom Party supporters in the early 1990s drove him back to his rural homeland, with a wife and six children in tow. His taxis had been destroyed, but he was able to exchange his concession for cattle. He had returned to his ancestral land to farm.

The Kubhekas have lived here for many generations. They were permitted to stay on white farmland during apartheid in exchange for free labour. "My father, my grandfather, all my uncles never got paid for working on the farm," he said.

Kubheka became a land activist in the run-up to the 1994 elections when the farmers around Ingogo, afraid of blacks taking over their land, were doing their best to evict their labour tenants, often using underhand tactics.

Common ploys were the impounding or poisoning of cattle, barring access and cutting water supplies.

"The farmer sent someone to sabotage our windmill," said Kubheka, pointing to it outside their kraal. Its blades refused to budge despite the breeze blowing. It used to supply their homes with piped water. Now they use buckets to fetch water from a borehole almost a kilometre away.

Kubheka claims to have received death threats from armed guards working for the farmer, who wants to incorporate the land into a game conservancy. He has approached Kubheka several times to offer him alternative land, but Kubheka refuses to budge.

"My wife is buried here. My father and mother, and their parents and grandparents, are buried here," he said, pointing to their burial mounds. "Why should I move?"

STEPHAN HOFSTÄTTER
Newcastle
February 2005

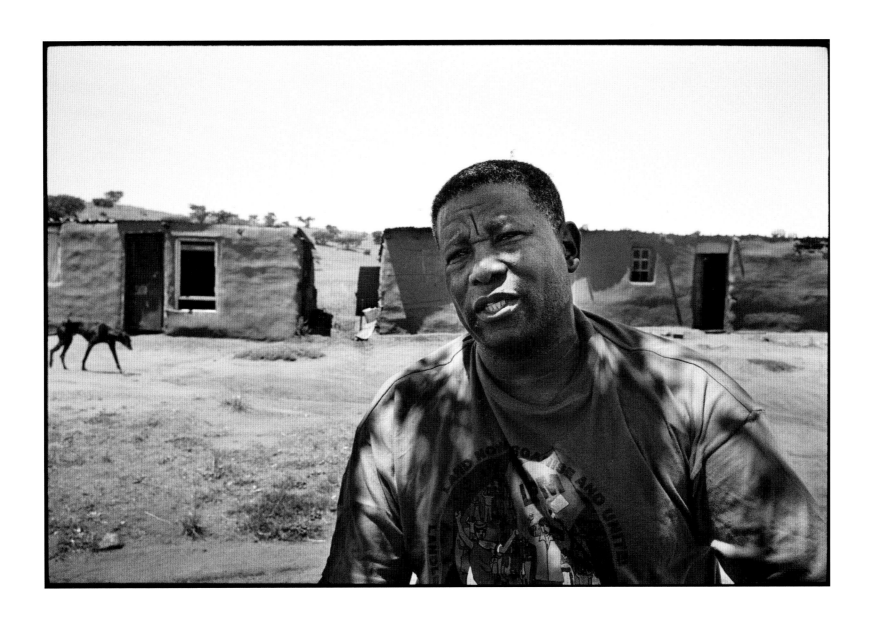

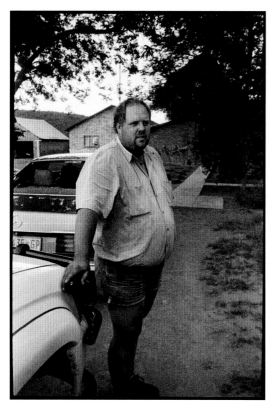

Farmer John Jordaan.

Vrede farm near Plooysburg, previously plagued by inhuman working conditions, has been improved by farmer John Jordaan.

Farmworkers Elizabeth Olifant (on left) and Shelley Ontsheng.

Vrede farm near Plooysburg had a bad reputation in the district. It was rumoured the owner kept his workers in the fields from the crack of dawn until late at night; he refused to pay them the minimum wage; and he let them live in shacks even unfit for livestock. Anyone who complained, so the stories went, would be beaten with a sjambok. He was always spoiling for a fight.

When we arrived at the farmstead, it was deserted. The silence was eerie… there was no barking of dogs, hissing of geese, or cheeping of chicks that normally greet visitors to farms.

Some workers we'd met on the way said the *baas* was fixing a pivot in a lucerne field next to his house. He'd probably meet us at the gate when he spotted our car. But minutes passed and there was no sign of him. We opened a meshed screen to ring the doorbell, cautiously peered around corners in anticipation of being mauled by a Rottweiler, respectfully knocked on back doors and called through open windows…

Then a revving engine and the sound of tyres skidding to a halt on gravel broke the silence. A white 4x4 bakkie had parked us in. It was a military manoeuvre: corner your enemy, make sure there is no easy escape.

John Jordaan is in some ways the typical caricature of a white South African farmer – a barrel of a chest threatening to split his short-sleeved khaki shirt in two, sandy hair thinning at the temples and an enormous paunch spilling over almost obscenely small shorts. His small, watery blue eyes betrayed no emotion.

His initial hostility dissipated as he gave vent to his anger at the challenges facing farmers – the maize price is so low… it's impossible to break even… how can he pay his workers a reasonable wage when he's running at a loss and can't even afford medical aid, or life insurance ("I could be killed when I go out at night to check on the pivots and my wife would be left with nothing").

Unlike many farmers I've met in other parts of the country, he does not have a gun on his hip. "What's the point," he said with a weary shrug of his ample shoulders. "You can't shoot someone on your own land any more."

Jordaan, 30, took over from the previous owner two years ago. He farms cattle, maize, lucerne,

Sanna Uys, 47, kitchen worker, with her child and Elizabeth Oliphant's children in front of her house on Vrede farm.

wheat and potatoes, and irrigates his crops with water pumped from the nearby Riet River.

Unlike his notorious predecessor, Jordaan does not appear concerned about meeting his legal obligations to his workers: "The minimum wage is no problem, and I look after them when they're ill, or need help."

This was confirmed by his workers. Sanna Uys, 47, works in Jordaan's kitchen. Although her nine-year-old son, Jantjie, has to walk for 15 minutes to the school bus stop, the mobile clinic that visits Plooysburg every month or two is a two-hour walk from the farm. "If someone is

very sick, the white farmer helps us," she said.

Part-time worker Elizabeth Oliphant said Jordaan "treats us very well". His workers live in four-roomed, brick homes that are "better than RDP houses". She earns R30 a day and full-timers get R350 every two weeks, which, with the few extra days in a month, works out to slightly more than the minimum wage of R714 a month.

Their one gripe is that water for domestic consumption is pumped from the river without being purified. This affects the health of her two children, Lesley, (10), and Ashley, five. "It's not good – it makes their tummies sore."

Jordaan said he doubted if he could continue to pay his workers for much longer if he failed to get a fair price for his produce. "The future looks bleak. There's no light at the end of the tunnel," he said with the apocalyptic pessimism typical of his tribe. "I suppose it will turn around eventually, but can we hold out long enough until the prices change?"

STEPHAN HOFSTÄTTER
Plooysburg
February 2005

Pakedi Moleko, the FAWU regional organiser, talks to workers about their rights after hours outside the Sun Raise Poultry Farm in Eikenhof where he is denied access.

Health, living and human rights issues are addressed by trade union official Pakedi Moleko.

Perhaps the experiences of Pakedi Moleko best tell the story of the Sun Raise Poultry Farm in Eikenhof, south of Johannesburg.

There were days when Moleko, as the Food and Agricultural Workers' Union (FAWU) regional organiser for Johannesburg south, would rise early and head for the farm to make new members aware of their rights. It was his business to know what was happening at Pat Watson's farm and to fight for better living and working conditions for the more than 50 workers.

We visited Sun Raise early in 2005 with Moleko. Throughout the day-long trip, listening to the trade unionist was a captivating experience. For him, it was just another encounter with farmers who, without a hint of care, seem to put financial gain ahead of the interests of the workers.

"The main issues that face the workers at Sun Raise, even up to this day, stem from the fact that the employer appears to be in breach of the Occupational Health and Safety Act. The employees do not have protective clothing, including gumboots, overalls or dust coats, and they do not have gloves or goggles either.

"Sometimes they have to mix chicken feed with their bare hands, and have to wade through buckets of stockfeed with their bare feet to mix chicken mash," he said.

At times they were exposed to a poisonous spray used on the chickens for mites and other insects.

The workers were not aware of their rights, and their employer refused to allow them to hold union meetings on the farm.

"When I started working with the workers at Sun Raise, they did not get compassionate leave and were not properly registered with the UIF [Unemployment Insurance Fund]. They do not have medical aid or a pension scheme, and they do not get on-the-job training either. "Sometimes they have to endure harassment, verbal and sometimes physical abuse from their employer."

Moleko said Sun Raise was also in breach of the basic housing provision guidelines set out by the ministry of labour, which state that employers should provide running water, toilets and electricity for their employees.

While there is electricity at the offices, sheds and chicken runs, workers who stay a stone's throw away live in conditions that appear to be worse than those of the chickens.

There is no running water, therefore the workers' children must walk and fetch water from a single tap far from where they live. At night they are in darkness, while all that they can see are the bright lights that allow the chickens that they are raising to feed all night.

Moleko was not allowed to set foot on Sun Raise because the employer had accused him of being a bad influence on the workers.

"As a result, I now rely on visiting the workers after hours, and I have to address their concerns outside of their working premises. Either way, I still manage to spread the message that it is time that they stood up for their rights," he said.

We contacted Watson's office and asked to speak to her about conditions on her farm, but she said labour issues were handled by her lawyer, Hannes Gouws.

Weeks after Gouws had promised to secure an interview with Watson, he finally phoned to say she was not keen to allow us to take photographs on the premises because "the union guy" (Moleko) who had told us about Sun Raise was pushing a political agenda.

"Ms Watson said I must tell you that she has nothing to say about what the unions are saying. She denies that she is in breach of the Occupational Health and Safety Act and argues that she has done a lot in recent months to improve the working conditions of her workers," said Gouws.

KENNETH CHIKANGA
Sun Raise Poultry Farm, Eikenhof
January 2005

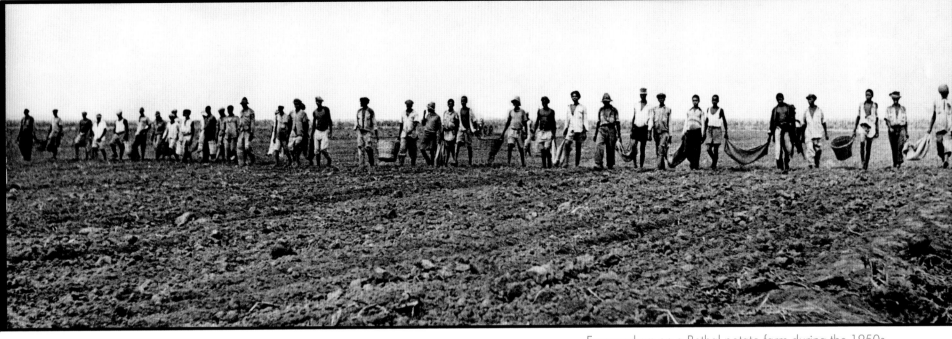

Farmworkers on a Bethal potato farm during the 1950s.

Bethal then and now.

In March 1952, journalist Henry Nxumalo and photographer Jurgen Schadeberg brought the inhumane working and living conditions of farm workers in Bethal to the attention of the world with an exposé in *Drum* magazine.

The eight-page story detailed how pass-law offenders were forced to sign up as cheap labour on white-owned farms: it detailed the brutal assaults, the whipping and battering of the labourers: and the dingy, squalid conditions of their living quarters.

In April 2005, 53 years after Nxumalo's exposé, Schadeberg and Lucas Ledwaba, a journalist at *Drum* magazine, returned to Bethal and found that, although the whips and the forced labour are gone, farm workers in the area now face a struggle of a different kind.

The view from Matthew Mthimunye's square mud house on the farm Schurvekop is breathtaking. Pastures covered with tall grass sway gently in the wind and winding dirt roads looking like spilt coffee stretch as far as the eye can see.

It is a view Matthew has enjoyed since he

settled on the farm in 1979. But these days the beauty does nothing to raise his spirits. It has been like this since early 2003 when his previous employer sold the farm. That is when trouble began for him and five other families on the farm.

"The new owner said he didn't want us on this land and wanted us out," Matthew says.

"First, he started by putting up a fence around the patch of land my previous employers gave me to cultivate for my family, then he ordered us to take our cattle from the farm."

As the farm tenants ganged up together to seek help from the government and lawyers, they faced another form of intimidation. Armed commandoes raided their settlement at night and fired shots randomly, one of them hitting a house near the Mthimunye household.

Idos Mokoena, a field worker for a NGO, Transvaal Rural Action Campaign, says that, although evictions seem to be a big issue in the farming community, work and remuneration conditions have still not improved to satisfactory levels. "People are still being underpaid and treated badly. The difference now is that people are be-ginning to take up their cases with the police and labour organisations," Idos says.

Matthew's four cattle died under mysterious circumstances soon after the start of the eviction battle.

"I've never been compensated for my cattle. Cattle are important to me because I can sell them off to get money to raise my children," he says.

Then one day his wife, Selina, who had been fearlessly vocal about the eviction threats, was bumped by a truck, allegedly driven by the farmer, while she was walking along a farm road. "We laid charges with the police, but nothing happened," Selina says angrily.

This statement is a chorus sang by most farm workers in the area, who allege that police are hesitant to act on charges brought against farmers.

Selina, her five children and two grandchildren were born on Schurvekop. "My whole life is here, why must I leave now? Where must I go?" she asks, fuming.

She met her husband on the farm and everything she knows, she learnt here.

"My father also worked on this farm. We can't move anywhere. The government must help us not to leave our home," she says.

The story of the South African farm remained the same for many years: white farmer and black labourer, white landowner and landless black labourer. But with the coming of democracy in 1994, the country has seen the emergence of a new breed of farm owner: a black middle class, and former black farm labourers who have become farm and landowners with the assistance of government grants.

Early in 2004, Sarah Xaba thought her fortunes would change for the better when a black family bought the farm Blesbokspruit, her home for 18 years.

For years, she had endured harsh working conditions and poor pay on the cattle farm. Five years ago, her monthly salary was a measly R160 a month, the price of a dinner in an up-market restaurant.

"When the new owner came in, he made it clear we were not welcome here," Sarah says. "He cut off our water supply for three months and then locked up my bull because he said it was troubling his cows. They locked up the bull and pelted it with stones."

Sarah and her children now have to walk almost a kilometre to a water tap, and, to do this, they have to cross the farm. This has landed them in trouble with the landowner, who has laid charges of trespassing against them.

Sarah and her family of 10 live in a five-roomed mud house, which is on the brink of collapse. She says the house, which has no electricity or running water, is flooded when it rains and the poor state of the zinc roof, in an area where the winter temperatures often fall to zero, does little to keep out the cold.

"We can't fix this house because it is not clear how long we are going to be here. We could be gone tomorrow," Sarah says. But her son, Vusi, who came to the farm when he was three years old, says he is going nowhere.

"This is my only home. I grew up here and I'm going nowhere," Vusi says. "I thought because the farmer is black he would treat us with respect, but it doesn't look that way."

Back at Schurvekop, Matthew rubs his hard hands together and thinks deeply for a while. Then he shakes his head slightly, almost like someone prepared for anything, especially war.

"Look," he says, "this is our land. I can't tell what's going to happen if someone tries to move me. But I can tell you, something will happen that day. Something will happen."

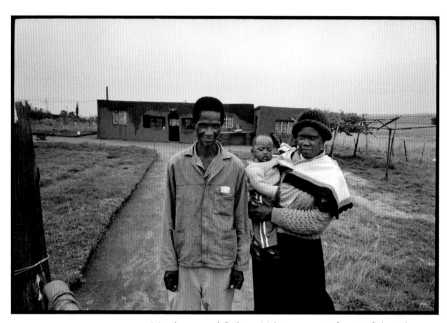

Matthew and Selina Mthimunye in front of their house.

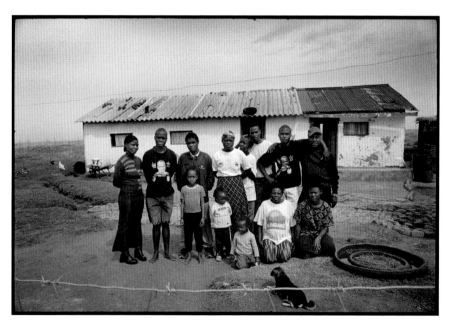

Sarah Xaba, fourth from left, with her sons and extended family who are all threatened with eviction.

LUCAS LEDWABA
Bethal
May 2005

What is the future of farm schools?

Sonny Dube, a 14-year-old grade seven pupil at the Ithemba farm school,[1] wolfs back a *vetkoek*.

Between gulps, he complains of finding his school and all his lessons "depressing" and "uncomfortable". "There is only one chalkboard for four grades," he tells me. Then, in a curious juxtaposition, blurts out, "I want to be a doctor."

Now it is my turn to be uncomfortable, as I am confronted, once again, with the sad confluence, in a child too young to know better, of innocent hopes and unlikely achievement.

It isn't just that Sonny goes to a dilapidated, two-roomed school with no electricity, a precarious water supply and not enough classroom furniture to give everyone a desk and a chair. It isn't the fact that the provincial department of education delivered Sonny's textbooks months too late this year. It isn't that the farmer who owns the land on which the school stands insists on using one of the school's erstwhile classrooms to house a panel-beating workshop and considers the pupils a convenient source of labour during harvest time.

It isn't the fact that Sonny's teachers have almost no vocational training beyond their secondary school examinations, and it isn't even that Sonny walks a 20 km round trip to school everyday. What makes it grimly unlikely that Sonny will ever become a doctor is that, next year, when he moves into grade eight, his parents, who earn R600 a month between them, will simply be unable to afford to pay the R40 a day in taxi fares to make the 140 km round trip to the nearest secondary school. In fact, proceeding to secondary school is an opportunity rarely afforded to children of any of the workers on the farm where Sonny lives.

Of course, he is not the first farm child to find himself denied access to adequate schooling. Farm schools were not initially intended to provide black children with social mobility.

They were created under the apartheid-era Bantu Education Act, with the aim of perpetuating a half-educated labour supply for white agriculture. Farmers received subsidies to set up and run rudimentary primary schools on their land, partly as a way of discouraging farm workers from moving to urban areas in search of better wages and access to social services. They were meant to stem what H. F. Verwoerd famously referred to as "the trek from the farms".

The carrot of schooling for their children was used in concert with the stick of repressive labour legislation to induce African labourers to stay on farms. Farm workers were excluded from apartheid-era legislation – the Labour Relations Act, the Wage Act, the Basic Conditions of Employment Act and the Unemployment Insurance Act – which set out minimum health standards and working conditions.

Farm workers under apartheid were generally badly paid, badly treated and worked long hours, with no rights to time off, overtime, safe working conditions or medical treatment.

Apartheid-era influx controls prevented many farm workers from moving to towns to look for work; apartheid-era labour bureaus regulated the employment of black people; and, once categorised as a farm labourer, a black worker could not change his or her category of work unless there was a surplus of farm labour or his or her employer consented.[2]

This regime trapped farm labourers in a highly dependent relationship with farmers. With few formal rights, whatever autonomy or comfort a farm labourer could expect was substantially dependent on the largesse of the farmer.

Farm schools were essentially "a reflection and an extension of this control situation".[3]

They almost never provided education beyond the primary level and gave farm-school children little hope of competing in the urban labour market, and thus ensuring the reproduction of a rural labour force.

Farm schools also provided a source of cheap, or free, labour during busy times of the year, such as the harvest, when schools were often closed down for days, or even weeks, at a time.

While the practice of child labour on farms was outlawed in 1986, the apartheid government did little to enforce the prohibition.

In practice, few farmers had much reason to ensure that their schools were provided with anything more than the most basic facilities.

Contrary to Verwoerd's purported vision of more skilled and "useful" workers, most farmers' sentiments seem to have been summed up by the comments made by one Stellenbosch landlord, cited in Bill Nasson's 1984 study of farm schools: "It's all very well to have gone to school, but that doesn't mean that you'll make a reliable tractor driver."[4]

Unfortunately, during the 10 years since the advent of democracy, little has changed.

Despite significant legislative and policy reforms throughout the education sector since 1996, a 2004 Human Rights Watch Report on farm schools could still assert, with some justification, that: "The South African government is failing to protect the right to a primary education for children living on commercial farms by neither ensuring their access to farm

schools nor maintaining the adequacy of learning conditions at these schools… The historical, social and economic conditions on commercial farms, inherited from years of an undemocratic, minority government, mean that farm schools … are among the poorest in financial resources, physical structure and quality in South Africa. Farm children attend schools without electricity, drinking water, sanitation, suitable buildings or adequate materials. Also children may face harassment from farm owners…"[5]

Farm-labouring households, characterised by high levels of poverty and vulnerability to eviction, often struggle to get their children into school in the first place, and what is waiting for them when they get there is often every bit as depressing as Sonny makes out.

Farm schools are, in the words of one ANC education minister, the Cinderella of the education system. The implementation of laws aimed at wresting control of farm schools from individual land owners has all but run aground.

Secondary education for most farm pupils remains a distant dream. Crushing daily walks of 20 km or 30 km to get to and from school are still common. Transport is provided for a lucky few. Farm pupils are still under pressure to provide labour and vulnerable to other forms of exploitation.

Sonny, still munching on his *vetkoek*, appears unaware of the social and historical barriers that will probably prevent him from reaching his goal. Yet I find a strange comfort in his optimism, tempered only by my frustration at the state's inability to match his enthusiasm with an investment of a well-resourced, secure learning environment.

1. The name of the pupil and the school have been changed.
2. Ibid. 79
3. Ibid. 88
4. Nasson, Bitter Harvest: Farm Schooling for Black South Africans, Cape Town, Saldru (1984).
5. Human Rights Watch – Forgotten Schools: The Right to Basic Education for children on Farms in South Africa (2004).

STUART WILSON
Centre for Applied Legal Studies,
Wits Law School
Johannesburg
May 2005

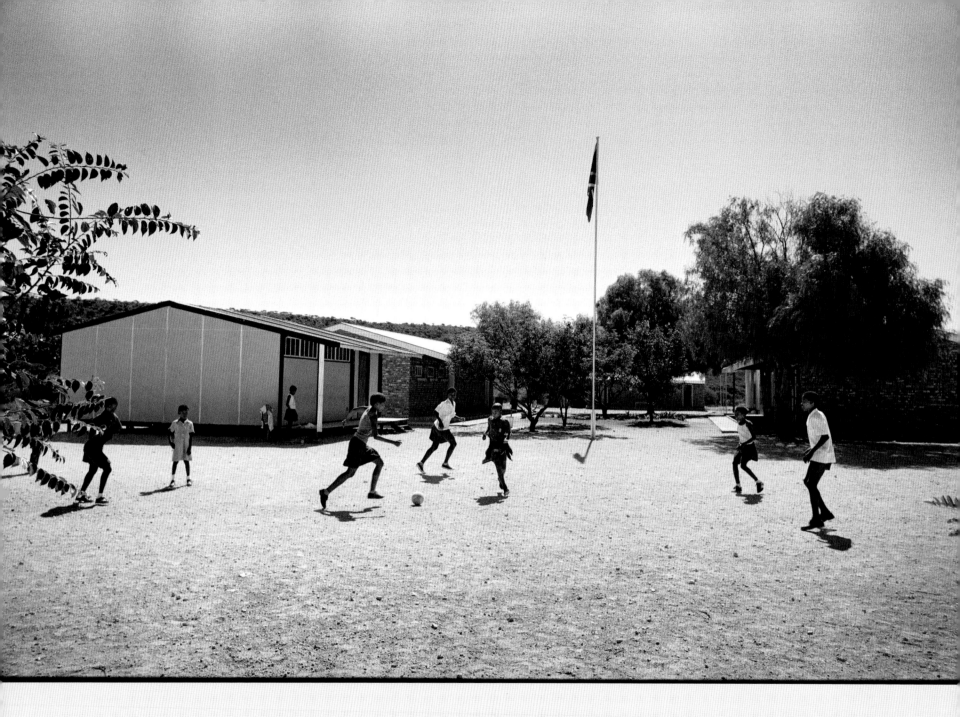

Jimmie Mopalama and Khulu Diedricks wake up at 3 a.m. every morning to go to school. From their rudimentary labourers' cottages on a farm near the hamlet of Plooysburg in the Northern Cape, it is a two-hour walk to the northern bank of the Riet River.

There they are joined by five schoolmates. The group descends the steep slope leading to the water's edge along a path hacked through dense reeds. In winter, it is still pitch dark. They grope above their heads for a steel cable

spanning the river, attached to a tree on each bank. Then, one after the other, they clear a metre gap to land on the makeshift raft that will carry them across a distance of 40 m. The raft consists of four oil drums lashed together with wire and a rusty piece of corrugated iron bolted on top.

A corner of the raft dips dangerously into the murky green water as they drag themselves to the opposite shore where the school bus is waiting.

The seven children cross the Riet River to get to school on an improvised raft made out of four oil drums tied together with wire surmounted by a rusty piece of corrugated iron.

Joye Wiid, the school principal, says: "Up to 2001, some of the children had to walk 30 km to get to school and back."

Jimmie, Khulu and the others are among about 200 farm workers' children who attend Plooysburg Primary School. It is an hour's drive east of Kimberley and one of four farm schools in the district. Before the school was built in 1995, they used to attend classes in the local church hall. None of the teachers were qualified.

Since then there have been many improvements. The spruce, brick classrooms, their walls adorned with colourful educational posters, were fitted with ceiling fans. Summer temperatures of 37 °C are not uncommon. A cooking shed was erected and at 10 a.m. every day a bell mounted on a railway sleeper is rung to announce it is meal time.

Up until four years ago, the farm schools did not offer any sport. Now the children play soccer on a stony pitch in front of the classrooms, and there are plans to offer volleyball

and athletics. This year the church agreed to donate some land for a sports field and a local farmer has offered to clear it for free with his grader. The school also has 10 brand-new computers, but these have been in boxes for more than a year because the education department has yet to approve funds for a computer room.

Eventually each unit will be connected to the Internet, a particularly useful learning tool for such an isolated community. The only serious deficiency is the dirty pit latrines.

The greatest improvement has been the school bus. "Until 2001, some of the kids had to walk up to 30 km to get to school and back," explains the principal, Joye Wiid.

"When it rained, I would take my husband's double-cab and drive backwards and forwards to get them here."

Wiid is a seasoned teacher who retired 15 years ago after marrying a local sheep farmer.

When the school opened she was asked to run it, and now has a staff of six fully qualified teachers. "We really try our best to provide a high standard of tuition."

But this doesn't make it easier for Jimmy, 12, and Khulu, 11, and their friends to get to school. For years Wiid has sent numerous letters to regional and district transport offices of the department of education to devise a solution, but to no avail.

"When the river is low, it's not too dangerous, but when the water is released from the Orange, they don't come to school for three or four days," she says.

The children say they are scared. "I'm really unhappy to use this raft every day. It feels as if it's going to sink," says Maria Langeveld, (15), who lives with her parents and four siblings in a two-roomed house on a sheep farm near the northern bank of the Riet. "If it

rains, we can't come to school because the raft fills up with water." Then there's the hour-and-a-half wait after school for the bus to do its rounds before it picks them up. They usually play soccer to pass the time.

"I'm hungry," says Jimmy, scanning the gravel road for the bus. At three o'clock the bus finally pitches up, which means Jimmy will only get home after six.

There is a carnival atmosphere as the children pile in, and soon they are singing "Do, Re, Me" at the top of their voices as we bump over boulders in dry river beds.

The children walk in a snaking line through the long grass that leads down to the river and their rickety raft. Early tomorrow they will do it all over again.

STEPHAN HOFSTÄTTER
Plooysburg
March 2005

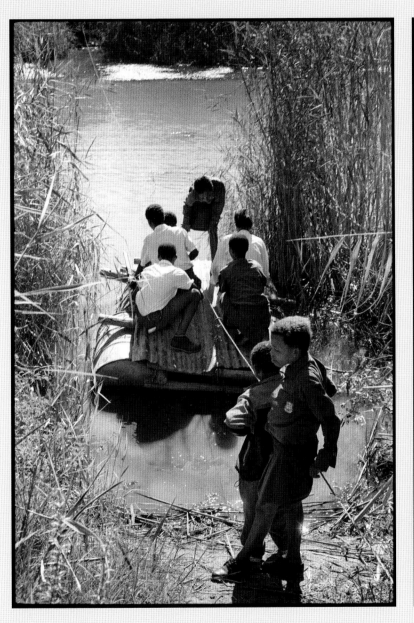

"If it rains we can't come to school because the raft fills up with water."

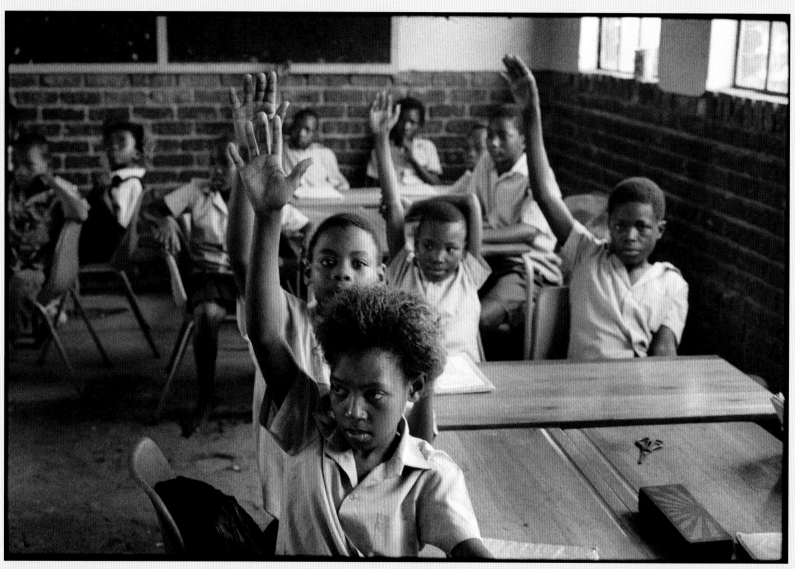

The Inyoni Primary School was established in 1995 and receives a R12 000 subsidy a year from the government. The farmer donates some R5 000 a year, has supplied computers and other equipment, built a crêche and provided land for the development of sports such as soccer and cricket. The school services 10 surrounding farms, from where the children are bused in courtesy of the department of education.

The school is 120 km outside Nelspruit, the capital of Mpumalanga and 25 km from the nearest town of Naas. There are 132 children, four teachers, including the principal, Erma van Tonder, and four classrooms. The school is on a farm that produces tomatoes, peppers, bananas and sugar cane.

The school's principal, Emma van Tonder.

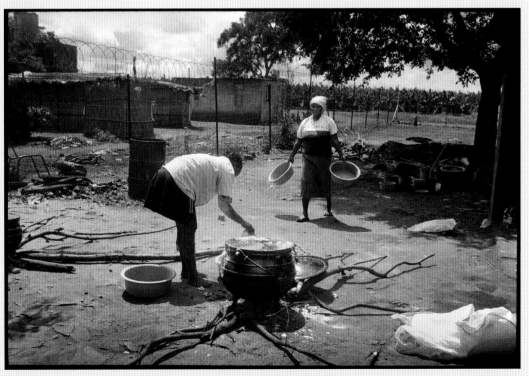

A pupil helps to prepare a daily school meal.

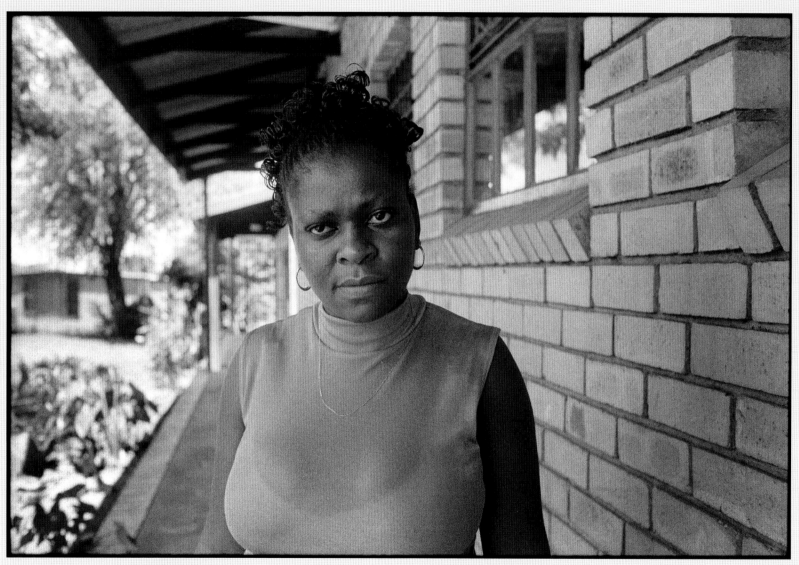

Turfbult Primary Farm School is 120 km outside Nelspruit. The school is 20 km from the local town of Naas, has 111 children, four teachers, including the principal, and three classrooms. Irene Hleza, above, is one of the teachers who has worked there for five years. The school was established in 1994 and relies solely on an annual government grant of R10 000. The farmer is not involved with the school and is not known to the staff. There is electricity, running water and a feeding scheme. This was not in operation for two days during our visit, which affected the attendance of many children, several of whom walk between 4 and 10 km to school every day.

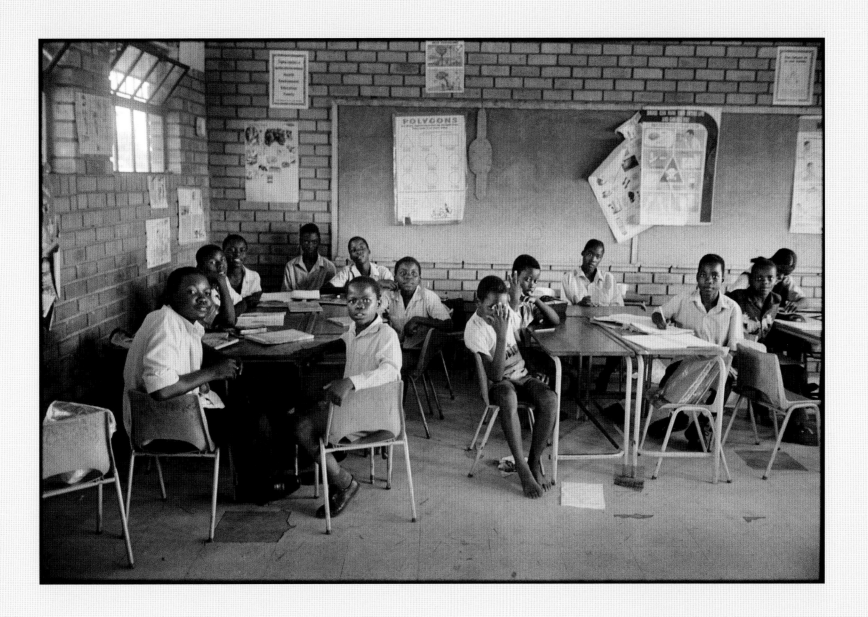

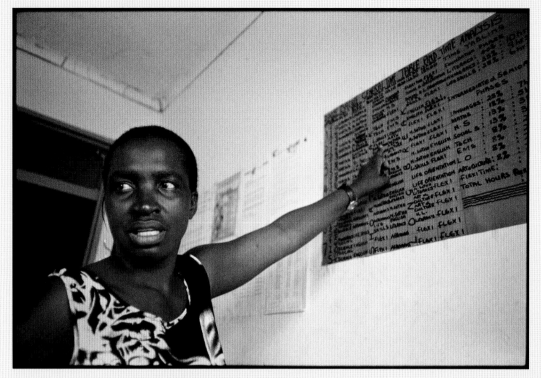

The Balule Primary Farm School is 200 km from Nelspruit and 32 km from the nearest town of Hoedspruit.

The school has 32 children, three teachers, including the principal, and three classrooms. The principal is Pricilla Seboke, left, who has been with the school since its establishment in 1990. The farm produces lemons, oranges and grapefruit.

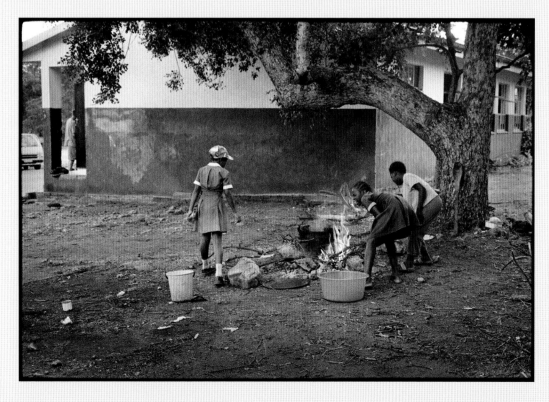

Schoolchildren prepare their meal for the day.

The farm, which is owned by Olifants River Estates, supplies water and electricity free of charge. The toilets have not worked for five years so the children and staff have to use the surrounding bush. Although parents of pupils are expected to pay R30 a year for school fees, many cannot afford it, so the fees are waived.

The Jonkman Primary Farm School, 25 km from Hoedspruit, Limpopo Province.

Anna Maabane, the principal, has been with the school for 14 years.

The school has 22 children, two teachers, including the principal, and the use of two classrooms. The school is on a citrus farm.

Jonkman Primary Farm School, which was founded in 1986, has no water, electricity or telephone. This is the first year that it has received a government subsidy. The farmer helps only with cutting the grass and collecting the garbage. In 2001 the school had 120 children but 98 dropped out due to transport problems.

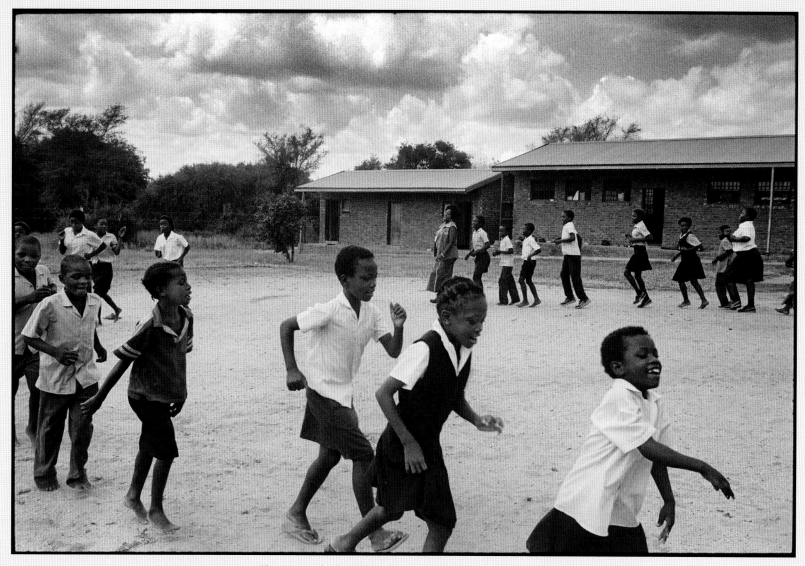

The H. H. Thiele Primary School was established in 1994. It receives an annual government grant of R10 000 and it serves the six neighbouring farms. There is no water and electricity, nor organised transport for the children. The farmer gives the school fruit and helps with the maintenance.

H. H. Thiele Primary School is 20 km from Hoedspruit, Limpopo Province.

There are 51 children, two teachers, including the principal, and three classrooms. The school is on a mango and orange farm.

Lucy Shai, the acting principal.

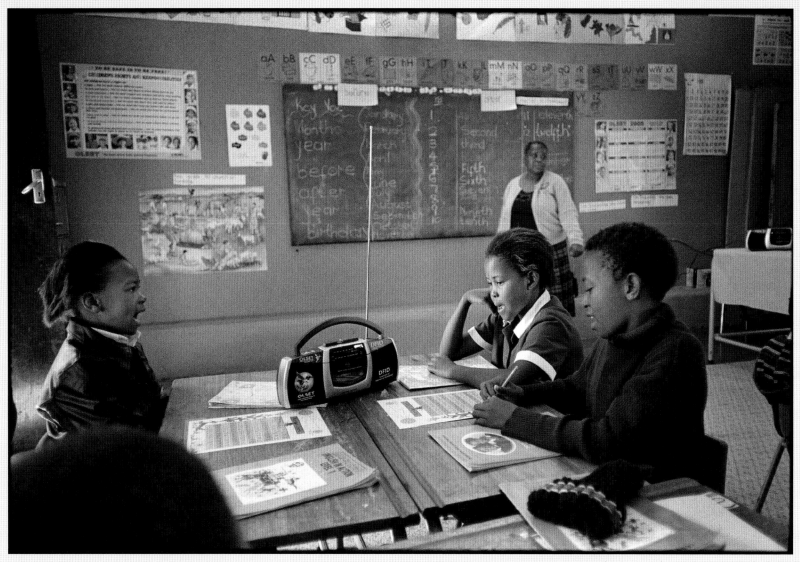

Above, teacher Johanna Mothabela.

Open Learning Systems Education Trust (OLSET) is a non governmental organization reaching out to the poorest, most under-resourced primary schools across the provinces of South Africa. The overriding objective of the organization is one of actively supporting teachers and improving their capacity to provide quality educational instruction for children through gradual adoption of innovative teaching approaches in the classroom, consistent with the new national curriculum. To this end, OLSET developed a series of core curriculum Open and Distance Radio Learning programmes titled English in Action, targeting the entire Foundation Phase cohort in schools.

In partnership with the Provincial Departments of Education and the South African Broadcasting Corporation, OLSET is able to provide inservice teacher training as well as daily radio broadcasts to the most challenged schools countrywide. An overriding advantage of Radio Learning is that it ensures children in the most impoverished remote rural classrooms receive the exact same quality of educational instruction as their urban counterparts.

The OLSET Radio Learning Programme presently affords some 1.8 million of the country's most vulnerable primary school children, often without water or electricity, opportunities for a substantially more meaningful educational experience. Their teachers benefit from OLSET Inservice workshops, receiving a radio together with a wide array of print support materials, for integrated use

Teaching by Radio –
Open Learning Systems Education Trust (OLSET).

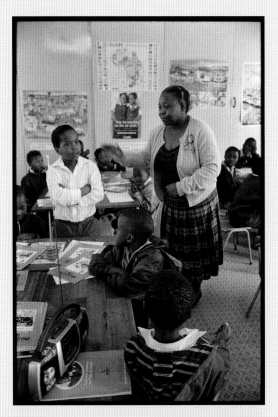

with the English in Action broadcasts. The English in Action programmes are highly interactive, every lesson requiring active learner participation and numerous opportunities for peer learning and mentoring. Lessons are also designed to ensure children associate learning with fun, hence incorporation of music, songs, dance, games, chain exercises, and other teacher-led activities.

A major strand of the OLSET Teacher Development programme, is the demystification of the new (Outcomes Based Education) curriculum, modeling innovative approaches for teachers, making for less stressful, more effective teaching practices. Successive studies and evaluations over a decade show that primary school learners are quick to master required skills and understanding.

English in Action, by all accounts, levels the playing field by delivering a uniformly high standard of learning to children such as those in the challenged Bathabile Primary School as indeed to those in all parts of the country, especially where there is a dearth of qualified or well-trained teachers.

OLSET has been able to support the national education transformation programme through the generous funding and assistance of international and local donor agencies. In this regard, special mention and thanks are due to the British Department for International Development (DfID), the Royal Norwegian Embassy, Royal Netherlands Embassy

and USAID, all of whom have made possible the inception and development of the OLSET Radio Learning Programme, in their respective commitment to a better education for all children.

Bathabile Primary School in Brits was founded in 1968 with 100 learners and 10 educators. Now it has 328 learners, 6 permanent and 2 temporary educators, and 2 volunteers. It takes in pupils from nearby areas and receives a government grant of R10 000 a year.

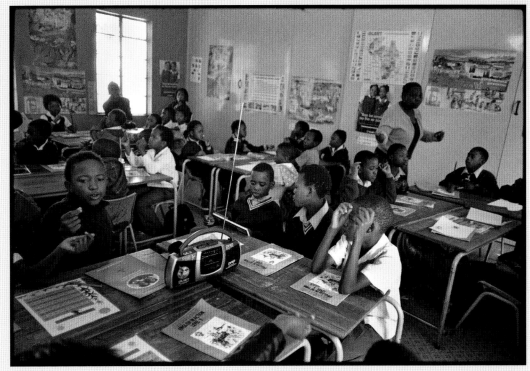

Mangete deadlock.

We were not prepared for the state of affairs on the Mangete sugar-cane farms in KwaZulu-Natal. It was a shock to discover how disputes over land could turn into life-and-death struggles, characterised by racial tension, arson and sabotage, and a vicious cycle involving government ministers, the Zulu royal family, squatters and farm labourers. In short, this was our encounter with the Mangete land owners.

In the 1830s, when the legendary Zulu nation was in decline and King Cetshwayo was battling to keep his tribal subjects united, Zululand (later to be named Natal) was flooded by Europeans – hunters, explorers, farmers, *voortrekkers* and tradesmen.

Cetshwayo had befriended a young white man, John Dunn, who had grown up in the turbulence of Anglo-Zulu politics. Because of his diplomatic prowess, his access to guns and ammunition, and his deep understanding of Zulu culture, he was appointed by the king to advise him on relations with the British crown.

Because of his influence, Dunn eventually became an *induna*. He had 49 Zulu wives and produced about 150 children, who were classified as coloureds. Cetshwayo also "gave" Dunn a large swathe of fertile lands north of the Tugela, which included a sprinkling of Zulu villages, to rule over.

Dunn, who died in the late 1800s, bequeathed his land to his descendants. Yet, unknowingly,

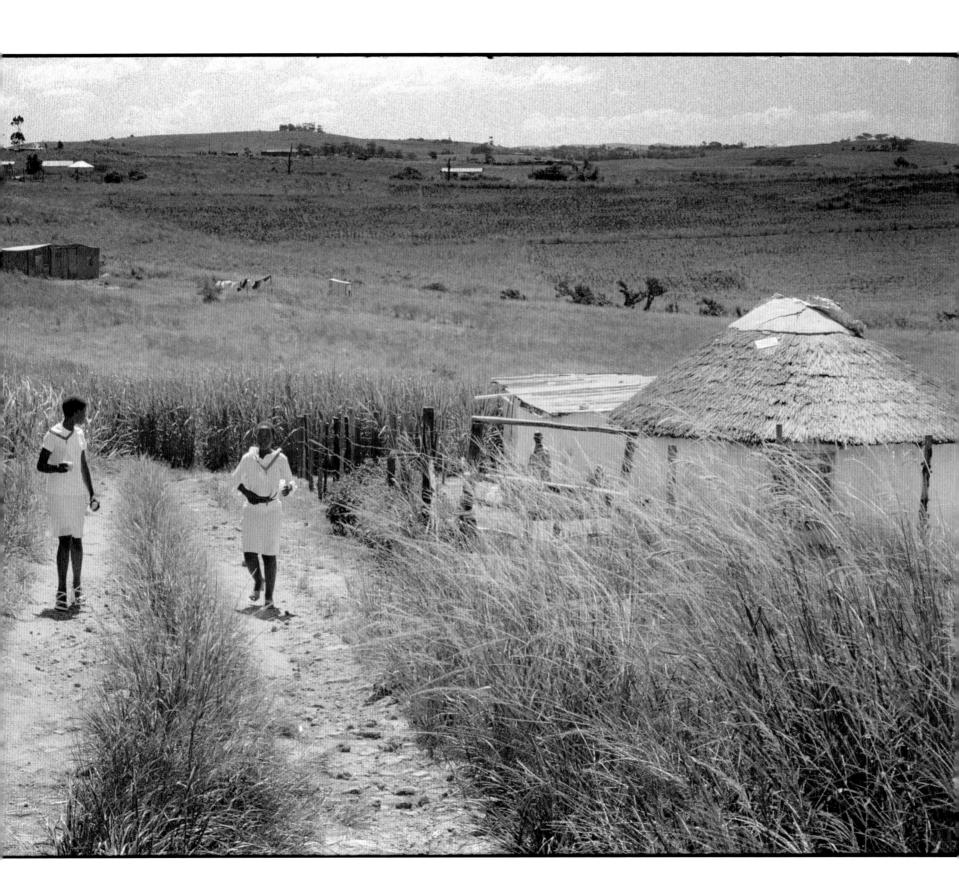

his legacy was bittersweet – to this day. Although, on one hand, it inspires a common, family consciousness, on the other, it has led to racial discrimination and bureaucratic inertia.

From about 1900 onwards, years after Kwa-Zulu-Natal was annexed by the British crown, many of Dunn's descendants joined the stream of migrants who left impoverished and over-populated reserves to work as wage labourers on the mines, railways and white-owned farms. A fortunate few earned a better living as artisans, transport riders, seamen and teachers.

Those Dunns who remained in Zululand fought a long and frustrating battle with successive governments for the right to live and work on their lands, unfettered by restrictive laws.

In 1902, the Zululand Lands Delimitation Commission, on the recommendation of the Natal government, was instructed to reserve 10 000 acres (4000 ha) for the use of the Dunn family. But their failure to get clear and inalienable title deeds to their land had serious repercussions.

After several impoverished decades, a viable sugar-cane industry was established on their land with the support of the South African Sugar Association and, by the early 1970s, the Dunn's long-standing appeals for the government to resolve the land issue was finally treated seriously and sympathetically. Their untiring labours were rewarded on October 10, 1979

when a moving ceremony was held at the Mangete Farmers' Hall to issue 10 of the 26 title deeds of grant.

After weeks of arranging a visit, we were finally granted time to speak to Pat Dunn, a doting grandmother who is now the leader of the Dunn community and chairman of the Mangete Landowners' Association.

Under sweltering, humid conditions, she took us on a field trip of the Dunn lands, including a scarred reserve where hundreds of families now live "illegally".

She later retracted everything she had told us and asked us not to publish anything, but we met her brothers, Gavin and Guy, who are among the 67 recognised Dunn residents on the disputed lands.

They say theirs is a battle against insecurity, threats and harassment to vacate land that "belongs to indigenous black people".

"What can we do? We have nowhere else to go and we have tried to build fences and secure ourselves."

But what is 'adequate' when it comes to farm security? Farmers all over live in constant fear of being attacked in their homes and fields, especially in our situation where we have so much illegal squatting on the land. We are hopeless and trapped on our own land," says Gavin.

Every year, he says, tons of ripe sugar cane are stolen, cattle are driven to graze on newly

planted cane and whole canefields are burnt – yet the police do not arrest anyone.

Three years ago, after new settlements were built without permission from the Mangete authorities and after an apparently heated meeting between Pat Dunn and local settlers, she and her husband, John Hunt, were attacked by four men. One of the assailants was jailed for 25 years for robbery and attempted murder, two co-accused were acquitted on the grounds of insufficient evidence and the other had escaped from custody early on in the investigation. It became clear from the community that the beating she suffered still causes her pain.

"One is constantly looking over one's shoulder and is never the same after an attack like this," Guy says. "There are many outstanding issues over the Mangete land claim and we do not see any real resolution taking place soon."

In recent months, Zulu King Goodwill Zwelithini; the former home affairs minister and Inkatha Freedom Party president, Mangosuthu Buthelezi; the provincial safety and security MEC, Nyanga Ngubane; the welfare MEC, Gideon Zulu; and the traditional leaders from around Mangete have got involved, but the issue remains unresolved.

The spokesman for the KwaZulu-Natal lands commission, Zweli Memela, acknowledged that there was a serious problem but said that the issue had to be dealt with in the proper context.

Gavin Dunn in his home on his mealie farm, which has been invaded by squatters claiming ownership.

According to the Land Restitution Act of 1994 and after investigations by the commission, research concluded that there were 199 households, of which 67 were the official Dunn households, and 132 who were descendants of the subjects of John Dunn from Cetshwayo's time.

The commission had to deal with the issue of seasonal farm labourers who did not have right of tenure, and not necessarily from the 132 households, but stayed on the land collectively owned by the Dunns and their historic neighbours by virtue of being relatives of people who were identified as legal settlers – and because they had nowhere else to go.

A third issue was land "hunger", and the commission had to balance claims by genuinely dispossessed people and hangers-on, who climbed on the band-wagon when meetings were held to discuss land redistribution in the province.

"As far as the Lands Claims Commission is concerned, the dispute over land at Mangete is solved. All we need is for the police, the sheriff's office and social welfare to arrange for the illegal settlers on the Dunn family land to be removed. We just do not know when that will be done because logistics have to be put in place," said Memela.

It is one of the saddest racial disputes on post-apartheid farmlands. There's no end in sight, the squatters remain, the fields get burnt and the attacks continue.

KENNETH CHIKANGA
Mangete
January 2005

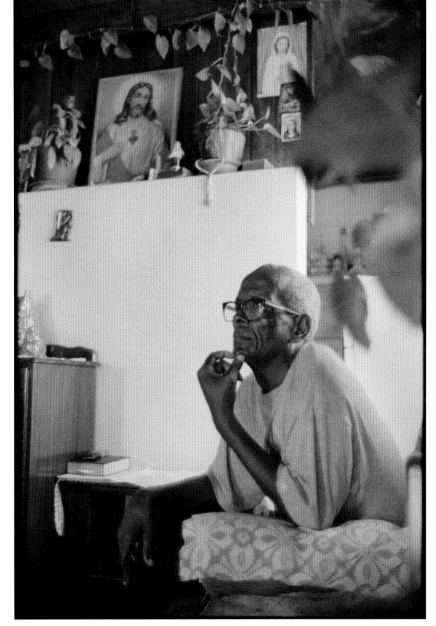

Poverty presents several faces. There is the face puckered by financial hardship – contorted and reconfigured, life's stress fractures – and the face reflecting not so much despair but a loss of hope.

This is the face of many women farm workers on the bountiful wine estates of the Western Cape.

Their poverty is reflected in their stooped shoulders and carbuncled hands. It is evident in the sub-human hovels many of them inhabit. But most of all, it is in their eyes, from which dreams of a better life departed long ago.

The landscape, simulated to resemble a little piece of Provence, presents a vignette of prosperity and privilege – an idyll of olive groves, vineyards, wheat fields and manicured mansions. The horrifying working and living conditions of the farm workers on some of the most esteemed estates are hidden like sores under the skin. Only when scratched, do they rupture.

We encountered workers who had been born on the farms, had worked the same land for 20 to 40 years, 12 hours a day, six days a week. We met women who had nursed the farm bosses, women who are paid no more than R40 a day.

They are fortunate enough to be classified as full-time labourers. Casual or piece workers are often paid a mere R1,50 a crate of grapes. It takes an able-bodied labourer at least 45 minutes to fill a crate. It doesn't take an economics professor to do the calculation and come up with the answer.

If these workers were living in inner-city slums, their homes would be condemned. Damp, dank and pest-infested, they are unfit for human habitation. Yet entire families are squashed into them. In some cases, 10 per cent of their wages are deducted for rent.

Protecting the rights of women farm workers is the prime focus of the Women on Farms Project.

And there they remain for generations, paralysed by a lack of education, dependent on the largesse of the *baas* for their shelter and survival, and the threat of eviction and unemployment is omnipresent.

Because of these fears, they endure the indignity of no water, electricity, refuse removal or adequate ablution facilities. The abuses still inflicted on farm workers, particularly women, such as assault, extortion and blackmail, seem to crawl from the most depraved corners of our iniquitous past rather than from a country hailed as a democratic role model worldwide.

Government officials are aware of these human-rights violations but, rather than ruffle the feathers of a lucrative export industry, some prefer to pretend they do not exist.

Of course, these conditions are neither endemic nor exclusive to South Africa's farming sector. In February 2005, *The Washington Post* exposed the horrifying abuses inflicted on farm workers in the prosperous state of Florida.

The Immokalee area, about 60 km inland from the Gulf of Mexico in southwest Florida, produces the largest supply of fresh tomatoes for the nation's supermarkets and for some of the biggest fast-food chains in the world. But the farm workers are still dirt poor. They still work long days, with no overtime, no benefits and no job security, seven days a week. They are crammed into hovels or derelict trailers. Since 2001, the Coalition of Immokalee Workers has launched boycott campaigns against products derived from the Immokalee area, and have conducted undercover investigations, which recently resulted in the conviction of three Florida-based farm bosses of slavery.

Reporter Evelyn Nieves, quoting Lucas Benitez, a farm activist and the coalition founder, described the conditions endured by the Immokalee farm workers as "the shame of this country".

In recent years, South Africa has succeeded admirably in transcending its legacy of shame. Significant strides towards improving conditions on farms have been achieved predominantly by labour legislation and intrepid initiatives on the part of NGOs. But, while South Africa's infamous *dop* system – whereby wine farmers pay their workers with alcohol – has largely been eradicated, many farms still supply wine to workers on credit, perpetuating an ethos of abuse. So the legacy of the *dop* system lives on: dissipated family relationships, domestic abuse, chronic health problems, HIV-Aids and foetal alcohol syndrome, not to mention other congenital abnormalities.

But this is not just a document of poverty. It is also a journal of empowerment, of farms that serve as models of equitable employment, where workers begin their gruelling day with a sense of hope and pride. There are many farmers who treat those who work their land as valued stakeholders in an industry largely dependent on cheap and plentiful labour for its survival.

The wine estates of Bouwland and Beyerskloof – to mention but two – have pioneered shareholding initiatives aimed at providing workers with a tangible stake in the industry. The slogan of the Fair Valley wine label, "the hands that work the soil feed the soul", encapsulates the spirit of worker-owned and driven initiatives.

Women's empowerment, in particular, has been bolstered by initiatives such as that at Old Vines Cellars, South Africa's only women-owned and controlled empowerment winery.

Old Vines has created jobs for women from historically disadvantaged backgrounds, with the 24-strong team made up (with one exception) of women doing everything from picking to winemaking, bottling and labelling.

Furthermore, NGO initiatives, such as the Women on Farms Project (WFP), have made extraordinary strides in instilling a culture of human rights among workers and employers alike. Based in Stellenbosch, the WFP works with women farm labourers in the Overberg, Boland and Witzenberg regions and is active in the wine and deciduous fruit industries.

It aims to improve their living and working conditions, and to achieve gender equality in the workplace, the home and the farming community, which is in accordance with the government's land-reform programme. This is based on the belief that agrarian reform is critical for job creation, poverty eradication and economic growth in the farming areas.

Since the WFP's inception in 1992, considerable progress has been made, but it still lags behind the daily hardship endured by most farm labourers. The global changes in agrobusiness contribute to the ever-increasing vulnerability of farm workers, particularly women. They are still the most marginalised, exploited group of the labour force, and the harvest they reap remains bitter.

HAZEL FRIEDMAN
Stellenbosch
April 2005

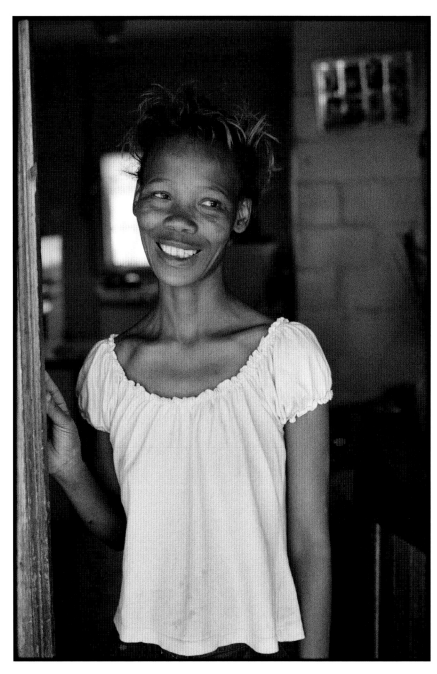

Elsie Jumat. "It's been six months now and I am feeling very well," says Elsie Jumat, beaming proudly. She's referring to the last time she had alcohol.

A worker on Beyerskloof farm for the past four years, the 35-year-old wife and mother of two daughters has much to smile about. She is one of the 60 beneficiaries of an empowerment initiative. They are members of 39 families who form the Bouwland Empowerment Trust and own 74 per cent of the shares in the Bouwland Estate.

"Many of the trustees are workers who literally grew up on prime wine farms and are specialists in vineyard cultivation. They are now are an integral part of creating superior vineyards, wine and a future for their children as co-owners of a wine enterprise," says Beyers Truters, who is co-owner of Beyerskloof and the former renowned cellar master of the Kanonkop Estate. "Besides being co-owners of an established 56 ha vineyard in a prime wine region, the trustees will also benefit from the fact that Bouwland is a well-established brand in Holland, Belgium, England and Denmark."

For Elsie, though, the spin-offs are much more about social empowerment than brand power. Fluent in Xhosa, English, Afrikaans and Zulu, she was one of the keynote speakers at the launch of the most recent publication of the Women on Farms Project. She is the embodiment of the empowered woman farm worker.

But she could so easily have succumbed to the drudgery of many of her predecessors and peers. At the age of 17 she ran away from her rural home in the Boland to KwaZulu-Natal, where she married a policeman. "I wanted to escape from the limits imposed on me by a strict upbringing," she recalls.

But, despite acquiring a diploma in child care, Elsie felt more trapped than ever. He husband developed a drinking problem and became abusive towards her and her child. She returned to the Western Cape, met and married a senior farm worker on Beyerskloof and, she says, life now couldn't be better.

"I want to set an example. That's why I decided to stop drinking. The future of the younger generation is at stake."

Two success stories of women farmworkers.

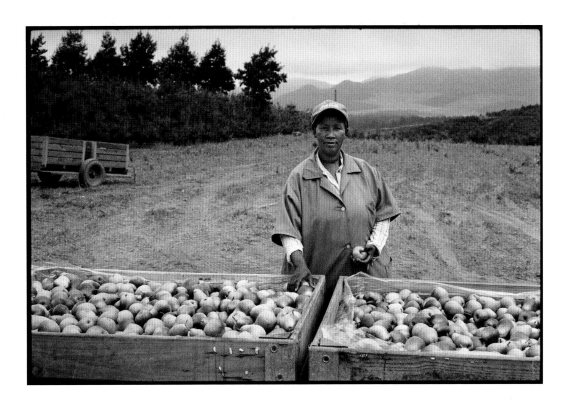

Aletta Plaatjes. It is not just an apple a day that keeps the doctor away from Oak Valley Farm. It is the workers themselves who keep all sorts of abuses at bay, including alcoholism and exploitation.

The apple-and-pear farm in Elgin has become a model of worker empowerment, and hoisting the flag for women-workers' rights is Aletta Plaatjes.

The 41-year-old farm labourer, the first female supervisor on the farm, has become a force to be reckoned with. Her portfolio includes lobbying for a pension fund for women, securing decent housing and working conditions, and educating them on human rights.

What makes her achievements all the more exemplary is the fact that her education extends no further than grade five. She started working at Oak Valley in 1985. Her daily wage was R29. Today she earns R420 a week.

She and her husband, who is a tractor driver on the farm, have committed themselves to providing the best possible education and opportunities for their two children.

"When I was a youngster," she recalls, "I thought I just had to accept my lot in life.

Now I realise that one also has to fight for a better life, and that is what I'm trying to teach my children and the workers."

Aletta attributes the farm's empowerment ethos to the Women on Farms Project. Five years ago the organisation began educating workers at Oak Valley on health, safety and labour rights. It has borne tangible fruits.

Today the 100 farm workers receive a decent minimum wage with overtime.

Stringent health and safety regulations are in place. Alcohol abuse has diminished markedly because the workers themselves have banned shebeens on the farm.

"When you treat people with respect and show them that their labour is valued, they don't feel the need to escape through alcohol," says Aletta. "Now we get drunk on life and all those good things."

HAZEL FRIEDMAN
Elgin
March 2005

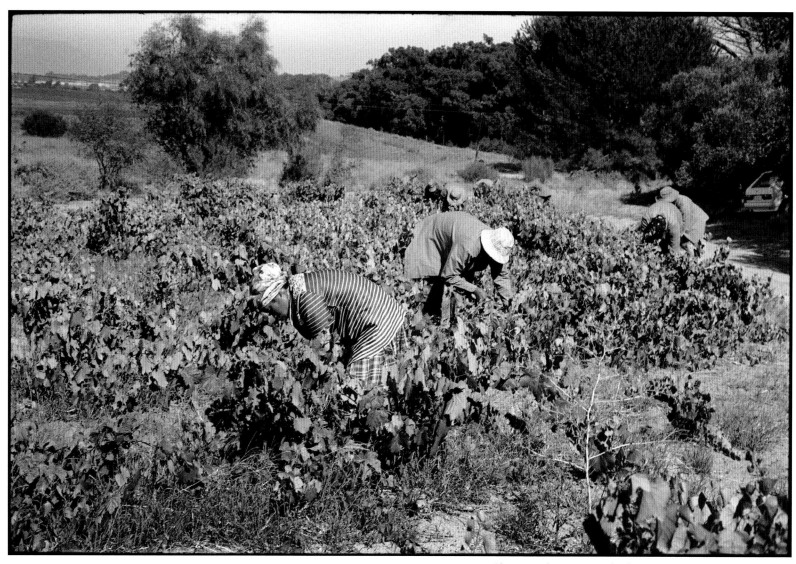

Cleaning the vines in the hot sun is back-breaking work.

Bouwland Farm, a vineyard near Stellenbosch, where the farm workers have to walk long distances in the blazing summer sun to find a shady spot for lunch.

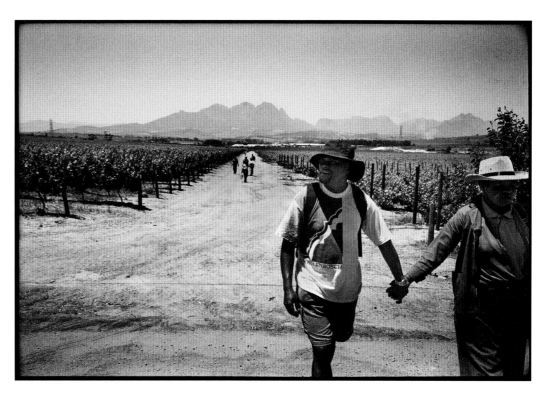

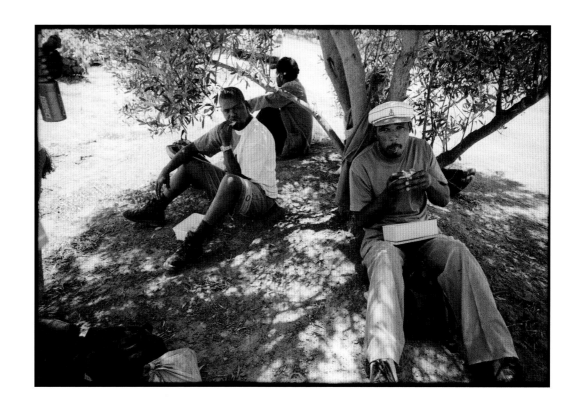

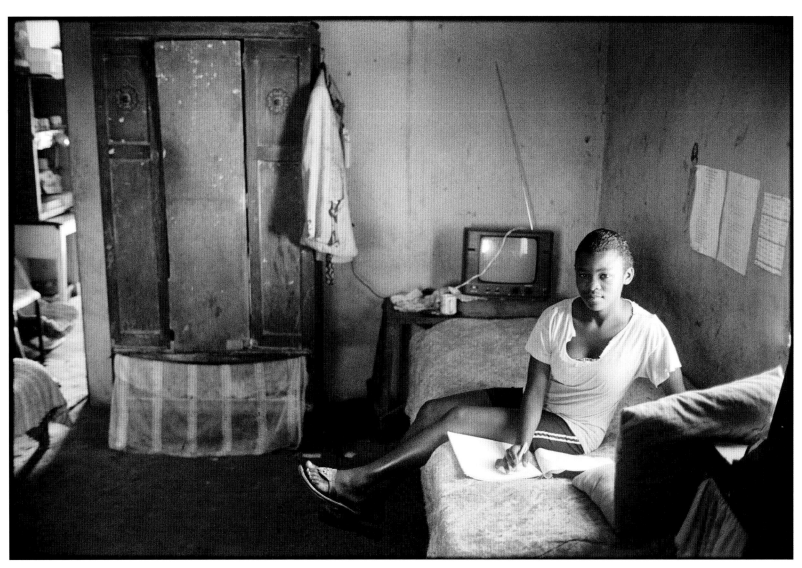

Daughters of farm workers: Revona Prins, above, is in grade eight, and Zilene Cupido, right, is in grade nine. Both are 15 years old and attend the local school near Stellenbosch.

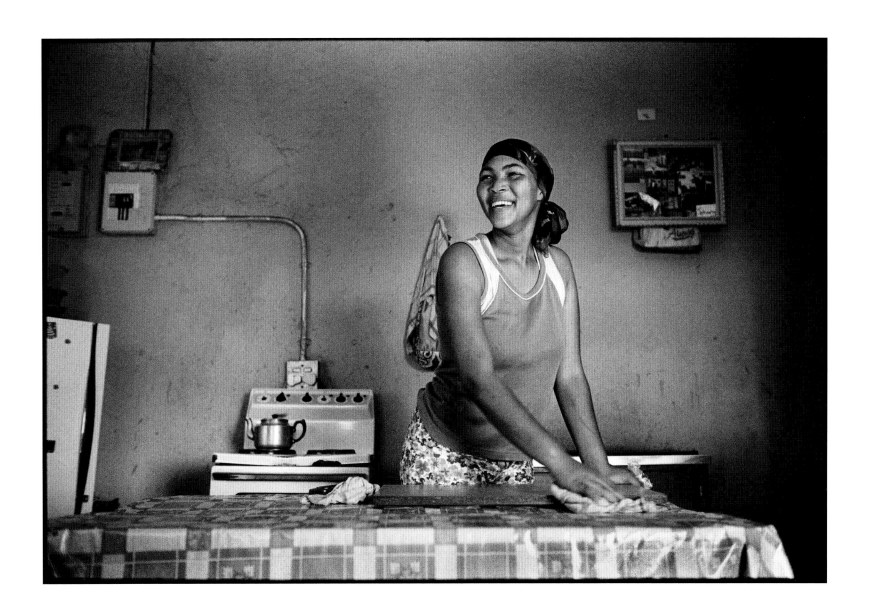

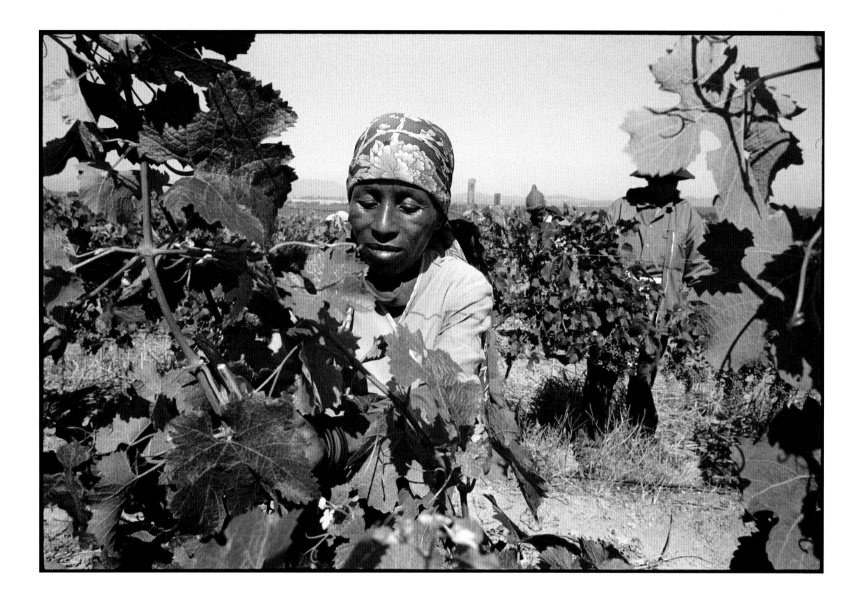

Elsie Arrison, 40, has worked for five years on the farm and earns R350 a week, working a five-day week, from 7 a.m. to 6 p.m.

Elsie Arrison remembers what it was like to have dreams. She has just forgotten what they were. Much of her life is a bit of a blur.

Yesterday she thought she was 39. Today she might be 42, and tomorrow… forty-something or thereabouts? Memory and desire – both have been blunted by season merging into season.

She remembers that she was raised for farm labour. It is the only work she has ever known. The only life she will ever have.

There's also the *dop* – a lifelong buddy, confidant, adversary, accomplice. On weekends, she sits with her friend and co-worker, Yvonne Prins, and they drink like two middle-aged matrons taking tea.

Elsie's husband, Simon Soekaatjie, sometimes joins them in their weekend ritual. It removes the burn from the heat, the bite of the cold and softens all sorts of sharp edges…

The farm on which they work, Bouwland, is the site of a pioneering initiative – the largest black economic empowerment project in the Cape wine industry. Beyers Truter, the owner of the Beyerskloof wine estate, and his partner, Simon Halliday, sold 74 per cent of their shares in the Bouwland farm to the Bouwland Empowerment Trust. Sixty farm

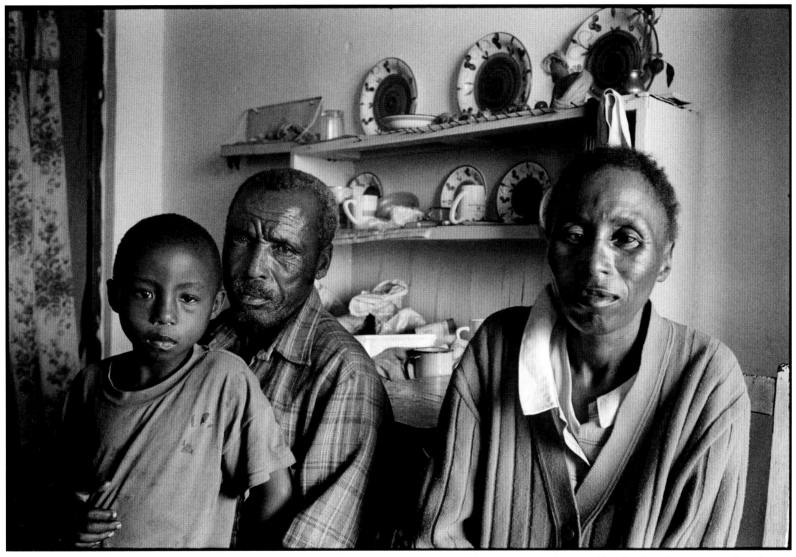

Elsie with her son Samuel, 6, and her husband, Simon, in their home.

workers from Beyerskloof, Bouwland and Kanonkop now own shares in the 56 ha farm and its trademark.

Worth about R10 million, this project was partly funded by the government's land-reform programme for agricultural development, which contributed R3,7 million in cash to the trust. Truter invested R2,4 million in the project and a loan was obtained for the balance of R3,5 million. The project's objective is to create agricultural and economic empowerment for a community that has been

part of the Cape's wine culture since the first vineyard was planted by Jan van Riebeeck in 1659.

But Elsie has yet to reap its fruits. She has been a permanent worker on Bouwland for the past five years and earns R350 a week. It is certainly much more than many of her counterparts, but it is hardly sufficient for medical bills and other basic expenses.

From 7 a.m. to 6 p.m., five days a week, she works, trimming, cleaning and picking – a repetitive ritual. Her home on Bouwland farm

has a sagging, soot-stained ceiling that hangs over an uneven, insect-riddled, concrete floor. A half-hearted display of domestic bric-a-brac does little to brighten the misshapen walls.

Future generations of farm workers will benefit from the trust. Elsie's son, Samuel, will be one. The six-year-old has a spring in his step, unlike the winter in his mother's eyes.

HAZEL FRIEDMAN
Stellenbosch
March 2005

133

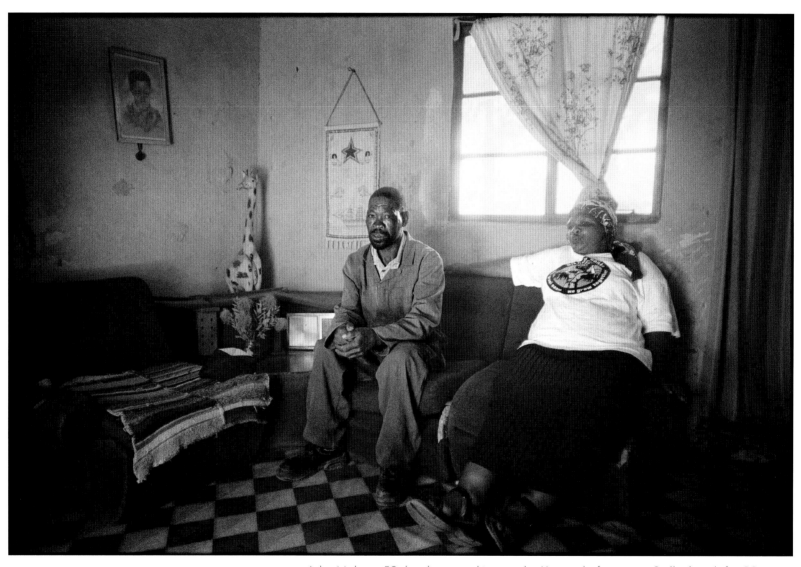

John Malgas, 53, has been working on the Kaapzicht farm near Stellenbosch for 33 years. He works from 7 a.m. to 7 p.m. and earns R220,50 a week.

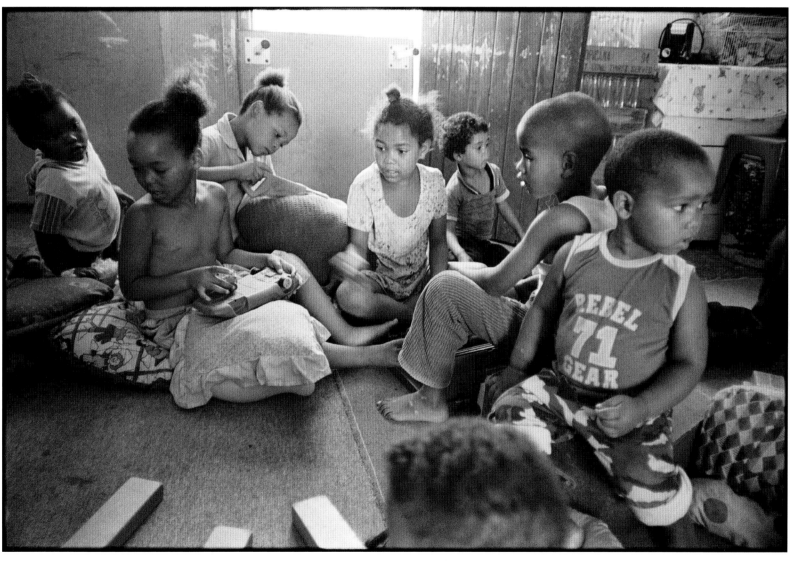

The crèche at the Kaapzicht farm. The 10 children who attend the crèche go home for lunch.
Their teacher, Shiree Solomons, is paid R18 a day by the farmer and the children's parents each pay her R15 a week.

Cheryl Heyns, 22, is a seasonal worker. She worked for 8 months in 2004 and earned R250 a week.
There are 120 seasonal workers who work from 7 a.m. to 5.30 p.m. on Rustenburg Farm.

Charlotte Constable, 40, is a housewife and is married to a farm worker. She has three children, two of whom work on the farm. She has lived on the farm for 14 years. And she is very happy.

Nimrod Blukwana, 35, is a winemaking assistant who has worked on the farm for 15 years. He is married with two children and earns R3 000 a month plus a housing allowance.

The opulent estate of Domaine des Anges attempts to do exactly what its name suggests: provide a piece of northerly heaven on southern soil. Inspired by feudal architecture, the estate meanders through lilac and green vineyards, bordered with olive trees, and lemon and orange orchards. The scent of lavender is ubiquitous.

In an area with a historic association that goes back to the 1680s and the arrival of the French Huguenots, Domaine des Anges consisted, once upon a time, of a single manor house and packing shed.

The rambling estate, bought by Liz and Phil Biden and two partners, has now been transformed into La Residence – a grape-picking paradise, targeting tourists in search of an authentic, soft, South African experience.

Today La Residence evokes the atmosphere of a superbly-run country house in rural France.

Tourists can help in grape-picking during the harvesting season, followed by a bountiful lunch. Although its wine output is limited, the estate has produced a cabernet sauvignon, marketed as "Domaine des Anges 2003 –

where heaven and earth embrace in the heart of the Franschhoek Valley".

And lest the more impolite bits of the Franschhoek Valley should intrude, such as rising crime, courtesy of rural poverty, a medieval-style wall insulates La Residence. It simulates the barricades that protected feudal settlements from invading armies and sullen serfs. It is the perfect structure for maintaining an earthly haven for heaven's chosen few.

Opulence rests side by side with bitter poverty in Franschhoek.

"Ek sal binnekort sterf. Ek weet dit, en daar's niks wat ek daaroor kan doen nie." ("I am going to die soon. I know this, and there's nothing I can do about it.)

Rachel Paulse puts her arms around me and sobs, heaving racking sounds that seem to emanate from a much bigger source than her bird-like frame. She has just returned from a nearby clinic where she was told she had had a stroke. She was given tablets but she does not know if they are for the stroke or for her sky-high blood pressure. She is completely numb down her left side, her speech is slurred, one of her hands shakes uncontrollably and she wobbles when she walks.

But no work, no pay, and possibly no place to stay.

Rachel has lived and worked on the La Provence wine estate with her family for the past five years. She works a 12-hour day for which she earns R120 a week. Her dependents sometimes perform casual work on the estate. The five-member family shares a one-roomed hovel. The broken ceiling, the stained walls and the precarious, crater-riddled floor are inhabited by an assortment of insects and rodents. In summer, the house is a furnace; in winter, a frost trap.

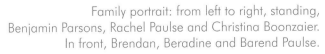

Family portrait: from left to right, standing, Benjamin Parsons, Rachel Paulse and Christina Boonzaier. In front, Brendan, Beradine and Barend Paulse.

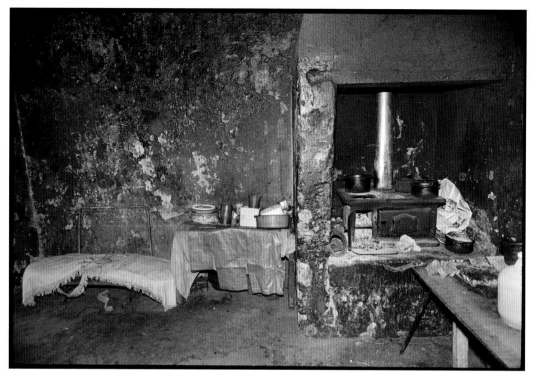

Portrait of poverty: Benjamin Parsons and Rachel Paulse in their home at La Provence wine farm, Franschhoek.

There is a single water tap outside for them and their neighbours. There is no electricity and no ablution facilities, either in the house or at the vineyards.

La Provence is one of the oldest wine estates in the Franschhoek Valley. It is one of 10 farms allocated to the French Huguenots shortly after their arrival in 1688. It was bought in 1990 by Count Riccardo Agusta, the Italian billionaire who was convicted of bribing the New National Party in 2002 in order to accelerate provincial approval for his R500-million Roodefontein golf estate at Plettenberg Bay. In 1997 Augusta added the adjoining award-winning vineyards and winery of Haute Provence to his opulent estate.

He also extended the winery to double production, built a restaurant and renovated the guesthouse on La Provence. He renamed the integrated properties Grande Provence to distinguish them from farms in the valley with similar names.

Today, La Provence is widely regarded as one of Franschhoek's premier estates, the bucolic town's poster-girl of taste, productivity and privilege. But the worldwide successes of some of Franschhoek's 21 wine farms have been cultivated on the backs of workers like Rachel and her family.

Although workers are protected by labour legislation, some wine farms in the Western Cape are models of non-compliance.

This is partly due to the fact that the enforcement of the laws is hopelessly inadequate. There are about 800 labour inspectors countrywide, but there are more than 70 000

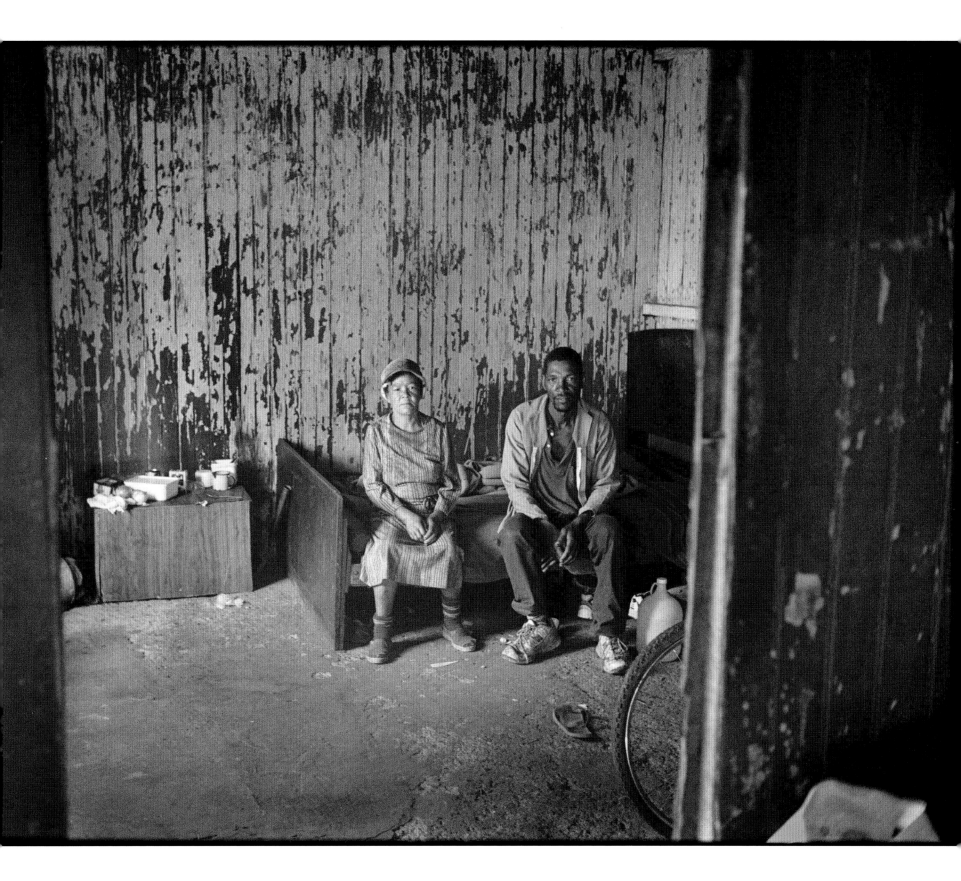

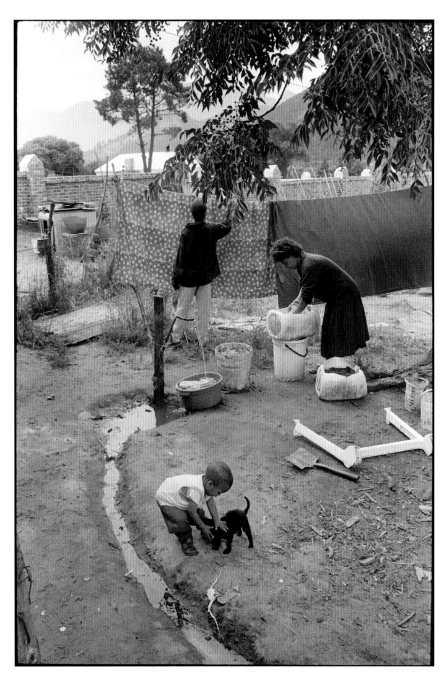

Outside Rachel Paulse's home.

farms alone. There is a total of about 300 farms in the areas of Stellenbosch (including Helderburg), Paarl and Franschhoek.

On these, like those elsewhere, labour reform tends to be regulated not by the law but by the landowners' largesse. Human-rights violations include low wages, long hours, dangerous, unhygienic working conditions, deplorable housing, child labour, and the continuing surreptitious use of the tot system, whereby workers are given alcohol as a part of their wages.

"Many of the chronic health problems experienced by these farm workers are alcohol-related," says a doctor who regularly treats workers from Franschhoek. "But alcohol abuse, although rife, appears to be more a symptom than a cause. Shockingly unhygienic working and living conditions and a lack of protection against pesticides and other agricultural toxins are the chief culprits.

"In the case of Rachel, years of systemic abuse and exploitation have taken their toll. My heart goes out to her, but whatever help she gets will probably be too little, too late."

HAZEL FRIEDMAN
Franschhoek
March 2005

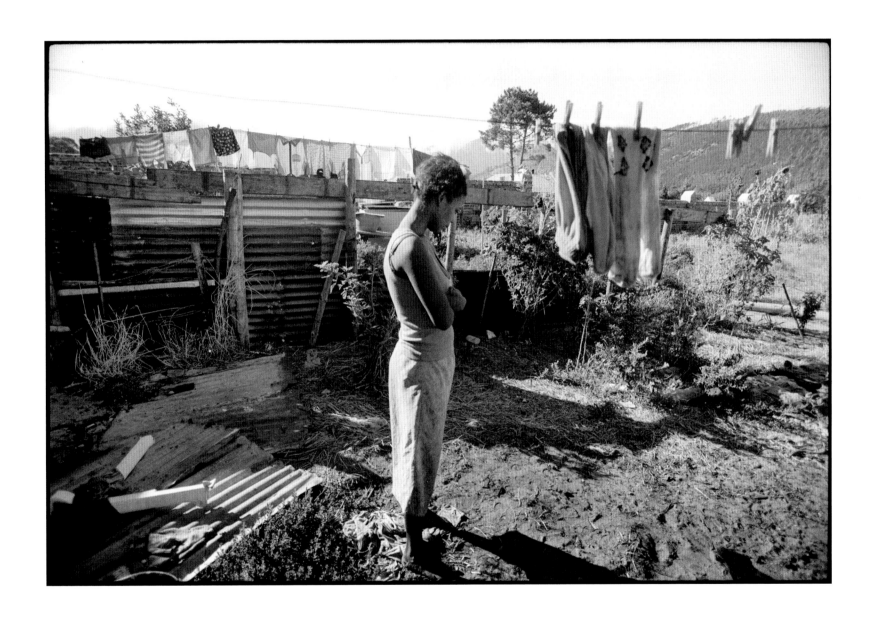

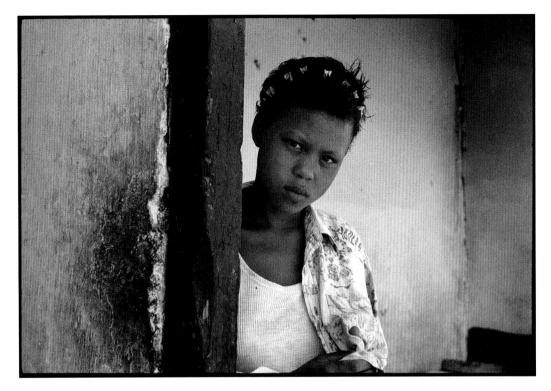

Where future education is hampered by poverty.

Francis Davis, with her gamine beauty, catwalk grace and gentle demeanour, seems out of place in her gnarled environment.

The 14-year-old lives with her parents, both farm workers in one of the worker cottages framing the La Provence wine estate.

Shy, but articulate, she exudes both timidity and remarkable self-containment. One senses an inner, secret, little-girl's world that differs markedly from the one in which she lives. She averts her gaze at the mention of boyfriends, movies, fashion and teenage fantasies. Her response is more guarded than coy.

But when she talks about her career ambitions, she becomes animated, exuberant even. She wants to be a policeman – to protect her parents, her friends, the community. Farm work, nah! She has bigger plans…

A grade seven pupil, she has not attended school since the end of 2004. During her last term, her mother took her out of school to visit relatives in Paarl. Her teachers didn't want her to go, but her mother said she needed her.

The annual school fees of R350 are also straining her parents' paltry pockets.

She misses school terribly. Her favourite subjects include Afrikaans, English and History. According to the Women on Farms Project, both the education and social welfare departments have been contacted about Francis's situation.

Apparently there's not much that can be done. But if she does not return to school, she faces a future much like that of her parents.

Without proper education, hers will be a future of unrelenting labour – as wife, mother and, principally, farm worker.

Her mother doesn't like Francis talking to me, especially in English. She hovers throughout the cursory interview conducted in Francis's "bedroom" – a corner of a bleak room, cordoned off by a flimsy curtain. "*Wat het jy oor my vertel?*" ("What did you tell them about me?") is the frequent demand of her mother, to which Francis replies, tremulously: "*Niks, mammie, niks.*" ("Nothing, ma, nothing").

As we leave, Mrs Davis yells. "*Fok julle almal. Moenie my kind wegvat van my nie. Sy's myne. Sy's al wat ek het.*" ("Fuck all of you. Don't take my child away from me. She's mine. She's all that I have.")

HAZEL FRIEDMAN
Franschhoek
March 2005

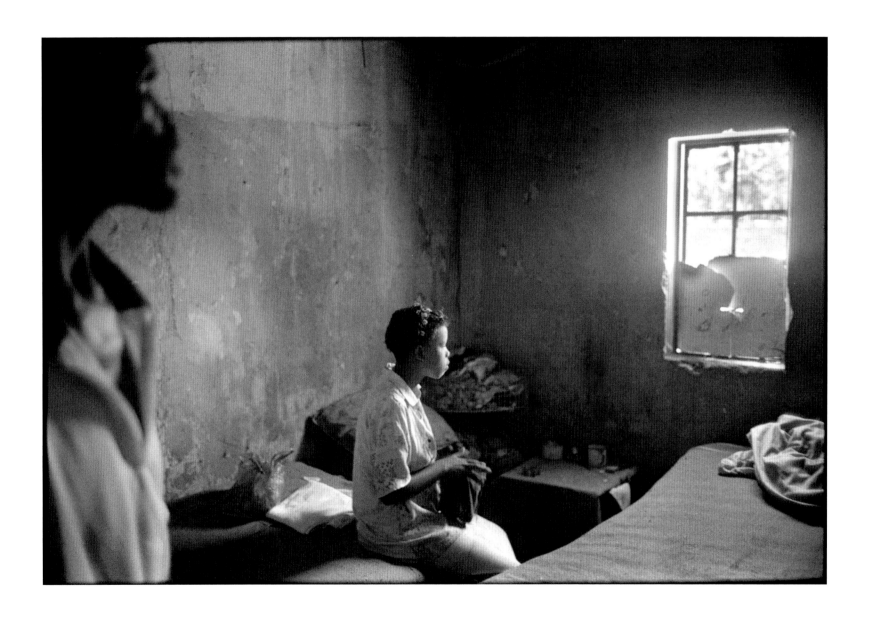

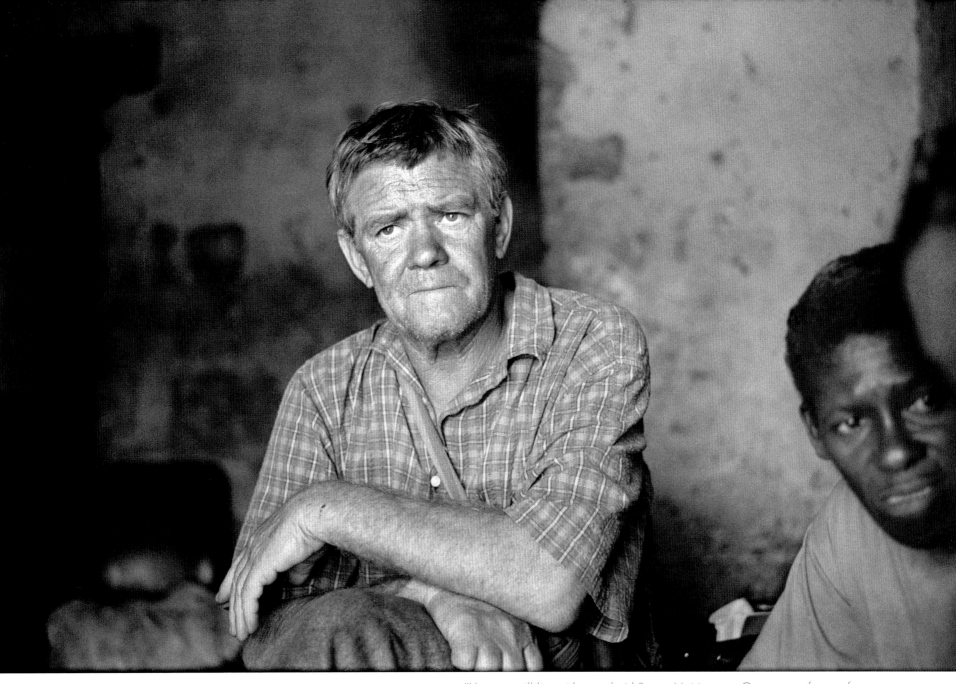

"Here we still live with apartheid," says Meiring van Greunen, a former foreman on La Provence, where he fought for workers' rights.

Ikapa elihlumayo is the Xhosa word for "the growing Cape". It is also the catchphrase for the government's programmes to redress the injustices of the past and eliminate poverty in the region.

But for Meiring van Greunen the term is fraught with irony. For 20 years he worked as a foreman on La Provence, fighting for workers' rights. Today he can see how much has changed. And how little.

His efforts to persuade his bosses to implement changes resulted in him getting the boot, he says. These days, despite his extensive farming experience he can't even get contract work. He believes his pariah status might also have something to do with the fact that, as a white Afrikaner, he is reviled by several farm owners for forming friendships with the predominantly coloured workers in the area.

"Here we still live with apartheid," he says,

> "The Freedom Charter says that the land belongs to those who work it – but that means nothing for these workers," says Meiring van Greunen.

citing numerous incidents of intimidation and abuse perpetrated by farm managers on labourers in Franschhoek and the surrounding areas. "*Op die plaas, die wit baas is nog soos God,*" he says. (On the farm, the white boss is still like God.)

As he talks Johanna Davis nods vigorously. Twenty-five years spent working on the nearby Akkerdal farm have yielded her no more than R180 per week. "And old Tommy here," Meiring says, beckoning to a grizzled, elderly man, "he worked on this farm for 40 years. At the age of 65, he's now entitled to a pension, but he's been waiting five- and-a-half months for his money."

Then there's Dina Felix. Born in 1952, she has spent most of her life working for La Provence. She says she helped raise the daughters of the previous farm owner. Today she earns R200 a week, which translates into R40 a day. Of that amount 10 per cent is deducted for rent of a hovel that has neither electricity nor ablution facilities.

Farm workers receive the lowest wages of any sector in the country. A proposed minimum wage of R2 000 has been strenuously opposed by farm owner organisations in the region. Wages on their farms vary from as little as R60 a month to R800 a month.

And although the notorious tot, or *dop*, system rarely appears in its crudest form, where workers are given alcohol to drink during the day, it is still used as an "incentive". Meiring mentions the farm café where workers can buy wine by the bottle and the cost is deducted from their wages.

"The Freedom Charter says that the land belongs to those who work it. But that means nothing for these workers. The only words which have any truth to them at all are '*bitter swaar*' [bitterly heavy] because that is the only way to describe their lives."

HAZEL FRIEDMAN
Franschhoek
April 2005

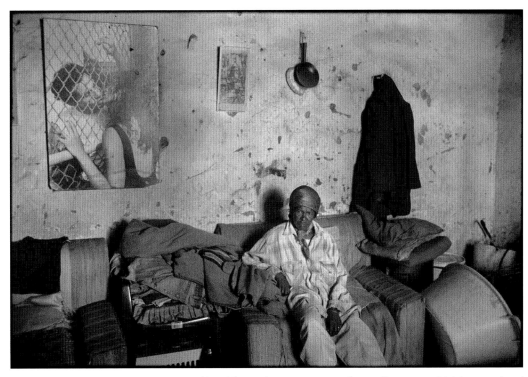

Dina Felix, 53, has spent most of her life working on a wine farm. She earns R200 a week, of which 10 per cent is deducted for rent for a house with no electricity or ablution facilities.

Evelyn Ockers, 48, former farm worker with a harrowing past, is now an active Women on Farms Project representative, educating rural women workers about their rights.

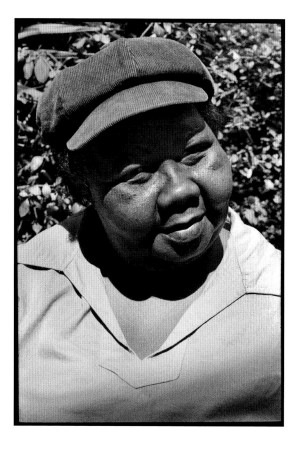

Evelyn Ockers, for much of her life, has had an intimate relationship with hardship. Her most vivid recollection of a childhood Christmas was the one when her father returned home blind drunk and attacked her mother with a pickaxe.

Childhood was an era that seemed to have passed her by altogether.

Evelyn, 48, was forced to leave school in grade three, and was already working by the age of 11. She fell pregnant at 14. Her child died 10 months later. Married since 1977, she has also been abused by her husband. She doesn't remember a time when she didn't work.

Yet her story is not one of victimhood. It is an inspiring tale of courage and compassion in the face of often-indomitable odds.

"*My ma, nou sy het verskriklik swaar gekry*" [My mother, she had an exceptionally difficult life]. But she taught us right from wrong. She also taught me to read because she was an avid reader herself."

It was Evelyn's obvious intelligence and charisma that attracted the attention of the Women on Farms Project (WFP). Stricken with asthma after long-term exposure to vineyard pesticides and unable to work full-time, Evelyn was approached by the WFP to assist in setting up a farm workers' trade union. That was in 1996.

Today the movement, Sikhula Sonke, has made enormous strides in educating women farm workers on their rights, challenging evictions, and promoting land and agrarian reform. She also works closely with social work-

ers to institute programmes to educate workers on the devastating consequences of alcohol abuse. With her intimate experience of alcohol-induced domestic violence, she offers an empathetic ear to wives, mothers and daughters who might otherwise be intimidated by "outsiders".

"Every day we deal with these problems, not to mention the general abuses inflicted on workers who have no protection from toxic pesticides, no ablution facilities, no [running] water…

"But the biggest challenges facing the WFP are evictions, unfair dismissals and intimidation."

This entails confronting recalcitrant farmers, intervening on behalf of frightened workers, empowering them and assisting them in

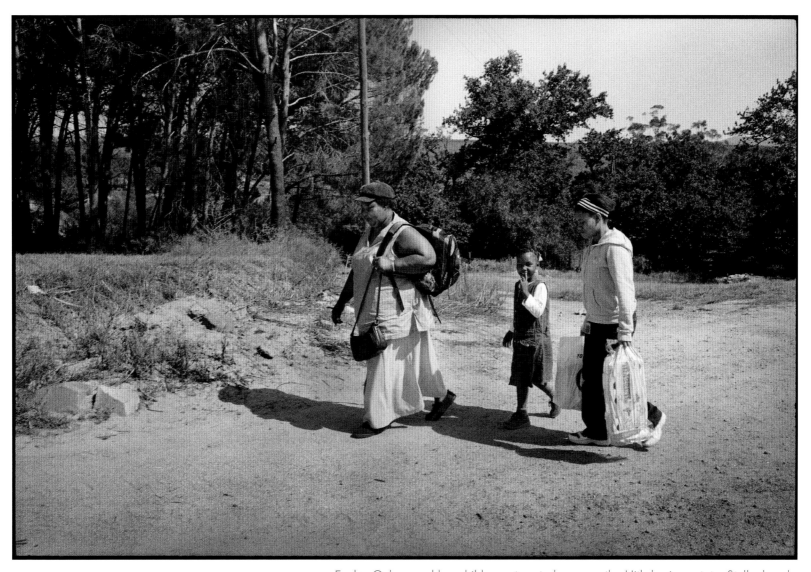

Evelyn Ockers and her children return to home on the Uitkyk wine estate, Stellenbosch, where she is very happy and treated well by the farmer.

bringing complaints before the Council for Conciliation, Mediation and Arbitration. She is perceived as a threat, not only by resentful farmers, but by some of her male counterparts.

"Sometimes the men feel their importance in labour and land issues is being undermined by the increasingly powerful voices of women activists," she says. "But the WFP is including men in their labour programmes because they also need to be educated about women's rights, and both gender voices need to be heard in unison."

Although she calls the WFP "her family", she is a mother not only to her own children but also to the four children of her recently deceased brother. Her asthma prevents her from working full-time on the farm, so she also works as a part-time charlady for university students and an events organiser for the WFP.

She stays on the Uitkyk wine estate just outside Stellenbosch where, she says, she is treated extremely well by the farm owner.

"I have learned that, just as one cannot stereotype women as passive victims, one cannot label all farm owners as cruel and reactionary. There are some wonderful white farmers who are committed to rural transformation, and we are working with them, side by side."

HAZEL FRIEDMAN
Stellenbosch
April 2005

149

Saturday afternoon at Joa's Valley shebeen, Stellenbosch, where farm workers take a break from their daily toil.

Chicco has this really fail-proof way of opening a pint. He puts the bottle-cap between his teeth and *ruks* (jerks) it loose.

No fuss. Not much mess, apart from the river of foam that sometimes seeps down his throat, mingled with the occasional spit 'n blood bubble – courtesy of the jagged edges of the bottle top.

For the Transkei-born son of casual labourers, Chicco (who didn't want his surname used), the shebeen is not only a place in which

to get totally, motherlessly *gesuip* (drunk). It's a place of solidarity. Here, crammed into a room the size of a single-car garage, eyeball-to-elbow, with a dysfunctional ghetto-blaster pumping in the corner, he can drink, dance and be merry.

He migrated from the Transkei to Stellenbosch eight years ago with his wife and three children. The pay for casual work is low but, earning R1 600 a month, he is on the more privileged side of the sliding scale.

"One has to get work at any price, even if the cost is one's dignity," says Chicco, a casual farm worker.

What makes him really happy is the fact that he is employed and racial divisions in much of the community rarely descend into outright hostility.

Chicco is one of about 50 casual workers living on the South African Forestry Corporation (SAFCOR) settlement in Jonkershoek in Stellenbosch.

For R50 a week, residents get a roof over their heads and access to a communal kitchen. Electricity is provided with a pre-paid card system. He lives here with coloured folk, most of them farm workers, and even welcomes the occasional "whitey" who ventures in for some cheap *dop* and light conversation.

His community is more the exception than the rule in a deeply divided countryside. The permanent farm labour force in the Western Cape is primarily coloured, with few black workers gaining entry to the "core". But, migrant black workers, both men and women, are establishing an increasingly strong profile on the Western Cape wine farms.

It makes good business sense for farmers to employ casual or seasonal labour.

It frees them of the burden of paying and providing housing for a full-time labour force.

It is also almost impossible for casual labourers to become adequately organised. They are largely ignored by the unions and the state alike and have to rely on their own resources, which means accepting the scraps meted out to them. And joining their ranks are an increasing number of former permanent workers.

During harvest time, farmers have to drive off the crowds clamouring for a day's work. As Chicco points out, one has to get work at any price, even if the cost is one's dignity.

HAZEL FRIEDMAN
Stellenbosch
March 2005

Chicco enjoys a drink at the crowded Jonkershoek shebeen, Stellenbosch.

Tommy Fortuin is the marketing manager of Fair Valley Wines, a wholly worker-owned label created by Fairview Estate owner Charles Back.

"Empowerment is not just giving people a piece of land and saying 'go make some wine', it's about growing and encouraging people to aspire towards a better life," says farmer Charles Back.

Tommy Fortuin, left, with Fairview Wine Estate owner Charles Back and his wife, Diane.

Tommy Fortuin can hardly contain his enthusiasm. Although he must have delivered his marketing speech on at least 20 occasions in the past month, each time sounds like the first.

He recently returned from a trip overseas where he hobnobbed with the movers and shakers of the multinational wine industry.

"They were so impressed with our sauvignon blanc and pinotage. We're definitely expanding our market," he says, holding up a banner with the logo of two stylised hands. The catchphrase: "The hands that work the soil feed the soul."

Fortuin is the marketing manager of Fair Valley wines, an entirely worker-owned brand. Fair Valley in Paarl is a 17 ha farm adjacent to the Fairview wine and cheese estate.

The owner of Fairview, Charles Back, has long been a champion of worker empowerment, long before it became a politically correct, black employment equity strategy. Fair Valley is his brainchild. It was established to provide labourers with security of tenure and it was funded by him and the government.

The Fair Valley Workers' Association, launched

Tommy Fortuin, proud home owner where farm workers have security of tenure.

in 1997 by 63 Fairview employees, has already suc-ceeded in completing several significant develop-ments on the farm. In March 2002, many of the families took possession of their own homes.

The sauvignon blanc and pinotage are already selling well in local and overseas supermarkets and the profits are being used to provide more dwel-lings and the construction of a wine cellar on the farm. Back assists the Fair Valley community in sourcing grapes, which are then processed in the Fairview cellar.

"But, ultimately, the Fair Valley community aims to become completely self-sufficient from the profits of our wines," says Fortuin.

Fortuin, who started as a farmworker, has be-come the global ambassador of the Fair Valley brand. Fair Valley's revenue is augmented by income derived from packing cheese at Fairview.

In addition, the cottages on Fairview are being converted to provide tourist accommodation. The rentals will also go to the property association.

Back, who is reluctant to accept any kudos for this initiative, sees his involvement as "my moral obligation as a South African who has benefited from a skewed system". He stresses that his role is strictly hands-off.

"Empowerment is not just giving people a piece of land and saying 'go make some wine'. It is about growing and encouraging people to aspire to a better life."

HAZEL FRIEDMAN
Paarl
April 2005

"Trophy hunting", "slaughter for sport" or "sustainable utilisation" are all phrases that are used for game hunting, a growing industry that has fierce, conservationist critics.

It's boom-time for South Africa's taxidermy trade. From Phalaborwa to Pretoria, to Port Elizabeth and beyond, the carcasses of game are being heaped up like the road-kill scraped off the highways during the holiday season.

The callous way the carcasses are discarded contrasts with the way the heads are treated – magnificent manes, horns and trunks are coiffed, powdered, polished and buffed like badges of honour, which is precisely what they are: badges or trophies for foreign tourists in search of an authentic safari experience.

Some call it "sustainable utilisation", others eschew the euphemism and describe it as "canned", "trophy" or "put and take" hunting. Others scathingly call it "slaughter for sport".

Whatever the appellation, trophy hunting is a booming business, particularly in South Africa, which is the source of 85 per cent of Africa's trophies.[1]

The government is actively promoting the development of game ranches to feed the voracious demands of trophy hunters, and many farmers are selling their cattle and buying game, such as giraffe, buffalo, lion, cheetah, hippos and rhinos, hoping to earn more money from hunting than farming.

In 2001, there were 5300 private game farms in South Africa, covering 11 million ha, or about 13 per cent of South Africa's private farmland. Since then the number of game farms is estimated at 9000. Since 2001, more than 8000

Game farms produce trophies for overseas markets. This often results in the eviction of local farm workers.

amateur and professional hunters have visited them. Up to 50 000 animals are hunted each year. This amounts to an annual revenue from daily rates, animals hunted and taxidermy work of US$80 million.[2]

The going rate in the United States for an impala is $350, and a zebra $700. Kudu top the $1 000 mark, while the price for killing a buffalo is about $10 000. Elephants and members of the feline family are strictly for blue-chip budgets.

Most game farms advertise a "no-kill, no-pay" policy. The average cost of a 10-day hunting safari is between $5 000 and $10 000. Photography safaris at private game farms, by contrast, cost about $500.[3]

Although permits are required, bounty tourists, mainly from Spain, South America, Britain and particularly the US, have been known to offer bribes to exceed the hunting quota, shoot the wrong species, age or gender, use illegal methods, or hunt without a permit.[4]

Trophies sometimes include elephant bulls that have escaped from the Kruger National Park, which are captured and sold to hunting safari operators. Kudu, waterbuck and eland males are sometimes taken to small properties where wealthy trophy hunters can kill them easily. Rhinos can be bought legally from many live game auctions. Large male lions can be bought from a hunting catalogue. Leopards are prized trophies because they are of the most

cunning and difficult predators to hunt. But if they are confined, a kill is guaranteed because the animals have no chance of escape.

Many of the animals are bought from zoos. They are sometimes killed in pens smaller than the cages in which they were raised. Some are shot while partially sedated; others are killed near feeding troughs and breeding pens.

Trophy size is determined by skull size. In order to avoid damaging the head, trophy hunters prefer body shots. This means death can be slow and agonising.[5]

Research has trashed conservationists' claims that trophy hunting is a form of ecotourism, that the only way that wildlife can survive is if it is given an economic value.

Profitable, it certainly is. But for whom, or what? South African tourism, landowners and farmers, labourers, the surrounding communities, the wildlife or the livestock?

A study by the University of Port Elizabeth, released in November 2004, estimated that hands-off ecotourism on private game reserves generated "more than 15 times the income of … overseas hunting".

According to Blythe Loutit, the founder of Save the Rhino Trust Fund in Namibia, "tourism is far better than hunting from the employment angle. Whereas hunting is quick income for one or two trackers and a skinner, three to five people in one family can earn permanent income

in tourism. There is also the probability of improved income as years go by."[6]

Even pro-hunters admit that economic and employment opportunities with hunting outfits are limited.

Canned hunting is condemned by the Safari Club International (SCI), which represents 45-million hunters worldwide, because it eliminates the principle of "fair chase".[7]

But there is more at issue than the principles of fair chase. The spread of diseases from game farms is a problem because wildlife carry bacteria and viruses that are lethal to domestic livestock, and research reveals that animals concentrated in a captive environment are more vulnerable to diseases than animals that live under more natural, wild conditions.

For example, African buffalo are the maintenance hosts of foot-and-mouth disease. Though it does not afflict the buffalo, it does afflict domestic animals such as cattle, pigs, sheep and goats.

Blue and black wildebeest carry bovine malignant catarrhal fever, which also infects cattle. Bovine afflicted animals are also highly susceptible to tuberculosis, which has been found in lions and African buffaloes in several game reserves in South Africa. The disease has also been diagnosed in cheetahs, baboons and kudus. All infected species develop the disease.[8]

Heidi Prescott, of the US Fund for Animals, in a recent letter to *The New York Times*, called for the canned hunting and farming industries to be shut down. She claimed that they present a threat to wildlife: "The killing of captive animals for trophies is a time bomb of disease that may destroy native wildlife populations."[9]

The environmental impact is not limited to the threat of disease. In the case of lion hunting, for example, those with the biggest manes are the prime targets. That often leads to the strongest and most dominant males being removed from the prides, leaving behind the weaker males, which impacts badly on the bloodline.

The government rejects these concerns,

arguing that it needs the money from sustainable utilisation. It has already accepted the introduction of hunting in several state parks, and there are increasing fears that it will soon be legalised in national parks as well.[10]

Changes in farming, especially the shift from livestock to game farming, has also resulted in the eviction of farm labourers. The South African Human Rights Commission has heard evidence from workers who, after living and working on a farm for more than 40 years, were summarily expelled after the farm changed hands and the new owner converted its operations to game farming.[11]

Evictions have been achieved with threats, violence and victimisation. Electricity and water supplies have been cut off, dwellings have been demolished and some workers have been forced to sign agreements that waived their legal rights.

Gareth Patterson, a world-renowned conservationist known as the "Lion Man of Africa", says that South Africa's hunting industry primarily benefits wealthy landowners, who are almost exclusively white – "the pale males", as he describes them.[12]

"As most of the profits are retained by the landowners, the hunting companies, their international agents and taxidermists, this so-called 'sport' heightens the concentration of wealth in the hands of the well-positioned few instead of the needy many."[13]

And championing the hunters is the Bush administration, which is clearly the sport's most powerful international ally. George Bush senior, during his presidency, proposed hunting rare antelope as part of a "kill them to save them" scheme. Some of that bounty has ended up on the walls of America's natural history museums because of schemes that have reaped rich profits for proponents of trophy hunting.[14]

The US also provides generous tax deductions for "taxidermist" donations – animal trophies dumped on non-profit organisations. As *Washington Post* journalist Marc Kaufman observes: this allows wealthy hunters to go on

big-game expeditions essentially at the taxpayers' expense – an arrangement so blatant that one animal trophy appraiser advertises his services under the headline, "Hunt for Free".

Nobody knows how many trophy mounts are donated yearly to non-profit collections, or how much tax revenue is being lost to the charitable deductions, he says.[15]

And finally, for surf 'n shoot enthusiasts, the US has devised a new internet slaughter-sport called live-action hunting.[16] By accessing an online website called Live-Shot.com, virtual hunters can control a camera and a firearm, and shoot at real targets in real time, via a computer.

Simply pay, point, fire and switch off. No fuss. No need worry about the mess left behind.

1. "Game ranch profitability in South Africa", Absa Economic Research, Game Management Africa, 2003 www.professionalhunters.co.za
2. PHASA (Professional Hunters' Association of South Africa), www.professionalhunters.co.za
3. Bernard Thompson, "Shooting Gallery", The Big Issue Magazine, www.wag.co.za
4. Ibid.
5. Wild About Killing 2, League Against Cruel Sports, April 2004, Www.bloodybusiness.com/trophy-hunting/Wild-aboutkilling-2.pdf
6. Ibid.
8. Onderstepoort Journal of Veterinary Research, www.arc.agri.za
9. Kas Hamman, Savvas Vrahimis and Hannes Blom, "Can current trends in the game industry be reconciled with nature conservation?", African Conservation Forums, December 2003.
10. Michele Pickover, "Entrepreneurs in death: killing as sport in South Africa", Xwe
11. "South Africa: report reveals dire conditions facing farm workers", World Socialist Website, October 2 2003
12. Gareth Patterson, "An alternative to sustained utilisation", www.garethpatterson.com/
13. Ibid.
14. "Big Game, Big Bucks: The alarming growth of the American trophy hunting industry", The Humane Society of the United States and Humane Society International, 1995
15. Mark Kaufmann, "Generous tax breaks for big-game hunters come under scrutiny", The Sunday Independent, April 10 2005
16. "Hunting by remote control draws fire from all quarters", Christian Science Monitor, April 5 2005

HAZEL FRIEDMAN
Cape Town
May 2005

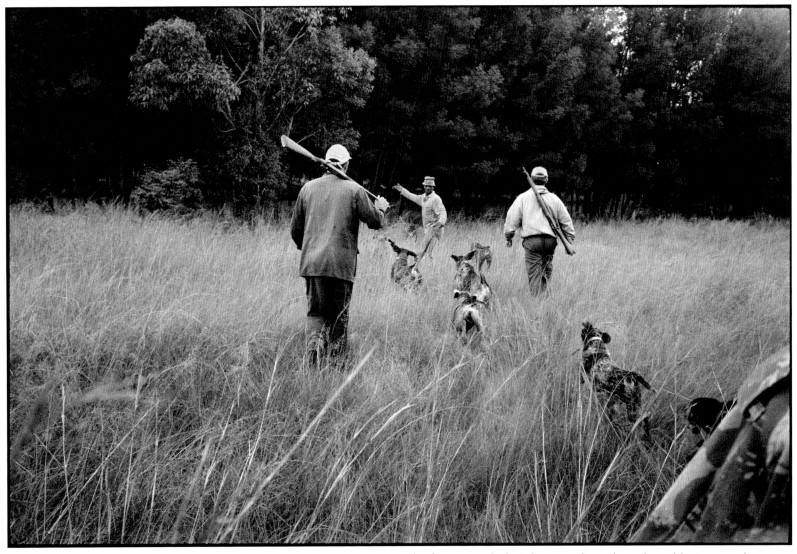

The farmers with their hunting dogs drive the wild pigs into the open.

Hairy and dark, the wild pig lay in the back of the bakkie, long-lashed eyes staring out across the mealie fields. Her tongue lolled out of her mouth, cartoonishly large and pink. The bullet had sliced open the flesh – a deep, clean gash along her one side.

A farmer took hold of a teat under her belly, squirting milk into the air. "This one had babies." The other men laughed.

Her rich blood flowed across the white paint, a thickly sweet and decaying smell.

There were no wild pigs here 15 years ago when farms near the lowveld town of Carolina were bordered by grassland. But then great stretches of pine were planted and many pigs have come from the east. They shelter in the cool, shady forests, and come out into the fields to eat.

They do a lot of damage. Maize farmer Nic Uys said he has lost R20 000 to R25 000 of his crop every year due to the pigs. "We've got a hell of a problem with them."

Farmers hunt wild pigs because, they say, they destroy their maize crops.

Last year he shot 193 on his 200 ha farm.

Roy Ferguson, a farmer from Vryheid, described how a pig would push over a tall stalk to get to the mealies, and then another, and another, until there was a bald patch that "looked like a Boeing has landed in it".

There's no mating season for the wild pigs; they breed according to the amount of food available. "If you don't hunt the pigs, they will devastate you. You'll have to give up farming maize."

Ferguson and 15 other farmers had got together to help Uys hunt the pigs on his land. They had all done each other this favour in the past – it is part of farm life, but also, they say, it is fun.

They gathered on a quiet road on a Saturday morning before dawn, speaking Afrikaans in low tones, their faces lit up by glowing cigarettes.

Uys, who heads the commando in the area, told of being attacked on his farm — three shots, all near misses. And of a farmer who "went round with the maids, and he killed his wife. Aids". Holding up a finger: "He's as thin as this. Only 62 and not going to last much longer."

Ferguson talked about the theft of his cows, and about a man who had tried to stab him.

On the side of the road with the bakkies was a large van, behind its steamed-up windows a pack of dogs, some dozing on one another on the floor, some pressing their muzzles against the windows, streaking the glass with saliva.

When all the men had arrived, they climbed back into their bakkies and drove to Uys's farm. A papery rattle came like a sigh

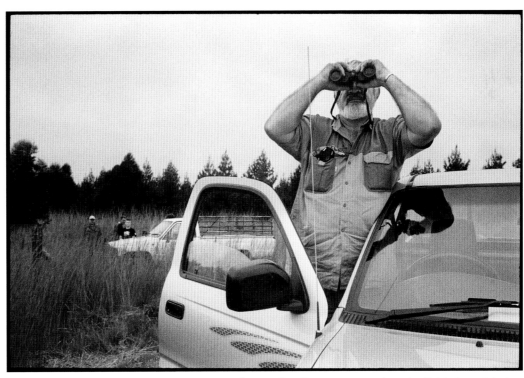

Farmer Roy Ferguson searches the fields for wild pigs.

from the mealie fields, which changed from black to green in the thin misty light. There the dogs piled joyfully out of the van windows, bounding onto the red earth, long ears flapping. Most of them – a sleek, mottled hunting breed, the American bluetick – belong to the three Guthrie brothers, who have been hunting with their pack for 16 years.

The Guthries are spare, quiet men, their khaki shirts darned many times over, trousers tucked into boots, old leather belts holding rows of pointed bullets. The three travel around the lowveld with their dogs, helping farmers to hunt.

"We just love the bush," said Keith Guthrie. "We grew up in the bush; we've been here all our lives. We used to hunt duiker and bushbuck. Now it's pigs."

The farmers spread out with military orderliness, driving to each corner of the farm, stopping on paths alongside the fields.

Speaking over crackling radios, they checked each other's position, and monitored the movement of the dogs. The sound of whistling and barking came from deep inside the fields, then a high howling. The pack had a pig's scent, and had begun tracking it.

Ferguson stood on the back of his bakkie in shorts and boots, his rifle in one hand, scanning the land. He didn't feel the cold, he said, with a smile: "The adrenalin's a bit up."

Then a crackling burst over the radio. The pig had changed course, now the dogs were driving it towards Ferguson. A dog darted out of the field, looking happy. Then another, wagging its tail. Ferguson raised his rifle to his shoulder and put his eye to the sight, but no pig. The dogs dashed back in.

The farmers with their trophies.

On and on the dogs ran and, as the sun rose higher, birds started to skim and dive over the mealies, looking for insects.

Over the radio news came at last that a pig had been shot, but that it had run back into the mealies, screaming. "There was a lot of shooting," said Ferguson, starting up his bakkie. "Nic said it sounded like a war down there."

He and the others drove to the same spot, to where the pig's blood was on the ground.

Two climbed out of their bakkies and skirted around the field, treading quietly along the road. "They see the blood but can't see the pig," said Ferguson. "They're young guys; they're scared to go in. A pig can kill you; they slice right through you. Their teeth are like razors."

A small white dog called Dawn, with what looked life a deep knife wound across her stomach, lay breathing slowly. She wasn't a hunting dog, just "one of these Mickey-Mouse dogs one of the guys brought with him". She had been in the way when the pack chased the pig out of the fields, and had been lifted into the air by a sharp tusk. Later the Guthries would stitch her up, joking that "we are nearly getting to the stage where we can do a heart transplant".

Another pet, belonging to Uys's wife, was shot in the same skirmish by what Ferguson, a professional hunter, described as a "trigger-happy idiot".

A braai to celebrate a successful hunt.

The hunting dogs are better at staying out of the way of the pigs, leaving it to the farmers to make the kill, though they often end up getting slashed by a tusk. Their only instinct at end of it is to rub their noses in the blood.

More men piled out of their bakkies and started to track on foot, the dogs baying all the time. Within an hour the wounded pig was spotted and shot again. Two smaller pigs followed in rapid succession, joining the first in the back of the bakkie.

A good day, the farmers agreed as they packed up and got ready to drive to Uys's house for a braai, because "only a fool thinks shooting a pig is guaranteed".

The dog had been lifted into the air by the sharp tusk of a wild pig and its side sliced open.

CAROLINE HOOPER-BOX
Carolina
January 2005

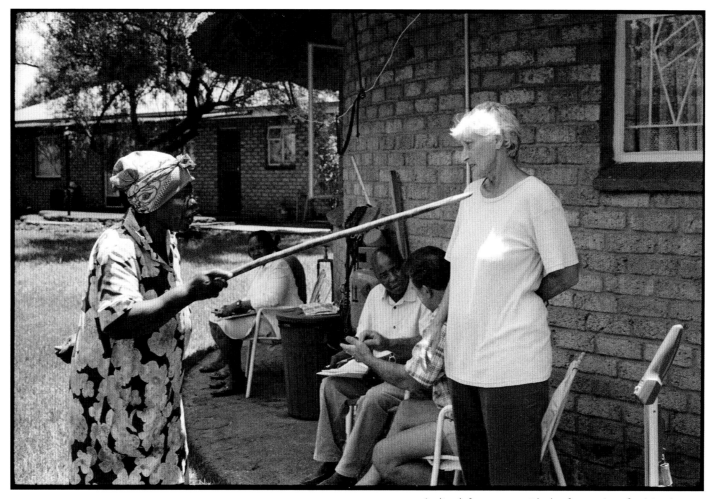

Lydia, left, argues with the farmer's wife, Mrs Jooste.

Lydia Mbele from Magaliesberg has been living and working on a farm in Hartebeesfontein for more than 20 years. Her husband died several years ago and she has became ill and mentally disturbed. Lydia reported to the local authorities that she was being evicted, but when Nkuzi and an official from the municipal offices investigated her claim, they found that her story was imagined. Social workers have been brought in to ensure that she takes her medication. Lydia is still on the farm, but there is talk of her being moved to a local old-age home.